DAVID BELLAMY'S
Watercolour
Landscape Course

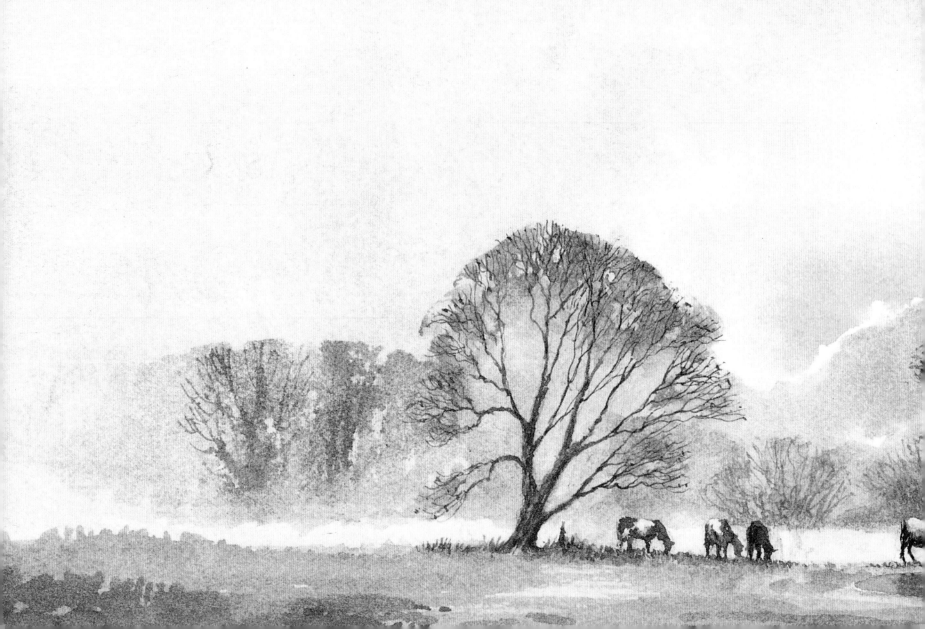

DAVID BELLAMY'S
Watercolour
Landscape Course

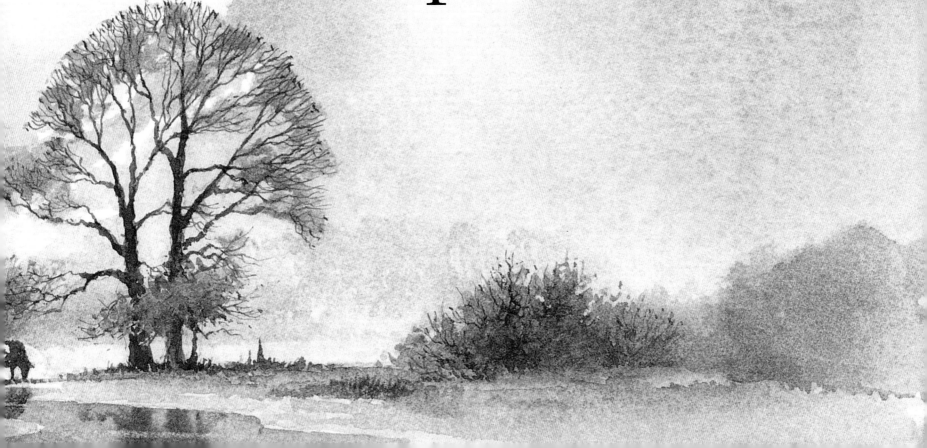

To Jenny, for whom there
is always something new to
learn about painting.

ACKNOWLEDGEMENTS

I should like to express my grateful thanks to Jenny Keal for typing the manuscript, photographing me at work, correcting my strange ideas on what students expect from a book of this sort, and generally putting up with my nonsense; also Christine Bellamy for checking the manuscript; and the many students who have made suggestions over the years and opened my eyes to the need for this book.

David Bellamy's videos on watercolour painting
are available from APV Films,
6 Alexandra Square, Chipping Norton, Oxfordshire OX7 5HL

First published in 1993
by HarperCollins Publishers, London

This edition first published in 2004 by
Collins, an imprint of
HarperCollins*Publishers*
77-85 Fulham Palace Road
Hammersmith
London W6 8JB

The Collins website address is www.**collins**.co.uk

Collins is a registered trademark of HarperCollins Publishers Ltd

09 08 07 06 05 04
6 5 4 3 2 1

Previous pages: EVENING,
FLOODED FIELDS
335 x 250 mm (13½ x 10 in)

Opposite: FFRWDGRECH WATERFALLS,
BRECON BEACONS
340 x 280 mm (13½ x 11 in)

A catalogue record for this book is available from the British Library

ISBN 0 00 716389 4

Art Editor: Caroline Hill

Set in Meridien
by Wearset, Boldon, Tyne and Wear
Colour origination by Colourscan, Singapore
Printed and bound by Printing Express Ltd, Hong Kong

Contents

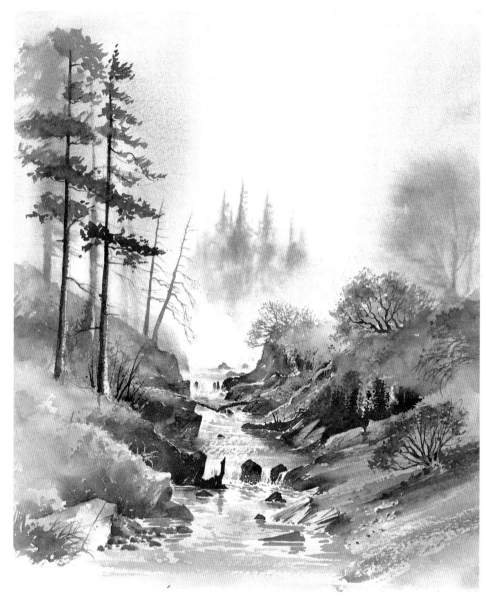

Introduction

As beginners to painting in watercolour, the beauty of the visual language of the medium can lure us into a false state of euphoria, leaving us unaware of the tortured anguish that lies ahead. We become addicted to flowing washes, transparent glazes, wet-in-wet and, heaven forbid, gungy green. Watercolour painting can carry us away from the heartaches of modern life, albeit temporarily, into flights of fantasy, to the places of our dreams; to tranquil summer meadows where the brook sings its never-ending song, or where winter frosts cast glittering ice sculptures on the rough-hewn crags of a mountain fastness. But before we are ready for such hedonistic transportation we need to arm ourselves with a firm foundation of techniques and not try to weave patterns on the wind before we can fly.

This book is unlikely to further any ambitions to fly, but it aims to give you a sound foundation in watercolour painting. It is primarily based on study packs that I introduced into my courses in 1990. Some students wish to work well into the night so the study packs were aimed at giving them as much extra work as they wanted. The study packs were designed around sets of exercises, not as a substitute for tuition, but as an extension to it, ideally followed by discussion. So enthusiastic was the response that this book became an obvious follow-up.

Unlike students on a course, readers cannot question the author, so I have tried to make the book as comprehensive as possible. Although it starts with the basics for those new to watercolour painting, it does cover a wide range of subjects and techniques which make it appealing to those with some experience in the medium. Students often receive a lot of conflicting advice, but perhaps that is what gives painting that added spice. You must learn to weigh up that conflicting advice and take what is best for yourself. Although rules are there to be broken at some stage, first of all I would like you to work your way through this book, sticking to the rules suggested. Go through it twice or more. Repeat exercises, varying your

response each time. Only after you have given my methods a try do I suggest you then decide what works best for you, and perhaps cast aside the shackles of convention.

USING THE EXERCISES

Each chapter covers a specific subject or area of painting and includes examples of how to achieve certain effects. At the end of each there are usually a number of exercises based on the subject matter of the chapter. Some of the exercises involve outdoor work; others require that you work from the book.

A number of the exercises suggest that you make a painting based on one of my landscape photographs. Whilst working from photographs is not ideal, they do provide excellent source material. Most of these exercise subjects appear as paintings in the gallery section at the end of the book. These are referred to as 'model answers' but this is merely a convenient label, as with any scene you can have numerous variations of the final painting, all of which could be just as good as the next. Ideally, it would help your work if you did not study the paintings in the gallery section until you have carried out the corresponding exercises, though you should read the gallery introduction before doing any of the painting exercises.

I should perhaps remind you here that whilst copying paintings or photographs is useful as an educational exercise, the results should not be passed off as your own work if you sell the paintings, as this may well contravene the Copyright Act.

HOW THIS BOOK IS ORGANIZED

The course is designed so that you begin painting pictures almost at once. In an ideal world you would carry out a great many exercises in making brush strokes, laying washes, mixing colours and so on, before doing an actual painting. Such a foundation would be of enormous benefit to all students. However, for those whose prime aim is enjoyment in their painting, such a course of action might seem like purgatory. As a consequence I have attempted to cover the fundamental techniques in a

The author fully equipped for sketching mud, somewhere in the heart of Bleaklow, Derbyshire

more interesting way. The more time you spend on these techniques, the better you will progress along the artistic trail.

In the first section, 'Exploring Watercolour', you are guided carefully through basic techniques, becoming familiar with laying washes, mixing colours, working with tones, building up a painting and looking at composition. The illustrations are kept as uncomplicated as possible. The next section, 'Evolving Your Own Style', is more thought-provoking and involves slightly more complicated work. The exercises become more challenging. By the time you reach the third section you will be into specific features of the landscape. There is no standard way to paint trees, water or mountains – no tricks or shortcuts are offered; you are simply encouraged to apply my working methods, allied to careful observation from nature.

In many parts of the book you will find my methods involve altering nature a little, in the manner of those artists in search of the Picturesque in the eighteenth century. This approach can be taken as far as you wish, for as the neo-classicist Valenciennes said, 'Happy is the artist who lets himself be swayed by the delights of illusion and so imagines he sees nature as it ought to be.'

David Bellamy with some of his students in Pembrokeshire, South Wales

STUDYING THE OLD MASTERS

You will benefit immensely, both in your work and your appreciation of art, from a study of the Old Masters, as well as the best contemporary artists. John Sell Cotman is perhaps one of the most rewarding artists to study during your early days. His glorious watercolours, where at times the subject positively glows, can teach you a great deal about the treatment and inter-relationships of the various elements. Books on his work, especially those with black and white illustrations, reveal his remarkable dexterity with tonal values. David Cox, the Birmingham watercolourist, gives so much insight into the manner in which the weather affects the landscape and the inhabitants of his paintings. A study of his work affords more than just a straightforward look at the landscape. Turner, of course, is in a class of his own. Many of his limpid, atmospheric watercolours or raging stormy scenes reveal a considered simplicity executed with awesome expertise. In

some of his paintings you can see how he has simplified and lost so much into the atmosphere – a marvellous lesson, as simplification is a strong element in the following pages.

GETTING INVOLVED IN THE SUBJECT

The best paintings, I feel, result from the artist having an affinity with the subject. Painting is nothing if not accompanied by the poetry of feeling. For me it is a question of more than just the visual impact of glorious scenery: historical associations interwoven with the visual image strike chords that touch the very heart of inspiration. You need to find those subjects that excite you most, for only when you find an involvement with the subject can you do your finest work.

Throughout this book you will find great emphasis placed on getting out and 'wrestling with the naked truths of nature', as Van Gogh wrote. Make sure you always have your sketchbook to hand and sketch every day.

HOUSEBOUND STUDENTS

Not everyone can get out into the wild blue yonder, though. Many artists are housebound or unable to get out very often. Painting is an excellent pastime if you are housebound, as it can take you away into new worlds of imagination, and some ideas are included later on what might be achieved with a little thought and application. Many of the exercises should appeal to those unable to venture far, so hopefully this book will stimulate such students to pursue their painting even more enthusiastically.

Running watercolour courses helps me to maintain an awareness of students' needs; otherwise it is easy for the professional to become rapidly out of touch with the problems encountered by those starting watercolour painting. Over the years I have gained enormous enjoyment out of the enthusiasm of students. Art is fun and the best kind of painting is that which we really enjoy. The results of your work will reflect this. I hope you find this book not just of educational value, but the means of entry into an exciting new world. Enjoy your painting!

Sketching from a canoe brings a new dimension to your work. The author with daughter Catherine below Château de Montfort on the Dordogne

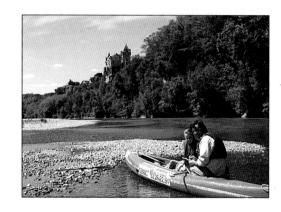

EXPLORING WATERCOLOUR

In this section you are introduced to the basic techniques of watercolour painting. At this stage you will be carefully guided along the way, while you become familiar with your materials. The essential groundwork is covered here, including such topics as application of paint, mixing colours, using tone to maximum effect, and building up a painting gradually. The importance of keeping your painting methods simple is stressed and you are also shown compositional techniques, which, if applied as demonstrated, will add power and appeal to your work.

By the time you have completed all the exercises in this section your work should be starting to show definite signs of improvement. For greatest benefit, try to put aside regular time for doing the exercises. Don't despair if you do not progress as fast as you would like; you can always redo some of the exercises to ensure that you are confident enough to proceed to the next section. Nobody finds painting easy, so you will not be alone!

BUNACURRY HARBOUR, COUNTY MAYO
305×455 mm (12×18 in)

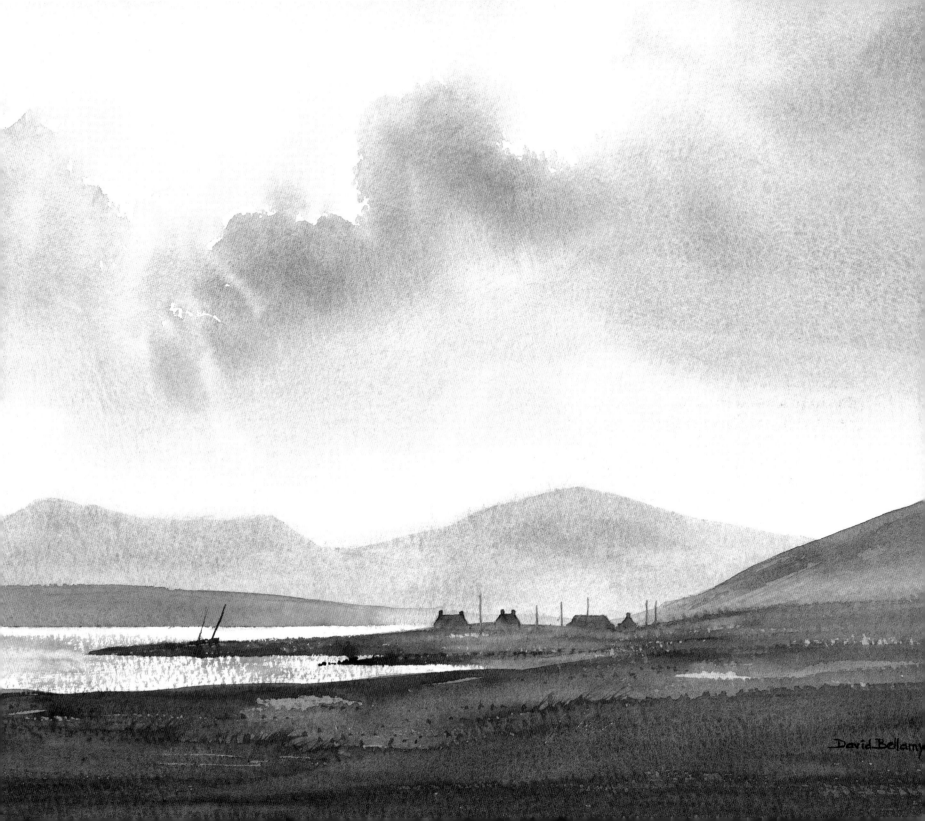

David Bellamy

1 Materials and Equipment

For those about to embark on the adventure of painting in watercolour, materials can prove to be an expensive outlay. The materials jungle contains a bewildering array of goodies to tempt the unwary, and many presentation boxes produced by manufacturers contain a lot of unnecessary items – for example, tubes or pans of Lamp Black and Chinese White. Some colours may never see the light of your studio, and, in the beginning, having a vast army of colours available to you makes life complicated. The temptation is to try a little of each in the mistaken assumption that 'they have to be used up'. Forget the brightly coloured boxes! Choose a few good materials and get to know them well.

The main concern here is to teach you how to use watercolour in the best way possible with minimum complications. Let us begin by looking at a few of the most useful materials. You really do not need much to begin working. You may even already have some materials which will fit the bill: if you own a No. 12 round brush, for example, it is not at this stage worth buying a No. 10.

BRUSHES

The main quality to look for in a watercolour brush is a good spring in the hairs, which must come to a fine point and be capable of holding copious amounts of water. The best brushes for watercolour are undoubtedly those made with Kolinsky sable, but these are expensive and not really essential for beginners. These days there are excellent brushes with synthetic filaments.

Firstly, you will need a large brush for laying washes. The size of this depends, of course, on the size of paper that you will be using. These large brushes come in either flat or round shapes. With flat brushes, unless you are painting on paper that is half imperial size or larger, a 25 mm (1 in) brush enables you to lay quite a large wash. If you are using a round brush then you need a large mop. These are not as common or as popular as the flat brushes.

Next you will need some smaller round brushes. To start with, a No. 6 and a No. 10 would be a good combination. When dipped into water and shaken these brushes should come to a fine point. The other brush I recommend is a No. 1 rigger, which has long hairs and is excellent for fine, detailed work. The rigger has the advantage over a shorter-haired brush as it can hold more paint and therefore does not need to be recharged so often. These are the absolute minimum number of brushes to start you off. Other useful brushes are a 12 mm (½ in) flat and a No. 3 rigger.

MORNING MIST
330×495 mm (13×19½ in)

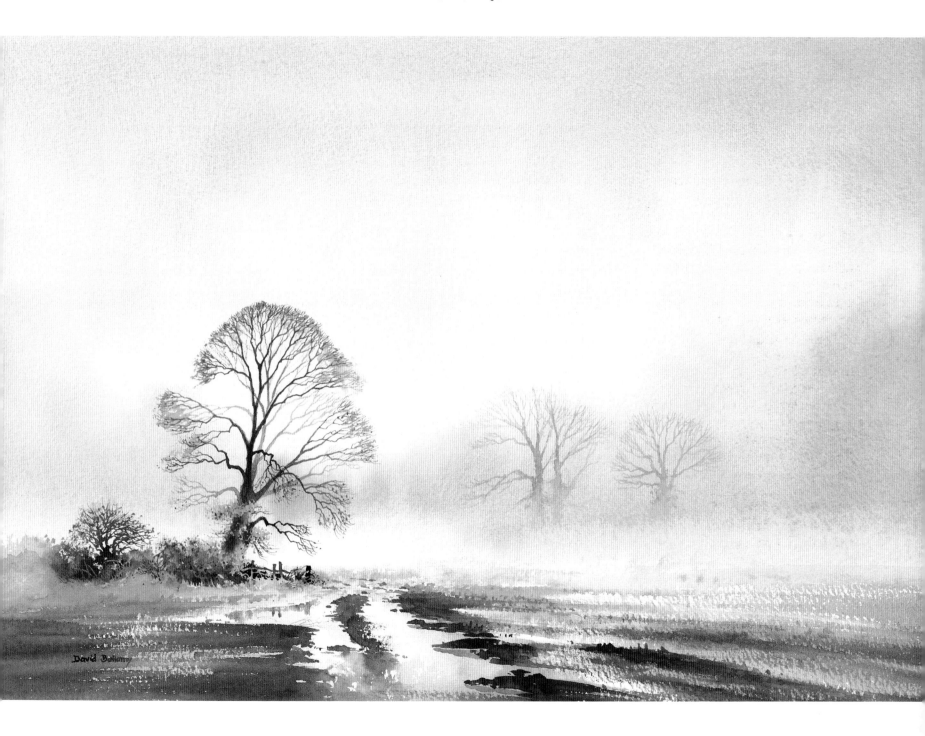

PAPER

Watercolour paper comes in a variety of weights, surfaces and sizes. To begin with it is a good idea to work reasonably small and I recommend a size of quarter imperial, which is approximately 280×380 mm (11×15 in). You can buy sheets of imperial-size watercolour paper and cut them up into quarters, or even eighths if you wish. Alternatively you can buy pads or blocks of watercolour paper. At first it is advisable to stick to one manufacturer's paper, but once you become more competent you can explore all the ranges available to see which suits you best. Everyone has their individual preference.

Most manufacturers produce watercolour paper in three different surface textures – that is, Rough, Not (which is not quite so rough) and Hot Pressed (which is very smooth). In the USA the Not surface is called Cold Pressed. Gain experience before trying Hot Pressed paper because it demands more control and skill with your washes. Throughout this course I have used examples of Not and Rough papers, and where it is important I have explained the reason for each choice.

Watercolour paper comes in a variety of weights, which traditionally are calculated on the weight of a ream (500 sheets of paper). Many now are also calibrated in grams per square metre. The lightest and cheapest paper is 90 lb and this is what I would recommend for doing small-scale exercises and getting to know your paints. However, for working on paintings I recommend 140 lb paper, at least, because this will not cockle so much. Even so, if you use a lot of water you will probably need to stretch 140 lb paper in the larger sizes. I shall discuss stretching paper later on. I recommend that, to start with, you buy a pad or a few sheets of Bockingford 140 lb or 200 lb paper. Bockingford paper has a Not surface which will take quite a bit of punishment. Personally, I use Saunders Waterford, which is slightly more expensive but is extremely robust and has an interesting surface texture.

PAINTS

Watercolour paints are manufactured from particles of pigment bound together by an agent such as gum arabic. Most manufacturers produce watercolour paints of students' and artists' quality. The students' quality paint is much cheaper but is not as finely ground as the artists'. Artists' quality paints tend on the whole to be more intense, more permanent and much better ground, but for the moment if you are starting watercolour painting it is just as well to buy students' paints. Once you start selling paintings regularly you owe it to your customers to use the best materials available, so then you can change to artists' quality.

If you obtain a colour chart from your art shop it will show the range of colours available and their permanence rating – that is, whether they fade quickly or are

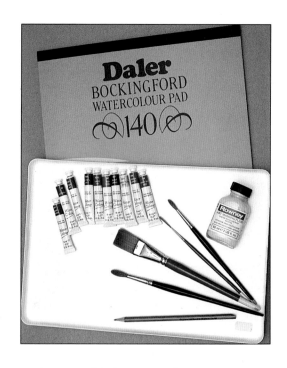

Basic starter kit for watercolour painting
This includes a watercolour pad, tubes of Daler-Rowney Georgian (students') watercolours, No. 6 and No. 10 round brushes, a 25 mm (1 in) flat brush, a No. 1 rigger, a bottle of masking fluid, a pencil and a large flat palette

more permanent. Some charts will also give you an idea of the transparency of the pigment: some paints are more opaque than others and therefore have greater covering power, whereas other paints when applied in a wash are more transparent. Paints may be bought in tubes or pans. It really is a matter of personal preference as to which you use, but personally I prefer tubes because I can squeeze out as much as I need and the paint is beautifully moist. Some people, however, find pans more convenient to handle.

The students' colours I suggest you start off with are Ultramarine, Raw Sienna, Burnt Umber, Crimson Alizarin, Cadmium Yellow (Hue), Light Red, Payne's Grey, Cobalt Blue (Hue), Burnt Sienna and Scarlet Lake. I have deliberately excluded green in order to encourage colour mixing. Most greens are staining colours and not easy to remove if things go wrong. The colours listed will give you an excellent range to work with during your initial paintings. You can gradually introduce new colours once you are familiar with these.

OTHER ITEMS

At least one drawing board about 455×610 mm (18×24 in) is essential unless you work solely on blocks of watercolour paper. A number of 3B or 4B pencils, plus a putty eraser which will disturb the paper surface less than a normal eraser, are necessary. Also, Medium, Soft and Very Soft grades of

Karisma Aquarelle water-soluble pencils will be needed to complete some of the exercises in this book. These are discussed in more detail in Chapter 4. Palettes come in a variety of shapes and sizes, but in the beginning you can quite easily use a white saucer or plate. Some supermarkets sell plastic trays which can be effective substitutes, but make sure they are plain white. Most manufacturers of art materials produce palettes with a number of wells in them. The round wells are superior to the square ones, which catch paint in the corners. In the studio I use a large butcher's tray as a palette, which gives me ample room on which to mix my colours. For demonstrations I use a Spencer-Ford palette – a large plastic one with a tight-fitting lid. It contains my mess whilst travelling, so that other materials do not become contaminated with paint. This would be an excellent palette for those with no permanent studio, as open, wet palettes do not make suitable bedfellows with sketches, books and the like.

There are a number of other materials which I find useful. Sponges are good for some techniques. It is not essential to buy a natural sponge although they are the best. Masking fluid can be effective when working on some features in a watercolour painting. Its use is discussed later. Some students find an easel indispensable. I do not generally use one, although for demonstrating I use a Daler-Rowney Westminster easel which will adjust to any angle, an essential

An outdoor sketching group with David Bellamy at St Brides Bay, South Wales

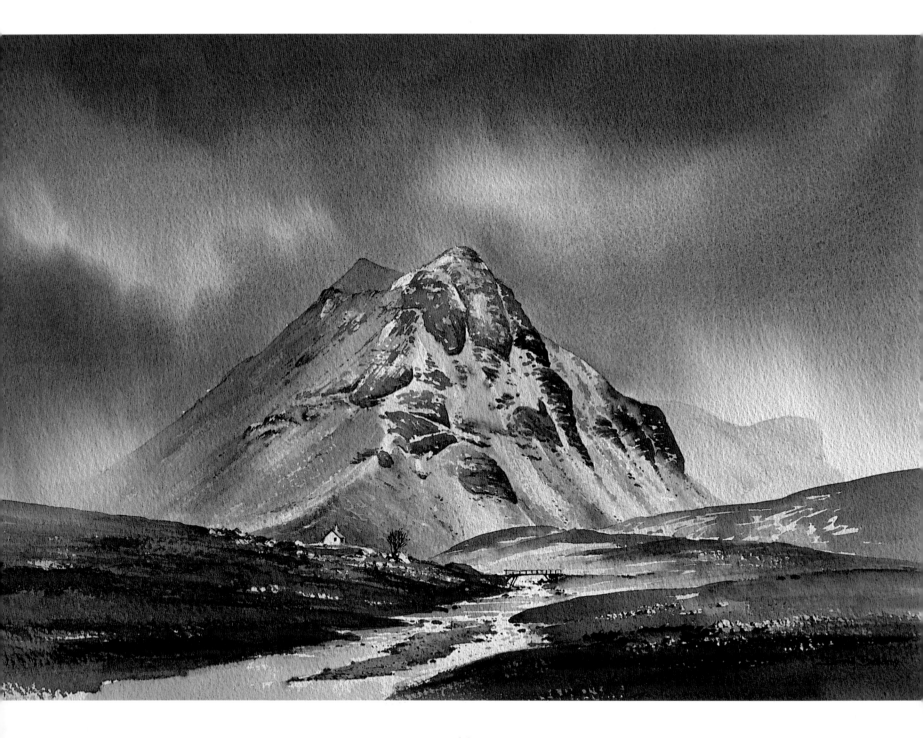

feature when working in or out of doors. Being metal and quite heavy, it does not blow around easily. Indoors I work on a desk. For those who are interested, there are various desk easels available.

STUDIO ORGANIZATION

Having a room dedicated to your painting gives you a tremendous advantage over those who have to resort to limited periods at the kitchen table. You are able to leave things in position, ready to start again at a moment's notice, and also have somewhere to store your paintings, equipment and materials. The desk or table you work on should have a large enough flat surface to take comfortably a drawing board, palette, water-pot, paints and brushes. Cramped places will not enhance your watercolour techniques.

Ideally, a pinboard above the desk can be used to hold sketches and photographs of the scene you are working on, as well as perhaps your work schedule and planning charts. At that height sketches are easy to view and less likely to be covered in paint. You may also need room for a table lamp for evening work or when the light is poor. Daylight simulation bulbs are far preferable to ordinary ones.

A plan chest is of tremendous value in storing your watercolour paper, paintings, mountboard and any other large sheets of paper. Ideally, watercolour paper should be stored flat. I use a ten-drawer chest: the flat top also makes an excellent surface for cutting mounts and framing pictures, though naturally it needs to be protected from damage. Storage space in the form of shelves and cabinets cuts down the clutter in your work area, of course, and as you acquire more photographs you may find the need for a metal drawer cabinet which can be used to file your photographs in area or subject order. Try to arrange the studio set-up so that it takes a minimum amount of time to get a painting under way.

Without somewhere permanent to work, life can be difficult. Even a corner of a room or a closet shared with the lodger's cat is better than nothing. A large, stout, zipped portfolio case is the ideal way of transporting unframed paintings, but it is also an excellent storage device for those without a studio. Failing that, cardboard folders clipped tightly will suffice. Watercolour paper can be chopped to size unless you work on full imperial, or, of course, you could buy blocks which obviate the need for stretching. Some stationers sell large plastic trays which fit into drawers and these can be used to hold all your brushes, pencils, erasers, paints and so on. This way they can all be extracted at once. If setting up to paint becomes too much like Sumo wrestling with a giant octopus, then your painting will suffer, so keep everything as simple and organized as possible.

The materials and equipment you will need when out sketching are described in Chapter 9.

BUACHAILLE ETIVE BEAG, GLEN COE
380×535 mm (15×21 in)
A rainstorm is passing over the further end of the mountain, and with the bridge and cottage quite small in the middle distance, the mountain appears more impressive

2 Basic Watercolour Techniques

Basic watercolour techniques sound about as exciting as playing ludo with a tired kipper! The temptation here is to skip over this bit and dive into the more interesting chapters. However, without a grounding in the art of brushwork your landscapes will become glorified mudscapes, with trees taking on the appearance of gone-to-seed cabbages. So, to make this chapter more attractive I have designed the exercises around extremely simplified compositions. At this stage it is of tremendous value to produce these little paintings, to provide practice in laying washes whilst at the same time producing what is effectively a painting. We are not concerned with colour mixing at this point, but simply in laying on colour in flat washes. Colour mixing will be tackled later. We shall now consider two fundamental aspects of watercolour painting: applying the paint to the paper and practising brush strokes.

BRUSH STROKES

How you use the brush is vital in producing the desired effects, yet the importance of this is grossly under-estimated. The most frequently used brush stroke involves holding the brush in the hand as you would a pen or pencil, at an angle of about 45 degrees to

the paper. Practise holding a large round brush in this way. Make sure your paint is watery so that it will flow well, then dip the brush in water and pick up some moist paint. Brush it across a scrap of watercolour paper, parallel with the top of the paper, for 50–75 mm (2–3 in). Provided you have sufficient water on the brush there will be a clear, sharp edge along the top of the stroke.

Normal brush stroke
This is executed with the brush held like a pencil, at an angle of about 45 degrees

Now try another brush stroke. Here you want a softer, less regular edge along the top of the stroke, so this time, hold the brush at a much more shallow angle, the handle parallel with the top edge of the paper. Gently apply a stroke of similar length to the first. Depending on the pressure applied and the amount of water on the brush you should achieve a certain loss of definition. Do several strokes of this type, varying the pressure and amount of water each time so that you achieve slightly different effects. Naturally, by changing the pressure within the stroke you can produce interesting variations along the edge.

Ragged-edge brush stroke
Creating a ragged edge by dragging the brush across the paper at a low angle, from left to right

CLIFFS NEAR DINAS FACH, PEMBROKESHIRE
405×560 mm (16×22 in)
Wild seas and a stunning coastline combine here to add drama, with strong detail on the closer rocks to accentuate them as a focal point

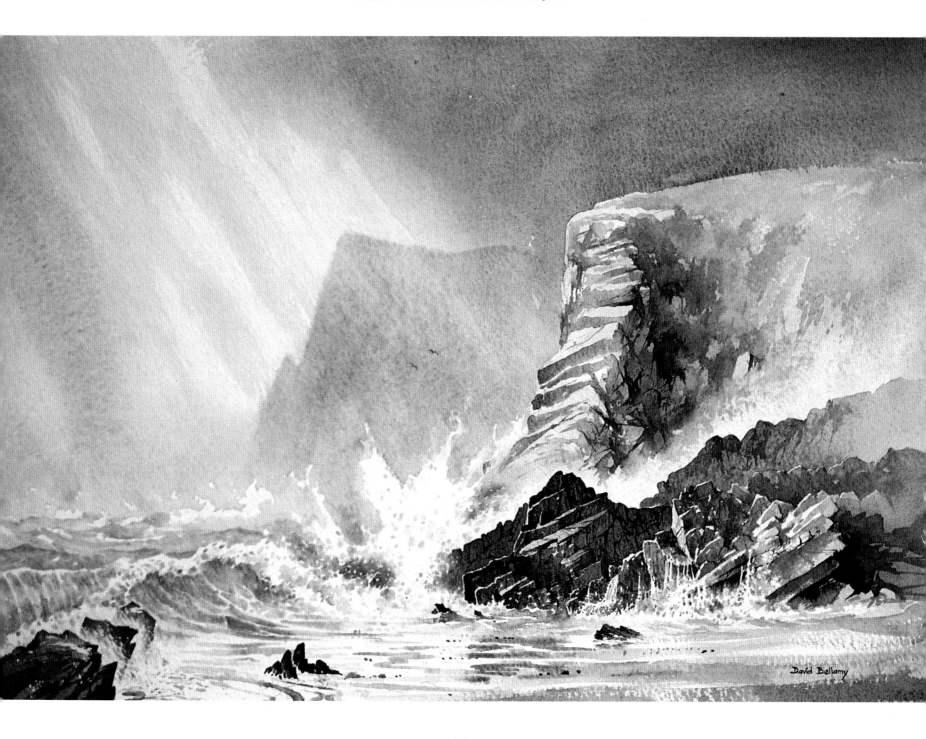

David Bellamy

Sometimes the resulting stroke will be indistinguishable from the first type and at others quite different. This second type of brush stroke is useful for suggesting distant hills or ridges, or anywhere you wish to avoid a hard, unbroken line.

Even when you are experienced it is worth doing a 'dry run' on a scrap of paper before committing yourself to the real thing. This is especially true of the second type of brush stroke, as it varies so much. Further brush strokes will be introduced during the course, but these are sufficient for now.

APPLYING PAINT TO PAPER

In watercolour painting, application of the paint onto the paper is done basically in four ways, depending on require-ments. Firstly, there is the wash, that most characteristic of watercolour techniques. This is used to cover the larger areas and is generally laid across the paper in a very wet manner, which exploits the transparent nature of the medium. A wash is best carried out boldly, quickly, and without poking around in it once it is laid – simply leave it to dry. Secondly, there are small areas to be filled in from time to time. These are blocked in usually with the tip of the brush. Thirdly, there are details to be put in. Doors, windows, fences, trees, figures, rigging and so on have to be applied with a brush in much the same manner as drawing with a pencil. For this, use a fine brush: a rigger is excellent, although if you are using sables even a No. 10 can

come to a sharp point suitable for detail work. Arguably, stippling – applying dots of paint with the brush – also comes under this category. The fourth method of applying the paint is by scrubbing with the side of the brush to render roughly

Hard and soft edges
Using the brush to create a hard edge on the left and, by easing off the pressure and keeping the tip of the brush away, a soft edge on the right

an area of variegated textures, such as rock. This works best on rough paper because the brush touches only the raised parts of the paper surface. This method is described later, but here we shall concentrate on the first three.

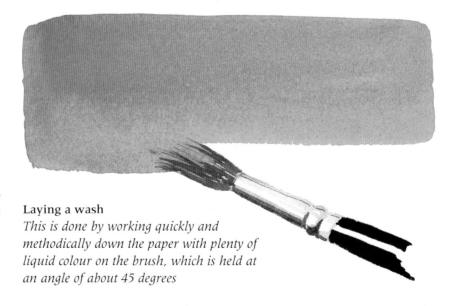

Laying a wash
This is done by working quickly and methodically down the paper with plenty of liquid colour on the brush, which is held at an angle of about 45 degrees

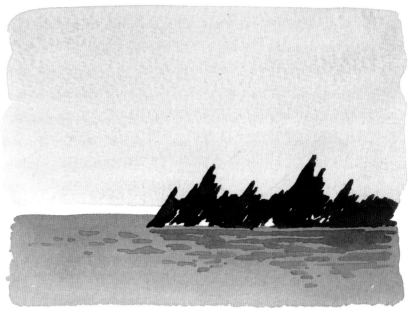

LAYING A FLAT WASH

Have a go at laying a flat wash and a graduated wash in conjunction with the illustrations here and overleaf. The flat wash is done in two stages. For this you will need a piece of watercolour paper about 180×125 mm (7×5 in). This should be tilted at an angle of about 30–35 degrees, to enable the wash to flow down evenly. Draw the outline lightly in pencil first if you feel this will be helpful.

▲ Laying a flat wash: sea and rocks
With a large round brush, pick up some Cobalt Blue (Hue) and create a tablespoon-size pool of medium-strength paint on your palette. Recharge the brush and lay a wash of colour about 100 mm (4 in) wide on the paper, working quickly down the paper with horizontal strokes and finishing with a straight, hard-edged line across the bottom. Make sure you keep the wash even and flowing, without any unnatural joins. Next, apply a weak wash of Payne's Grey just below the blue wash, exactly as shown above. Apart from the first half line, keep this wash the same width and again finish it with a hard line at the bottom. Leave this to dry completely before going on to the next stage: this is an essential aspect of watercolour painting

▲ *Once the paper is completely dry, pick up some Payne's Grey. Make sure it is dark in tone (almost black) – if need be, test it on scrap paper first. With diagonal strokes, paint in the dark rocks, making the bottom almost horizontal and the top irregularly saw-toothed. Use the filling-in technique for this. If you wish, you can leave slight gaps here and there to suggest lighter parts of the rocks, as I have done. Then recharge the brush with mid-strength Payne's Grey and paint in the rippled effect over the original wash of weak Payne's Grey. You have now completed your first 'painting'*

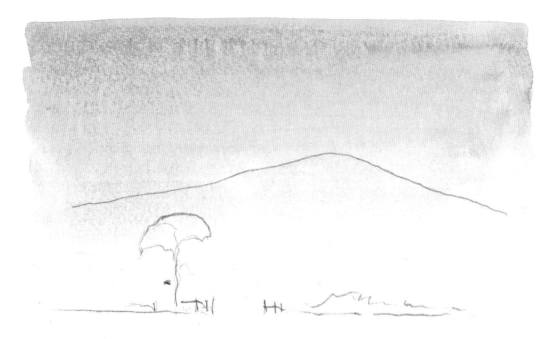

Laying a graduated wash: pastoral scene
Create a pool of colour on your palette with some medium-dark Ultramarine and, using a large brush, apply the sky wash quickly so that it does not have time to dry. Keep the wash flowing across the paper as you bring it down, gradually adding more water to the brush. This will cause the wash to become lighter at the bottom, so producing a graduated wash. Paint the wash down beyond the line of the hill and then let it dry completely

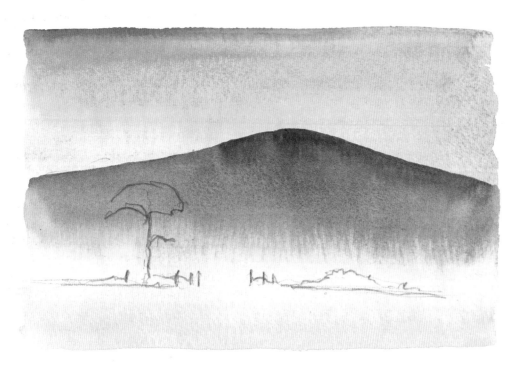

Once the initial wash is dry, take up a similar amount of Payne's Grey on the brush and paint in the hill. The tone should be darker than the darkest part of the sky area. About one third of the way down the hill, introduce some more water into the mixture to weaken it, which will again produce a graduated effect. Around the hedge line the wash should be almost pure water. This gives the impression of mist along the lower part of the hill. From here, with a clean brush, start introducing some Raw Sienna into the wash, weakly at first. Working horizontally, gradually increase the amount of colour so that it becomes darker at the bottom. This is to give the effect of depth in the picture. What you are aiming for is a soft transition between the hill and the field. Wait for this wash to dry completely before continuing

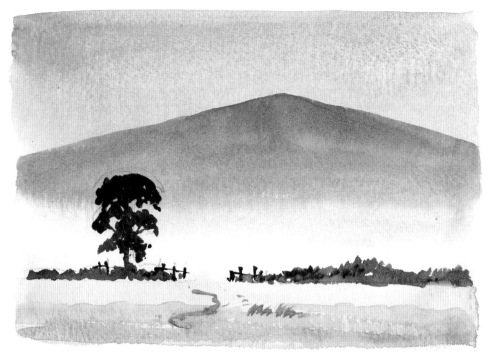

With a strong wash of Payne's Grey, almost at its darkest, draw in the tree, using a large round brush with a fine point. This is an example of the third method of application of the paint: drawing in the detail. Paint the tree in silhouette and then the hedgerow, making the line of the hedgerow reasonably straight at the bottom. The top should be less regular, suggesting bushes here and there. With a No. 1 rigger, pick up some more strong Payne's Grey and indicate the bits of fencing. Finally, introduce some strong Raw Sienna, mixed with very little water, across the foreground. For this, use the side of the brush to create a softer edge

LAYING A GRADUATED WASH

For the graduated wash, use only Ultramarine, Payne's Grey and Raw Sienna. No colour mixing is involved, however. A piece of watercolour paper about 200×125 mm (8×5 in) will be suitable, again tilted on a drawing board. As this scene is a little more complicated, pencil in the outline lightly before you begin painting, using a soft pencil such as 2B, 3B or 4B.

Try not to feel inhibited in any way. By all means use cartridge paper instead of watercolour paper if this will help you lose your inhibitions; even starting on the back of a used envelope is better than not starting at all! You can use the back of your watercolour paper as well

for exercises – unless, of course, you have a masterpiece on the front! Before you begin, play around with the brush on scrap paper. Get the feel of how the watercolour washes behave. Five minutes of wet doodling can be valuable in loosening you up before you start the proper wash. Use generous blobs of paint.

Once you have practised your first graduated wash, which is an extremely useful technique, note how watercolour lightens as it dries out. This is particularly apparent with Payne's Grey. There will be times when you need to compensate for this by making the initial wash a little stronger than seems to be necessary. Experience will teach you how to cope with this problem. In order really to get to grips with these techniques you should try several of these simple studies, based perhaps on simplified versions of paintings in this book. This will have the two-fold purpose of giving you practice at brushwork and also encouraging you to simplify the composition.

From this moment, keep all your paintings even if you do not like them. As you progress, your earlier works will indicate how your standard is gradually improving. By the time you have worked your way to Chapter 13 you may well have some material on which to practise the rescue techniques described there. Even when you reach the end of the book you will find it helps to retain some of your earliest work. You may find by then that your friends and relatives will be snapping up your better efforts.

3 Painting in Monochrome

In watercolour, because the paints are transparent you have to put on the lightest first, then the darker ones, ending with the very darkest. If you tried to paint a light colour over a dark one it would hardly show up and would be almost guaranteed to end up looking like mud. So at this stage it is important to consider tones. Even students who have been painting for some time find it difficult to come to terms with tone and colour simultaneously. For absolute beginners this can become confusion of nightmare proportions. So here we are going to forget about colour and concentrate simply on tone. Tone is the degree of darkness of a colour when it is applied on the paper. Not all colours will have the same range of tones.

THE TONAL RANGE

When working from nature you need to modify your tone scale to some degree because the range in nature is much greater than what can be achieved in any painting medium. The sun itself, for example, the brightest tone imaginable, is far brighter than white paper. It helps enormously when viewing a scene in front of you to ignore colour and look at it solely from the point of view of tones. Look at the scene through half-closed eyes – this helps to diffuse distracting

detail. Search out the lightest and darkest tones in the subject. Your lightest tone will be represented by the bare paper, and your darkest by the darkest mixture that you can produce. All the other tones have to come in between these two extremes.

It is important to reserve the lightest parts of your painting and make sure that they are not covered up. The biggest danger of this happening, I find, is during the excitement of laying the large washes. It is always more difficult to remove paint and try to recover the whiteness of the paper. If you find this a constant problem, try using masking fluid. This can be painted onto the areas that need to remain light, and allowed to dry, before the wash is laid on. Afterwards it can be rubbed off, leaving white images. Use an old brush for applying the fluid as it is harmful to hairs, and wash the brush out immediately with warm soapy water.

Some artists like to put down their darkest tones at an early stage in the painting to give a measure of where the other tones come on the tonal scale. However, this is not a recommended method until you have had some experience, as it can cause other problems, so remember to start with the lightest tones and gradually introduce the darker ones.

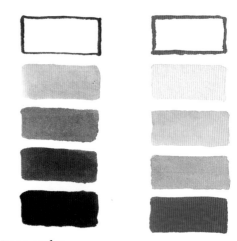

Tone scales
These illustrate the range of tones available using Payne's Grey and Light Red

PENRHYN COTTAGE
This old traditional Pembrokeshire cottage presented a superb subject, its all-over whitewash making it stand out against the background. This sketch was done as a course demonstration in Payne's Grey to illustrate the importance of tones

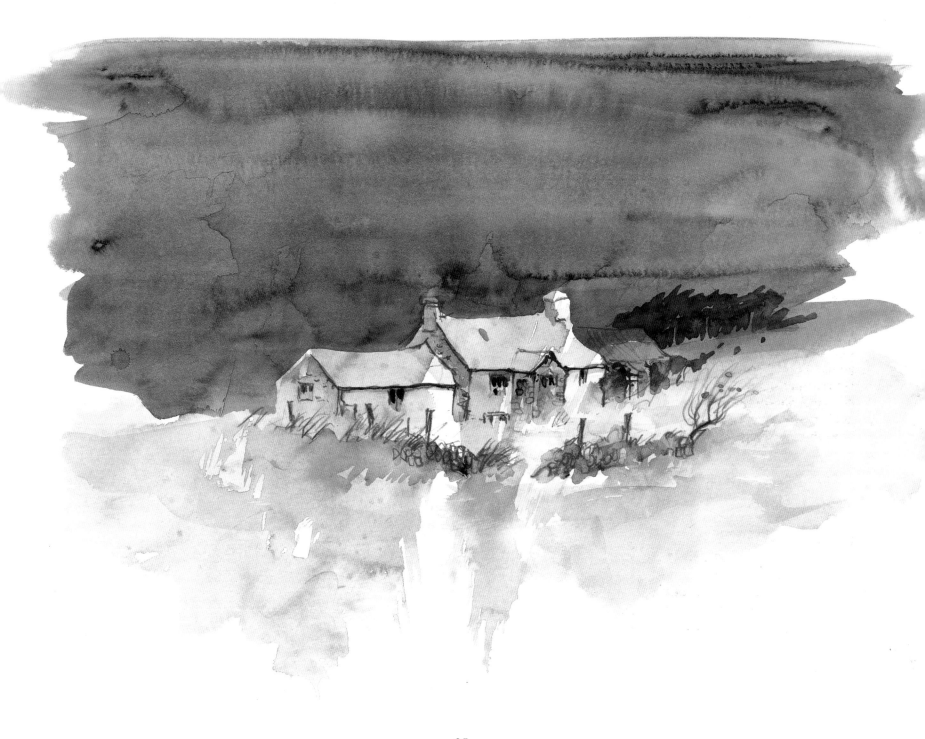

DEMONSTRATION

BLACK AND WHITE COTTAGE
140×200 mm
(5½×8 in)

❏ **Stage 1**
The outline was carefully drawn in with a 3B pencil on Bockingford 140 lb paper. Then the painting was begun by laying a graduated wash across the sky area and over the background hill, avoiding the chimney, the white walls of the cottage and the right-hand tree.

The strength of the heavy tone at the top of the sky suggests a heavy cloud.

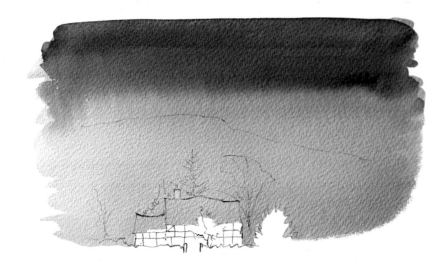

Stage 1

Stage 2

❏ **Stage 2**
When the original wash was completely dry the background hill was painted in with a medium tone. Again the wash was graduated to avoid any dark tone near the bottom.

❏ **Stage 3**
The trees and bushes were painted in with various degrees of tone, working from light to dark. The roof, chimney and walls of the cottage were gradually defined with tone rather than line.

With a No. 1 rigger the detail on the house was then drawn in and a half-open gate added. The foreground was kept simple with just a medium weak wash of Payne's Grey, leaving the pathway as white paper.

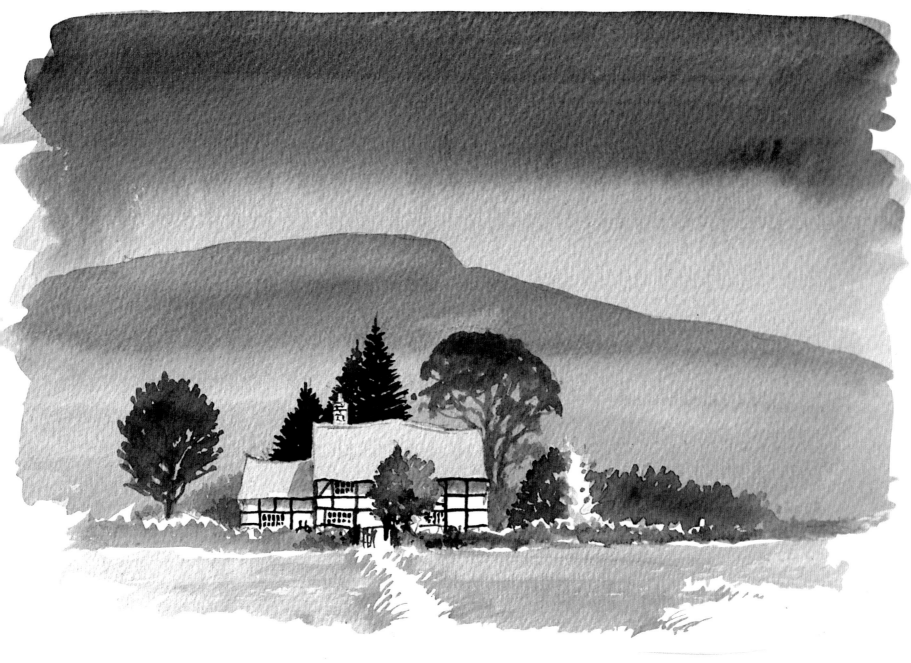

Stage 3

▲ Poor tones
Despite being painted in many colours, most in a similar tone, the building here does not stand out. It needs more contrast

▼ Strong tones
Here the tones have been exaggerated to improve the contrasts, resulting in a much better picture. Compare this with the previous illustration from some distance away: you will see the need for good tone work

USING TONE TO DEFINE OBJECTS

In cartoons and most drawing line is used to delineate objects, but in painting to achieve a reasonably realistic rendition objects are defined, in the main, by the use of tone. Colour is largely ineffective for this purpose.

Let us take, for example, a cottage in the middle distance. If you paint the cottage walls Raw Sienna, the roof and chimneys Ultramarine, and a mass of trees behind the house in a mixture of Raw Sienna and Ultramarine, then paint the foreground in Raw Sienna, you will find it difficult to make out the details if you stand away from it. If, however, you leave the walls and chimneys white and paint weak Ultramarine over the roof, followed by dark green trees of Ultramarine and Raw Sienna, the cottage starts to stand out. Once you have put in the Raw Sienna foreground, stand back again and see the difference. That is why tones are so important. You need to make them work for you, to eliminate the need for outlines and to give the painting impact. Use the dark of the background trees, or even the sky, to define the lighter roof and chimneys. Constantly relate each passage to the next, so that tone is used in the most effective manner.

At this point I should mention that every painting in this book was started by drawing in a light pencil outline to act as a guide. By the time a work is complete, such lines are superfluous and can be erased if they are intrusive.

For the painting of the Malvern Hills cottage on the previous pages I used Payne's Grey because, being dark, it has a wide range of tones and is therefore an excellent colour for a monochrome painting. Notice how the basic shape of the cottage stands out simply because of the dark tones painted around it; there is no need for any line work to define the details. This is particularly apparent where the chimney is shaped by the dark conifers behind the cottage. Carrying out a number of monochrome paintings such as this one will really help you to understand tone. As well as Payne's Grey you could use Burnt Umber, Burnt Sienna or Ultramarine, as most dark colours will provide a sufficient range of tones to work with.

EXERCISES

•

Paint a monochrome watercolour based on the photograph of plastic fields near St David's, Pembrokeshire (below). This is an extremely simple subject and should not present many problems. I had passed this scene on several occasions but it was only when sunlight lit up the plastic sheeting one spring morning that the cottage stood out. The plastic covers protect potatoes during

late spring, and look quite obscene during this period. There is no 'model answer' for this exercise.

•

Look around for simple subjects of your own choice and carry out monochrome paintings of them. Try using other colours, but obviously only the darker ones. This practice will be of enormous benefit to your painting.

4 Separating Tone and Colour

In this chapter we are going to paint a picture in three stages, concentrating on just the tones at first and then laying down colour washes, rather in the manner of early eighteenth-century watercolourists who worked on 'stained drawings'. These works were carried out by washing transparent colours over a monochrome Indian ink underpainting. Here, however, we shall use Karisma water-soluble pencils in conjunction with watercolour. First, let me introduce you to these fascinating pencils.

Karisma water-soluble pencils come in three different grades: the Medium pencil is the lightest and is particularly useful for background areas; the Soft pencil is darker; and the Very Soft pencil is extremely dark. You therefore have quite a choice in degrees of tone to work with. Try rubbing each pencil across a small area of paper in a dark mass and then brushing it with water. See how much darker each of the softer pencils becomes. Here I should issue a word of caution. You do need to fix the graphite with water before applying any colour, otherwise the particles will dirty the watercolour.

These pencils can be used in a number of different ways. They can be rubbed on the paper and then water brushed across to create tonal areas. They can be rubbed on a spare piece of paper, as though this

were a palette, leaving particles of tone which can be picked up with a wet brush and applied to a sketch. They can also be used to draw into a wet area where perhaps you have already laid a tone. Beware, however, of doing too much work into a wet surface, as the paper can take only so much of this treatment because it is more vulnerable when wet. Papers do vary, of course, so try this technique on a variety of surfaces. Cartridge paper in particular will not take much hammering. Note also that when laying some graphite on the paper to be picked up from a 'paper palette' you should hold the pencil almost horizontal and use the side of it, rather than the point, so that you set down more graphite. That is especially important when laying large washes.

▲ **Using the Karisma Aquarelle pencil**
On the left is a scribbled patch of water-soluble graphite from a Karisma Aquarelle pencil, which has been half washed with a wet brush. The image on the right was painted with a brush, using some of the graphite wash picked up from the left-hand patch

COTTAGE, EVENDINE LANE, COLWALL
200×305 mm (8×12 in)
This is an example of how the Karisma water-soluble pencil can be used to create an image in tone, by washing water on the pencil work. Once this first stage was dry I laid weak glazes of colour across the paper

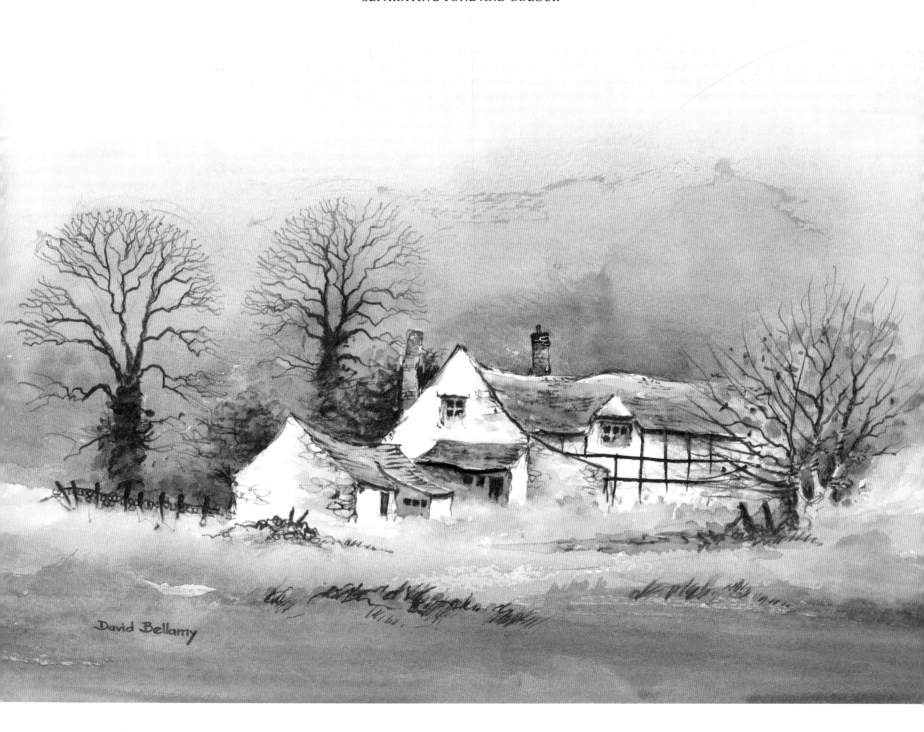

David Bellamy

DEMONSTRATION

TWILIGHT LANE
190×255 mm
(7½×10 in)

❑ **Stage 1**
The image was drawn on Bockingford 140 lb paper with a Soft grade Karisma pencil and rough tone applied across parts of it.

❑ **Stage 2**
Water was washed over the graphite and more detail added. Some branches were drawn into the wet paper.

Stage 1

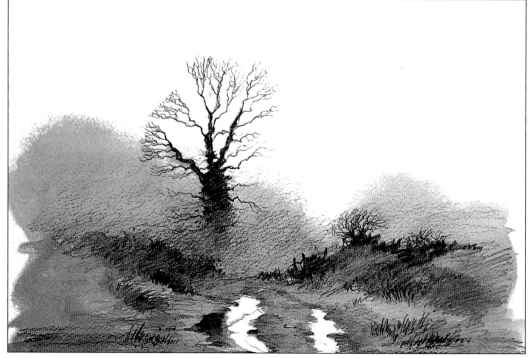

Stage 2

❑ **Stage 3**
Once the monochrome part of the painting was complete, and all the graphite fixed with water, the colour could be added. Flat colour washes of Cadmium Yellow Pale, Crimson Alizarin and Raw Sienna were laid over the work, the darker tonal areas being brought out by the underlying graphite.

▶ Stage 3

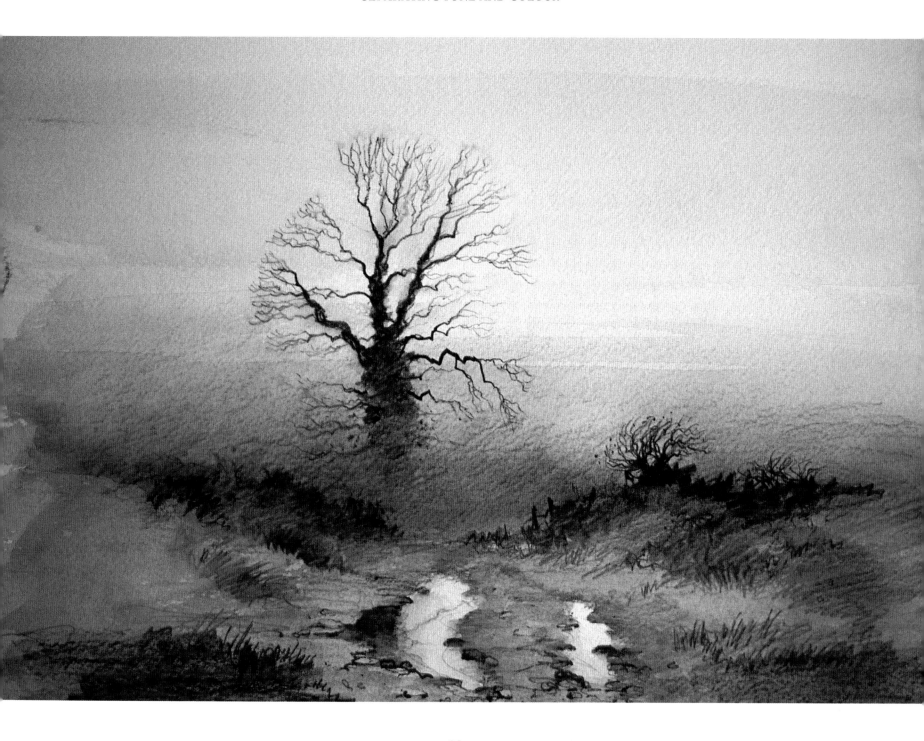

PAINTING A PICTURE WITH AN UNDERTONE

The exercise on the previous pages illustrates how you can achieve a pleasing watercolour painting without the need to consider tone and colour at the same time. With this method you might well end up with some areas appearing a little muddy, but despite this you will most likely achieve an interesting painting with strong contrasts in tone. At this point we are not concerned with producing a perfect painting; more important is the need to build up a strong foundation of techniques. This exercise is a valuable one even if you feel your results are not worth framing, because it will really help you to come to terms with tone as opposed to colour. Eventually your work will be that much stronger for the effort expended. This is also an excellent method for sketching out-of-doors, and produces rapid pictures even of fairly complicated scenes.

STRETCHING PAPER

By now you will be aware of how the paper behaves when you lay your washes down. Most of the time it will cockle to some extent and this becomes more pronounced if you are using a lightweight paper. If you are working on watercolour blocks, which are gummed down along the edges, then this problem is resolved for you. With sheets, however, unless you are using 300 lb

paper you will need to stretch them on a board – although some people seem to manage on 140 lb paper by using little water. I like to use a lot of water so I always stretch my paper.

To stretch a sheet of watercolour paper, cut four strips of gummed tape – not masking tape – the length of each of the edges of the paper. Totally immerse the paper in water for about 15 seconds, then hold it up by a corner to allow excess surface water to drain off. Lay it flat on a drawing board and immediately tape it down by immersing each of the gummed strips in water, squeezing off excess water and firmly placing each strip over the edges of the paper. Allow it to dry completely, keeping it flat. The surface will then be beautifully taut. Should you find the tape tearing, it is usually due to the paper having been immersed too long in the water. Over the years a number of stretching frames have appeared on the market, but I have never come across anything to rival the simple gummed tape for flexibility. You can change your format at will with tape, something you cannot do with stretchers.

Stretching paper
When taping down wet paper on a drawing board to stretch it, leave 'dog-ears' turned up at each corner to assist removal of the tape

In the previous chapter we looked at painting in monochrome as a means of coming to terms with using tones without having to be concerned about colour. Here tone and colour have been separated as an exercise in stressing the difference between them. Before going on to the next chapter, where we shall be mixing colours properly as opposed to simply laying on weak washes, try doing some little studies with water-soluble pencils, fix them with water and, when dry, use colour to enhance them. In the following exercises, use either watercolour paper or good-quality cartridge paper. There are no 'model answers'.

EXERCISES

●

Try a two-stage painting using the methods outlined in this chapter, based on the photograph of Carn Llidi, Pembrokeshire, at sunset (below), a scene chosen because of its simplicity and strong colour.

●

Copy the painting COTTAGE, EVENDINE LANE, COLWALL, *but use completely different colours. Again, do the first stage in Karisma pencils and keep the colour washes transparent.*

5 Exploring Colour

If tone sets the image, so colour is the icing on the cake which delights or subdues the eye according to the choice of palette. Before you launch into a full-colour painting it is invaluable to try a number of works using only three colours. This will help you to get accustomed to your colours and also achieve a greater sense of unity in your paintings. It also benefits beginners by forcing them to make colour compromises and therefore to feel free to alter colours to a degree. There are a number of colour combinations that lend themselves to this exercise – a blue, a warm earth colour and a yellow are best, with at least one colour capable of producing dark tones. By working methodically with colours in this way you will quickly learn to use colour to advantage. Later on in the course we shall be touching on other aspects of colour practice, but here we will consider some basic colour points.

MIXING COLOURS

In watercolour painting colours are lightened by introducing more water and darkened by adding more pigment. There is no need for white in the watercolour palette, although it can be effective if used sparingly for such things as white gulls or masts. Black is also best avoided as it tends to deaden watercolours, although some find it of use in mixing greens, for example.

Practise mixing colours on scrap paper to see how they behave. At this stage, use only two colours at a time. Until experience is gained, mixing three colours will encourage murky results. With a clean damp brush, pick up some Ultramarine and place it on the palette. Rewetting the brush so that the colours remain clean, add Crimson Alizarin to the Ultramarine and mix them together. When the mixture is fluid, brush it across a sheet of paper. By adding more of one pigment the resulting colour varies, as you will see if you try a few different combinations at random. Keep the colours fairly fluid; they should never be of the consistency of paste. The more opaque your mixtures become, the more likely you are to create muddy colours.

COLOUR CHARTS

In landscape painting the majority of students need to mix up more greys and greens than any other colours. Because there are so many different combinations available it is a good idea to be methodical in your experimentation on mixing. One way in which you can find out more about producing interesting

TENBY ROADS
305×395 mm(12×15½ in)
This is a watercolour and gouache painting on Bockingford Grey tinted paper

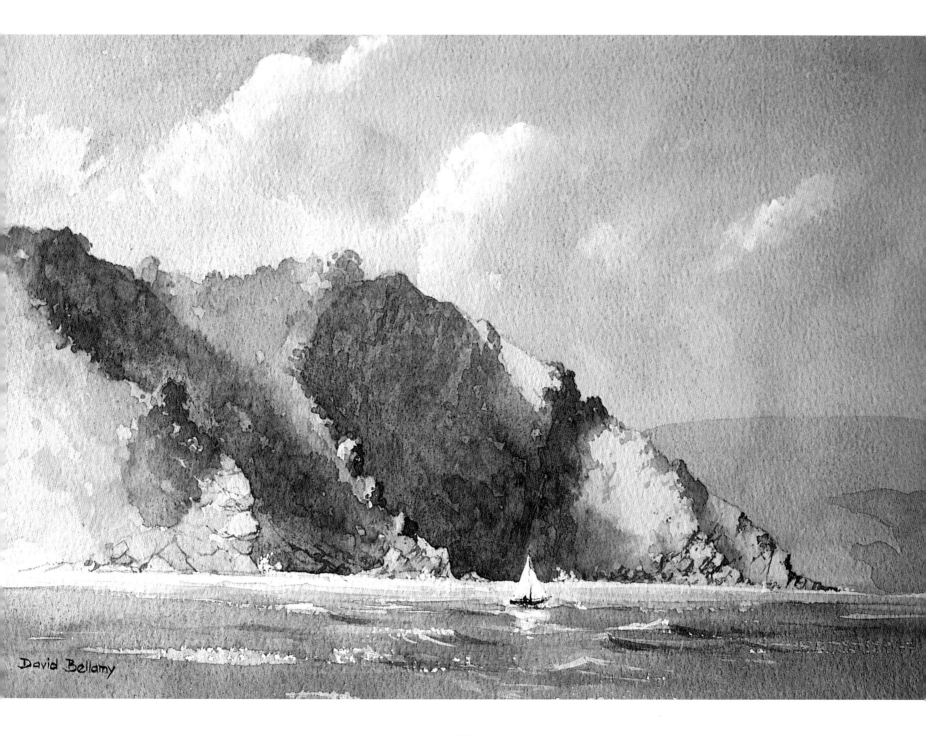

David Bellamy

greys and greens is by compiling colour charts. Draw a grid of 38 mm (1½ in) squares with a pencil, as shown in the greens mixing chart. Paint pure blues across the top line, ignoring the first square. Then take Cadmium Yellow (Hue) and paint it into the first square of line 2. Mix an equal amount of Cadmium Yellow (Hue) with the first blue on line 1 and insert the mixture in the square below on line 2. Then mix Cadmium Yellow (Hue) with the second blue and insert the mixture into the third square on line 2. Repeat the process for the third blue, remembering to mix equal amounts of colour as before. Take care to wash your brush in clean water between each mix.

Then paint Raw Sienna into the first square of line 3 and mix it with the first blue on line 1, inserting the mixture into the second square of line 3. Continue along the line as before. When you extend your range of colours you can include even ready-made greens in the first line of blues, and orange in the column of yellows. Study your chart and highlight your favourite greens by circling them prominently.

Make a similar chart for greys, again with blues across the top and the earth colours (the browns and reds) down the side, as shown in the greys mixing chart. Note how the greys change as you mix different colours with Ultramarine, for example. Light Red and Ultramarine

make a lovely warm grey; Burnt Sienna and Ultramarine make a darker, not quite so warm grey; Burnt Umber and Ultramarine make a cool grey, still dark. Again, circle your favourite mixtures.

The charts can be repeated using different colour ratios, which will teach you a lot about colour mixing and also ensure that you do not miss a possibly interesting combination. It will also help you to get to know your colours more intimately. As you buy new colours, introduce them in your chart. Watch how some combinations will produce lovely transparent mixes whilst others border on mud. Being selective with mixtures will give your work a more vibrant, clean appearance.

Colour mixing chart: greens

Colour mixing chart: greys

DEMONSTRATION

SOMERSET LEVELS
180×255 mm
(7×10 in)

❑ Stage 1
For this simple painting only three colours were used – French Ultramarine, Burnt Sienna and Raw Sienna – on Saunders Waterford 140 lb Rough paper.

Once the minimal pencil outline had been drawn, a wash of French Ultramarine was laid across the top of the sky, leaving hard edges here and there, and softening them elsewhere. Without delay a mixture of French Ultramarine and Burnt Sienna was put in to create the dark clouds, merging into the wet sky wash in places.

Raw Sienna was then applied to the lower part of the sky, letting the wet French Ultramarine and Burnt Sienna mixture run into it.

The foreground grass was suggested with some weak French Ultramarine mixed into Raw Sienna. Then the whole painting was allowed to dry completely.

❑ Stage 2
With a No. 6 brush the distant bushes were suggested in a light mixture of French Ultramarine and Burnt Sienna. Then the hedgerow, posts and tree were painted with a strong mixture of the same colours, using a No. 1 rigger.

The foreground was then darkened with a stronger mixture of the initial foreground wash, though allowing some of this to show through and at the same time retaining the vignetted effect.

Finally, the reeds were indicated.

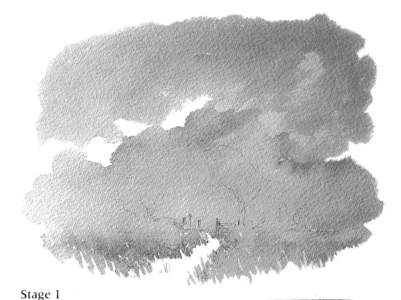

Stage 1

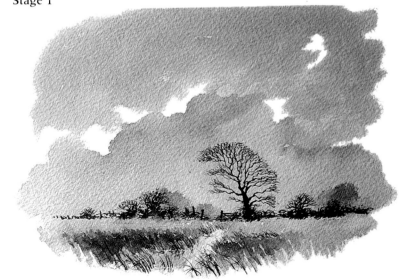

Stage 2

Mixing on paper
This bridge, with its variegated colours, provides an ideal opportunity for mixing the colours on the paper rather than on the palette, and allowing them to run into each other

MIXING ON PAPER

A useful device where, for example, you need to paint some mossy green patches on a roof, rock or wall, is to mix colours on the paper instead of the palette. In this case, lay on the colour of the roof and then immediately drop in the green to create patches with soft edges. This is extremely effective when painting rocks, tree trunks and features that contain a variety of colours. Make sure there is not too much water on your brush, otherwise cabbage-like run-backs will form, and although getting rid of these is covered in the chapter on rescues, there is no point in encouraging these horrors! Experiment with this type of mixing on scrap paper, as the resulting experience can be invaluable. Try dropping light colours into wet, dark ones and dark ones into wet, light colours, but do learn about characteristic tendencies before incorporating this technique in a painting.

WINTER TREES
165×240 mm
(6½×9½ in)

TINTED PAPERS

As well as limiting your palette to achieve unity it is worth considering using tinted papers to see how effective these can be in colour experimentation. Many eighteenth-century artists preferred tinted paper – some even tinted paper by dunking it in their coffee! In *Winter Trees* I have used Bockingford Oatmeal tinted paper and limited my colours to Light Red, Raw Sienna, French Ultramarine and Burnt Sienna. The Bockingford tinted papers are only lightly tinted and will encourage you to leave much of the paper free of paint, rather like pastellists do. Tinted papers seem to be less intimidating than ordinary white paper! If you use darker tints you will of course need to emphasize the highlights with White Gouache or similar pigment.

COLOUR TEMPERATURE

By judicious placing of certain colours you can create the illusion of warmth or coolness in a painting. A sunlit area, for example, can be made to appear warmer by making the adjacent shadows bluer. Cool colours, such as blues and greens, suggest distance and so are useful to create a feeling of recession in your work; whilst warm colours, such as reds and oranges, splashed into the foreground will make that part of the painting come towards you.

In the following exercises you will become more familiar with colour, but this is only the tip of the iceberg; later on we shall examine further aspects of colour practice.

EXERCISES

•

Try some colour mixtures on paper, using the bridge scene in this chapter as a guide. Drop two colours into the first wet wash, but resist working into the wash with your brush. When dry, draw into the colour with Payne's Grey, using a rigger to define your subject. Repeat the process with other subjects, such as tree trunks, weather-beaten roofs and dry-stone walls.

•

Using just three colours, paint a picture of the cottage at Dunster, Somerset (below). If you wish, you may paint the background trees as a flat wash of grey/green to avoid complications. My rendering of the subject appears on page 149.

•

If you have not already done so, attempt the two colour charts.

6 Building up a Painting

The order of working on a watercolour is an important aspect to consider before starting to paint. Methods vary from artist to artist. Even the usual way of working from light to dark is sometimes ignored, as you will see in various parts of this course. I generally begin with large, flowing, transparent washes across the paper, then insert detailed areas in and around the centre of interest. The large washes accentuate the beauty of watercolour – its transparency. The detail provides the interest, or meat, of the work. Failure to consider this latter stage will result in a greater degree of visual incoherence. The secret is to suggest enough detail to allow the viewer to fill in the missing parts, rather than tediously rendering the obvious.

A METHODICAL APPROACH

As we have already seen, by starting with washes of the lightest tones and building up the darker areas gradually, effective watercolours can be produced. These darker areas can overlap the lighter washes, but not vice versa. So, when deciding how to tackle a painting, you need to work out in what order the areas are to be painted. Generally it is easier to work your way down the paper, starting with the sky and ending with the foreground. In this way you are less likely to disturb passages you have already painted. This procedure is not always followed, but unless there is good reason to do otherwise, it is sensible to stick to the orthodox method.

Build-up overlays
In the left-hand illustration the dark crags were inserted first, then a shadow wash of Ultramarine applied. Even though the crags were dry when the Ultramarine was washed on, the result is messy. The right-hand sketch was done by laying on the Ultramarine first, then including the crags

▶ Cottage in the Llanberis Pass, Snowdonia
200×280 mm (8×11 in)
Not only do the track and wall lead in towards the focal point, but the rocky ribs also emphasize it

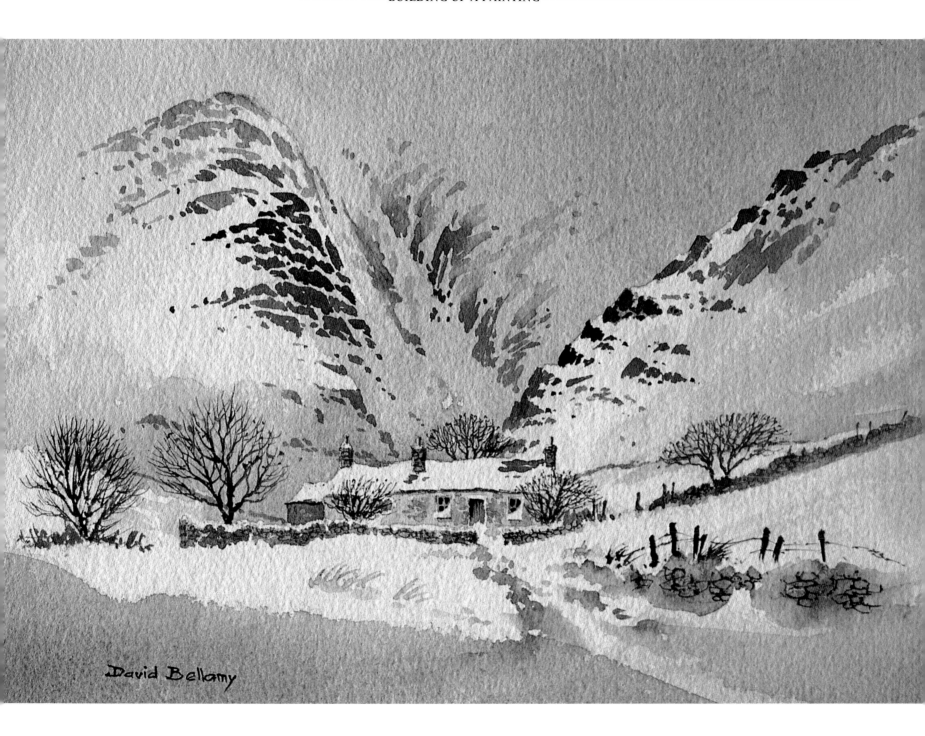

David Bellamy

DEMONSTRATION

SNOWDONIA FARM
215×300 mm
(8½×11¾ in)

❏ Stage 1
I began with a light
pencil outline on
Saunders Waterford
140 lb Rough paper.
Weak Cadmium
Yellow Pale was
then washed across
the lower sky, with
Cobalt Blue laid
immediately above
this and allowed
to run down.

Payne's Grey was
added to the bottom
of the sky to
accentuate the
hard-edged areas of
snow. The
foreground was
painted with a mix
of Cobalt Blue and
Payne's Grey.

❏ Stage 2
The stonework was
rendered with pure
Raw Sienna and
then the right-hand
hill was put in with

Stage 1

Stage 2

Payne's Grey,
softening it towards
the extremity of the
painting.

A mixture of
Cobalt Blue and
Burnt Sienna was
used for the trees
and the shadow
sides of the farm
buildings.

❏ Stage 3
Detail on the
buildings and wall
was inserted with a
No. 1 rigger, as well
as the tree on the
right of the farm,
the bush and the
gate.

Stage 3

David Bellamy

One of the biggest killers of good paintings is impatience. Some artists want to see a masterpiece forming before their eyes after 10 minutes or so; many may have less than an hour to do a painting when they arrive home from work, for example. However, it is very important, particularly with the washes, to stop and think how you want the end result to appear before brush touches paper. Dry-run your brush above the paper if it helps to prepare for the actual application. Also, I cannot stress too strongly the importance of making sure the paper is completely dry before you continue to the next stage – unless, of course, you are using the wet-in-wet technique which is discussed in a later chapter. At times small areas may bleed into others but invariably this is less of a problem than the immediate carnage of the paper caused by attempting a rescue.

If you are really eager to continue, then use a hair dryer or fan heater to speed up the drying process. Be careful, however: if the paper becomes too hot, the next wash to touch it might dry instantly, with less than ideal results. I get on with another painting whilst waiting for washes to dry, or break for coffee.

As a painting is built up, students invariably come up against two particularly frustrating problems. The first of these is when passages in the painting take on the appearance of mud, and the second is knowing when to stop.

▼ Muddy colours
Mud like this is created by overworking paint on an already painted passage. If you are unhappy with a wash it is usually best to sponge it off gently and start again. Like rabbits, give mud a wide berth!

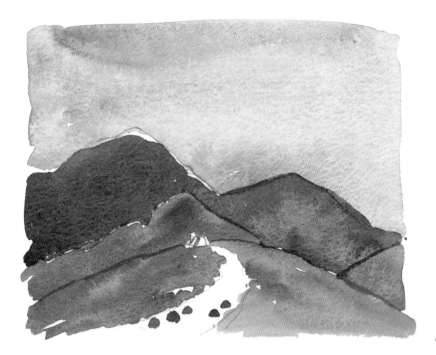

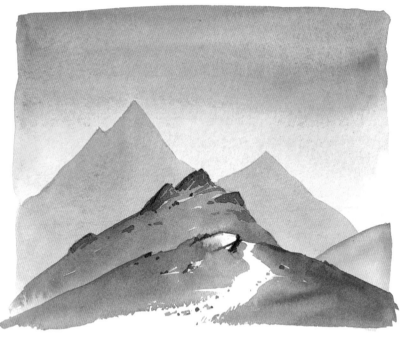

Mountain ridges

These illustrations show the wrong and the right way to paint mountain ridges. The example above is a fragmented scene having the appearance of a 'painting by numbers' picture, caused by simply filling in the pencil shapes without thought to coherence.

In the other example (above right), whilst the pencil outlines are the same, the ridges have been rendered by washing on the colour of each part and considerably weakening the wash at the bottom, just before the ridge disappears behind another. Each ridge was put in after the previous one had dried. This gives a much more unified feeling to the scene, implying recession

AVOIDING MUDDY PASSAGES

Mud is created in a number of ways. Most commonly it is a result of tentativeness: students often feel that it is best not to be too bold when laying a wash, thinking it is safer to err on the side of caution as they can always lay another wash on top of the first. Inevitably, many of these efforts see not just a second, but often a third or even fourth application of colour over the same area. By this time it will be mud. The effect is exacerbated by overworking with too many brush strokes. Other causes are attempting to correct wayward glazes, as with shadow areas (see Chapter 18), and mixing too many colours into an opaque morass. To

prevent the latter happening, make sure the depth of tone is right to start with by testing the wash on some scrap paper before committing yourself to the painting. Use as few strokes and as large a brush as possible. Nevertheless, some pigments are more likely to cause mud, especially the more opaque ones.

FINISHING THE PAINTING

Knowing when to stop vexes us all, no matter how long we have been painting. Putting too much detail in the foreground is a common error. Most contemporary watercolours benefit from simple passages in this area. Often great phalanxes of hedgehog-like clumps can be seen marching across the foreground

when all that is needed is a simple wash. Always err on the side of understatement where the foreground is concerned.

As you approach the end of a painting, keep placing a cut mount over the work – it is amazing how this highlights problems and unfinished passages. If you are unsure about including that boa constrictor in the foreground, put the work away for a couple of days and then look at it afresh. If you are still at a loss, often a sympathetic partner can help out with this tricky problem by providing an objective point of view.

Building up a painting is a slow, methodical process. It does have its moments of panic and exhilaration, in between which you should reassess progress and consider the next stage carefully. An aid to this is to prop up the painting on the back of a chair or table and look at it from a normal viewing distance. This will show up any glaring errors or omissions that might be difficult to see when your nose is very close to the paper. This constant appraisal of the development of your painting is of paramount importance, particularly during your early days of painting.

EXERCISES

●

Carry out a restricted-palette painting (about four colours), based on the photograph of Stob Coire nan Lochan, Glencoe (below), *building it up gradually and particularly bearing in mind the need for clean washes (no mud!). Keep the foreground simple. My version is on page 150.*

●

Draw a mountain ridge scene similar to those illustrated in this chapter. Paint the scene using the overlapping wash method, where each wash is brought down over the upper limits of the adjacent area. As each passage dries, wash over the next, overlapping each time to avoid the hard edges which would appear if the washes were confined by the pencil lines.

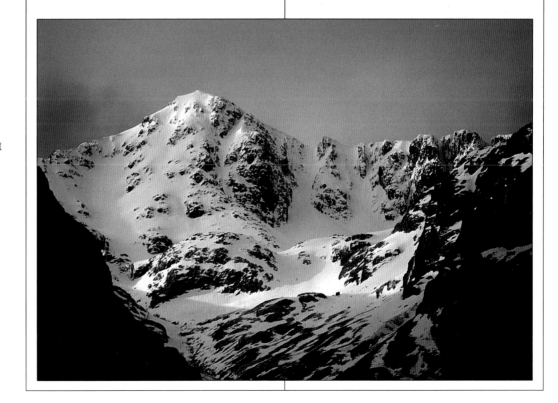

7 Creative Composition

Composition embraces so much within a painting: not just the position of the various elements within the framework, but also their treatment in terms of tones and colour, lighting, emphasis and a host of other considerations. It even affects apparently minor points, such as ensuring that a cow is looking into the painting and not staring at something out of sight beyond the edges. Intuition plays a significant part in compositional design; the rules cannot be reduced to some simple formulae. Much of what we learn about composition comes to us gradually with experience, but for the moment let us look at some of the more basic aspects of the subject, concentrating especially on the centre of interest (or focal point) and the need to use thumbnail sketches to strengthen a work.

THE FOCAL POINT

The focal point, or centre of interest, is that part of a painting which draws the gaze of the viewer. In a landscape painting it can be a cottage, bridge, tree, stream, mountain, a patch of light, or any feature you think is suitable. To get the best out of a focal point you should emphasize it with contrasting tone, strengthen the detail on it, or perhaps enhance it by the use of strong lighting.

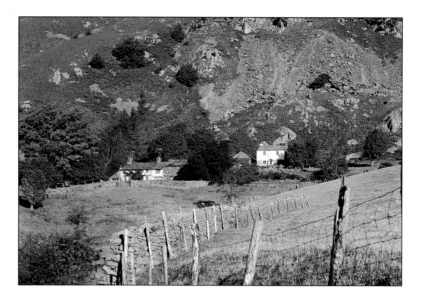

Farm in Little Langdale, Cumbria
This lovely scene, with the farmhouse of typical Lakeland architecture as a focal point, should gladden the hearts of most landscapists. However, there is no sky, another dwelling causes a conflict of interest and there is much clutter in the foreground with walls and fencing, so it presents quite a challenge as a painting subject

▶ Farm in Little Langdale, Cumbria
230×330 mm (9×13 in)
In my painting I have ignored the lack of sky – it is not always necessary. Focusing on the farm, I have left out the other buildings, as well as the foreground clutter. The mountainside has been simplified, with the rocks almost 'aimed' at the farm to strengthen the composition. The gate in front of the house is important in drawing the viewer to the centre of interest.

Although this is not a set exercise, you may wish to have a go at the composition. Work from the photograph, rather than the painting, and compare results afterwards

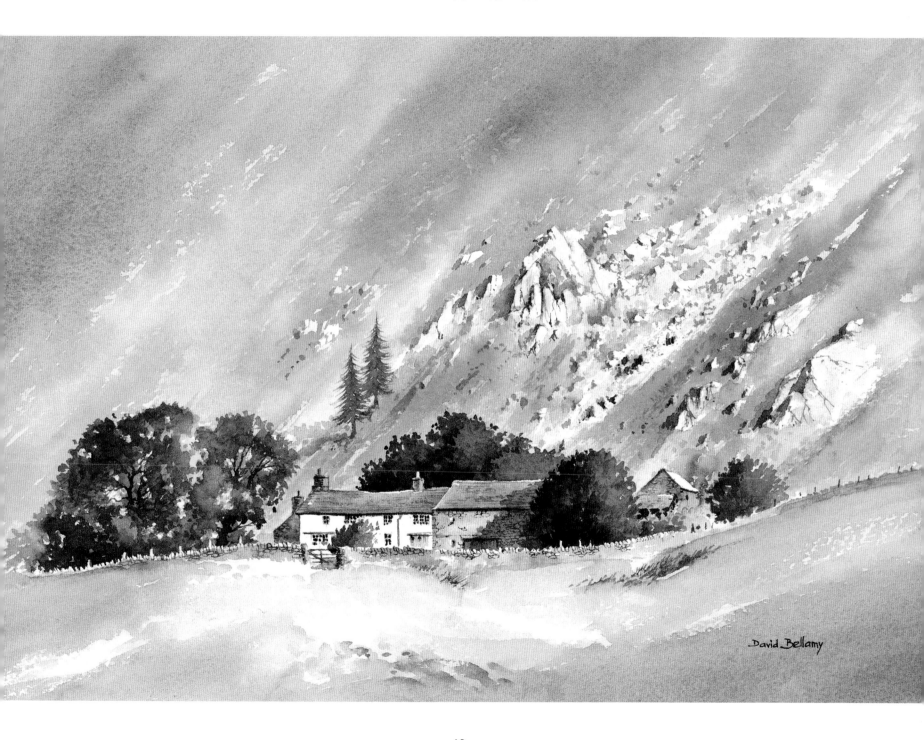

David Bellamy

Thumbnail sketches
By doing two or three of these simple thumbnail sketches, based on your original sketch or photograph, you can rearrange and improve the composition to suit your needs

Breaking up horizontal lines
By putting in the telegraph poles this composition is made more interesting. Always try to break up some of the horizontals in your pictures

Too many focal points
There are too many competing elements in this scene. A single focal point needs to be decided upon and the remaining houses subdued or eliminated

Too many coincidences
In this sketch the left-hand tree touches the mountain ridge – it should be pushed above or below it; the right-hand tree is directly below the mountain summit and above the edge of the curve in the road – it should be moved slightly to the right

Isolating the focal point
The dreadful fence across the foreground here not only inhibits the eye of the viewer reaching the focal point – the tree – but is also too regular. If it must stay, make it less even, perhaps by breaking it up with bushes or undergrowth; alternatively, vary the distance between the fence posts, make some of them lean slightly, and subdue others in long grass

Compositional diagram
This diagram is an aid to strengthening your composition. The strong diagonal lines around the edges denote danger areas where there should be little or no detail. The four shaded areas near the centre are the best places to position your focal point. Their centres are located at the four intersections of lines drawn from points at one third intervals along each edge

Without a focal point the painting will lose its way; there will be nothing for viewers to rest their eyes upon. Compositions are more effective when there are no competing areas of interest, so include only one focal point in a painting. Subdue or remove any glaring features that pull the eye away from the centre of interest, or alternatively, push them closer to the focal point so that they lend support rather than competition.

THUMBNAIL SKETCHES

On many occasions a composition will suggest itself. The more experienced you become, the more often that will happen. However, even professionals need to use devices at times to work out the optimum composition or determine how far they can stretch convention. The best tool here is the thumbnail sketch. It is excellent practice to draw two or three of these simple monochrome or linear sketches before deciding on the final form of a painting. They need not be larger than postcard size; half that is quite adequate. Pencil, charcoal or Karisma water-soluble pencils are all excellent for these, whether you need a tonal sketch or just a linear one.

DANGER ZONES

The extremities of a painting – the edges and, in particular, the corners – are the danger zones. Any detail of significance in these areas will weaken the composition because it will take the eye away from the centre of interest. Slight suggestion of detail might work, but anything stronger detracts from the illusion of harmony. All paintings need quiet passages, not just in the extremities, but these are particularly vulnerable places. Study the paintings in this book with these areas in mind. When you are working on a painting, do not feel you have to fill up every square centimetre with riveting detail, as that will be too hard on the viewer's eye. There are, of course, exceptions, but that is no excuse for making every painting an exception.

BASIC COMPOSITIONAL GUIDELINES

All rules about composition are broken successfully at times, but generally only when the artist has mastered the basic problems associated with constructing a picture, for only experience will suggest how far these rules can be disregarded. Here we are primarily concerned with producing a pleasing, harmonious grouping of the various elements within a painting. For the moment it will help your work if you keep to a set of conventions, as shown in the Composition Checklist, which in due course you may wish to ignore at times.

COMPOSITION CHECKLIST

FOCAL POINT
✓ Have only one focal point

✓ Highlight it with strong lighting or strong detail

✓ Do not position it in the dead centre

✓ Subdue or eliminate any competing detail

✓ Unless the focal point is there, keep the foreground fairly simple

LEAD-IN
✓ Use a road, stream, wall, gateway, or whatever, to lead in to the focal point

✓ Make a break in a hedgerow, wall or fence across the foreground to create a lead-in

BALANCE
✓ Avoid putting all the detail on one side

✓ Keep strong detail away from the extremities

✓ Break up long horizontals with trees, masts and so on

✓ Take care that large foreground trees do not isolate the focal point from the rest of the picture

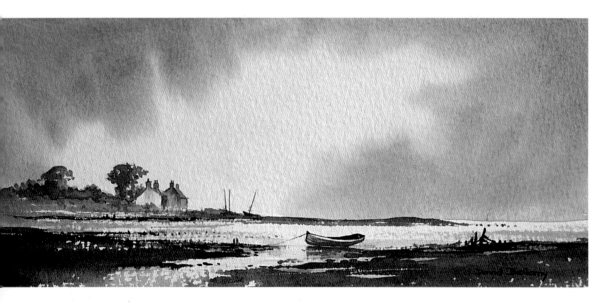

ANGLE, PEMBROKESHIRE,
200×405 mm (8×16 in)
Here most of the interest is on the left-hand side, so a couple of posts have been added on the right to give balance

COMPOSITIONAL CREATIVITY

Some people feel that any form of interference with the composition of the actual subject, or exercising a little creative influence, is unforgivable. Certainly great masters such as Turner took tremendous liberties in their compositions, almost completely changing the topography on occasion. Beautiful as the landscape is, it is necessary at times to alter the order of things. It is then a case of deciding to what degree the changes are acceptable to the individual. Whilst it may be fine to move or omit the odd stone or boulder, you will need care in trying to do the same thing with a mountain. Mist or a blizzard could obliterate a mountain positioned beyond your focal point, in which case it could be omitted. To take a specific example: if you were to look up

the Ogwen Valley in North Wales with the craggy peak of Tryfan as your subject, you could actually leave out Foel Goch to its right as this mountain is beyond Tryfan – with mist or a blizzard it would not be visible anyway. However, you would need to be careful on a really clear day!

As well as large-scale features, there are, of course, smaller ones such as gates, trees, barns, cottages, caravans, walls and hedgerows, and you must consider how to treat these. If you are doing a portrait of someone's house for them, you need to be reasonably faithful to the place. If you are going to name a place – whether farm, mountain, lake or village – then again you need to take care with your creative instincts. Perhaps features can be moved slightly, exaggerated, obscured or played down in some way. Shadows or mist can be used to great effect here. You

can sometimes avoid a problem by carefully positioning yourself when doing the initial sketch, but do remember that the ideal composition is a rare bird. And when it hits you, the usual result is that you are too astounded to do a proper job! Such is life.

Suitably vague titles such as *Morning Mist*, *Lakeland Barn* and *Coast near Fishguard* can hide a lot of creative misdemeanours and send you off into wild flights of imaginative rearrangement of the topography. Here you can really let yourself go and use the original sketch or photograph as just a beginning on which to base your fantasy or composition.

INTRODUCING PROPS

In some of my paintings I introduce props to balance the composition. By

props I mean minor items that are in character with the scene being painted. Examples of this are one or two posts placed to break up a shoreline and balance the focal point; or a post or bit of fencing strategically positioned to cause a reflection in a puddle. Puddles themselves are useful props to create interest in an otherwise boring passage. Bushes of all shapes can be used to interrupt the line of a regular hedgerow or wall, and boulders can be useful, too. Do be careful where you put your boulders, though – in the middle of a Hampshire field they are not very convincing!

On a few occasions I have literally added a prop to a scene I wanted to paint. During the filming of *Mountain Adventures in Watercolour* I came across a fallen tree and heaved it back up, holding it in position with tape whilst we filmed. It was only a small one, I should perhaps add!

As you gain experience, your strategy for good composition will be greatly affected by the sketching you do outdoors. Whilst sketching you can move features, filter out bad elements of a composition, such as a caravan beside traditional buildings, ugly plastic bags and anything else that jars, and take advantage of the more promising ones. Sketching is dealt with in more detail in Chapter 9. So, start thinking about the final composition when you are out sketching your subject. It will make the battle in the studio far easier.

EXERCISES

●

Draw three or four simple thumbnail sketches from the Galway thatch picture (below).

●

Using the thumbnail sketch with the most promising composition, paint the Galway thatch scene. The 'model answer' is on page 151.

●

Photographers are limited in how far they can alter the impression of a scene so you will often find published photographs that need improving compositionally. Dig out photographs of landscapes from calendars, magazines or books. Take some examples of the more complicated subjects and try three or four thumbnail sketches from each one. This will quickly train your compositional sense. If you have photographs or sketches of your own, then have a go at those as well. Try a number of paintings based on these thumbnail sketches.

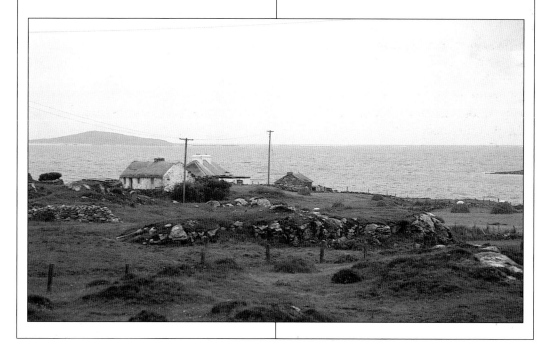

8 Wet-in-wet Techniques

When it works, wet-in-wet is a marvellously atmospheric technique which takes full advantage of the properties of watercolour. If you have not yet come across this process, it simply means applying wet paint onto an already wet surface – an exciting technique that is excellent for achieving misty, moody effects. It does take some practice, though, so do not expect perfect results overnight. The technique can be used over large areas or restricted to small passages. It should not be used as an excuse for unimaginative skies.

Basically there are two critical points to watch when using wet-in-wet. Firstly, having laid on the first wash, it is important to charge your brush with the right consistency of paint. The commonest error is to put too much water on the brush, with the result that the second wash is too weak and almost invariably produces an obscene 'cabbage' effect, or run-back. Whilst the paint must not be too thick, there should be only a little water on the brush when applying the second wash. Secondly, you need to lay on the second wash at the right time: too early and it will dissipate weakly into the wet surface; too late and it will cause run-backs or create mud. Look at the wet area from the side and against the light, and apply the second wash just before the sheen leaves the surface.

TESTING THE WATER

By practising on scrap paper you will become more adept at the technique and avoid the possiblity of fouling up a masterpiece. When working on the actual painting, check the critical points – the timing and the paint-to-water ratio – by trying out a wash either on a separate scrap of the paper you are working on, or on a small area to one side of the painting. If you do this in an area that can be covered up later – either by a mount or some feature in the painting – then you will have lost little if it goes wrong. Some pigments behave differently from others when dropped into a wet wash, so do be aware of individual characteristics.

As with ordinary washes, do not fiddle with wet-in-wet passages while they are still wet. One or two quick strokes can sometimes halt a potential crisis, but any more and the dried wet-in-wet will become blobby and ugly. Far better to let it dry completely, then rewet the area and have another attempt perhaps, though even this is fraught with hazards (see Chapter 13). Sometimes it is best to rewet small areas with clean water and then introduce the second wash in a limited way. This works well for such things as wisps of mist on mountain crags, or reflections in puddles.

MISTY POOL
This studio sketch illustrates the wet-in-wet technique where the sky and water have been painted in with a weak wash of French Ultramarine. A strong mixture of French Ultramarine and Burnt Umber was then applied to the wet wash to suggest trees in mist, with bushes to the right. The reflection was rendered likewise. When the paper was dry, strong foreground details were added to push back the misty tree

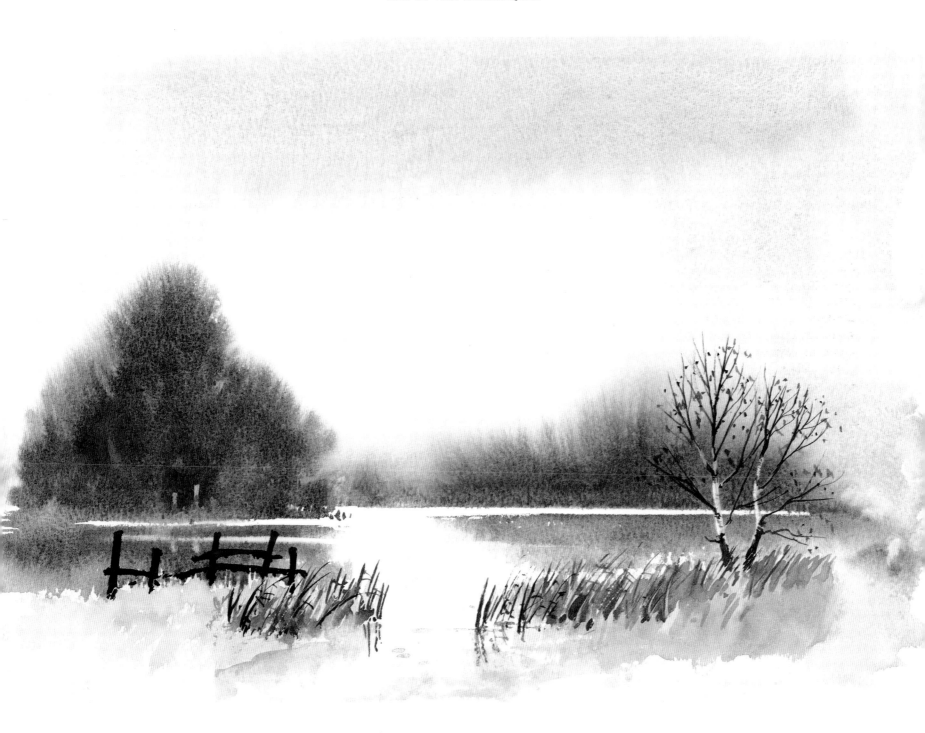

DEMONSTRATION

Sir William Hill, Derbyshire

Stage 1

Stage 2

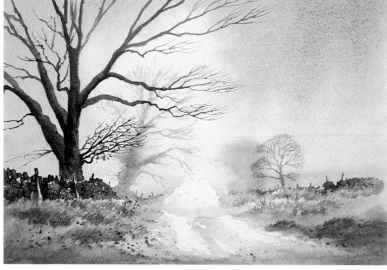

Stage 3

SIR WILLIAM HILL, DERBYSHIRE
200×305 mm
(8×12 in)

❏ **Stage 1**
This was painted on Saunders Waterford 140 lb Not paper. The sky was put in with a simple wash of French Ultramarine and Burnt Sienna, in keeping with the misty environment.

Raw Sienna was brought down over the verges and Light Red dropped into the wet foreground. Then the two more distant trees were indicated in the wet sky wash with French Ultramarine and Burnt Sienna.

❏ **Stage 2**
When the paper was absolutely dry again the closer trees were described, mainly with French Ultramarine and Burnt Sienna.

The strength of the left-hand tree helps to push the misty one further back, as do the walls.

❏ **Stage 3**
Strong detail on the walls in the foreground together with warm colours on the close verges bring forward these features and so accentuate the feeling of recession in the work. This is emphasized further by a wash of French Ultramarine and Raw Sienna drawn across the foreground road.

ACCENTUATING WITH DETAIL

The use of masking fluid combines well with the wet-in-wet technique. When you are in full flow the last thing you need to worry about is intricate detail. Being able to wash rapidly over the area, whilst preserving your highlights, produces a cleaner, more professional finish. Strong, sharp detail in front of the wet-in-wet area will accentuate its softness. In misty woodland scenes, for example, where the background is vaguely suggested by dim, soft shapes created with the wet-in-wet method, the stronger features in front, put in once the wash has dried, can bring a real sense of depth to the painting. The technique also works well in stream scenes as it can eliminate most background clutter and enhance the focal point in or near the foreground. You can have immense fun experimenting with this procedure on scraps of paper, producing mini-paintings extremely quickly.

Wet-in-wet is superb for creating atmospheric skies, misty scenes, cloud shadows across the landscape, reflections in water and a host of other effects. It is one of the most powerful techniques in the watercolourist's repertoire. Once mastered, it can really add a new dimension to your watercolours.

EXERCISES

●

Try some small, quick paintings of misty scenes, such as MISTY POOL, using the wet-in-wet technique.

●

Paint a picture of Crook Gill packhorse bridge, Yorkshire (below), introducing wet-in-wet into the background to lose some of the extraneous detail there. My version is on page 151.

●

You will not see misty scenes crying out for the wet-in-wet technique every day, so go out and seek a woodland scene with a path, pool, stream or glade (see Chapter 9). Paint it with a wet-in-wet background and strong detail in the foreground to suggest recession; in other words, impose your own 'mist' on the subject.

EVOLVING YOUR OWN STYLE

I n this section you take more of the initiative. You are encouraged to try slightly more complicated work, with more challenging exercises. There is not such close guidance here as in the previous section, since the object is to stimulate you into thinking, observing and planning your work for yourself. The crucial importance of sketching and carrying out studies directly from nature is emphasized. You are further shown how to render subjects with a firm foundation in drawing, which is vital to all those who wish to paint the landscape in watercolour. The mystique is taken out of perspective before you progress to the chapter on simplifying the scenery in front of you. Often not enough emphasis is given to the actual planning of a painting and this subject is considered in depth, before you try out techniques that will enable you to rescue a watercolour that seems to have lost its way.

Once you have completed the exercises in this section you will be well armed to launch into your own painting projects and will possess the fundamentals for developing your individual style.

ABERFFRAW, ANGLESEY
290×380 mm (11½×15 in)

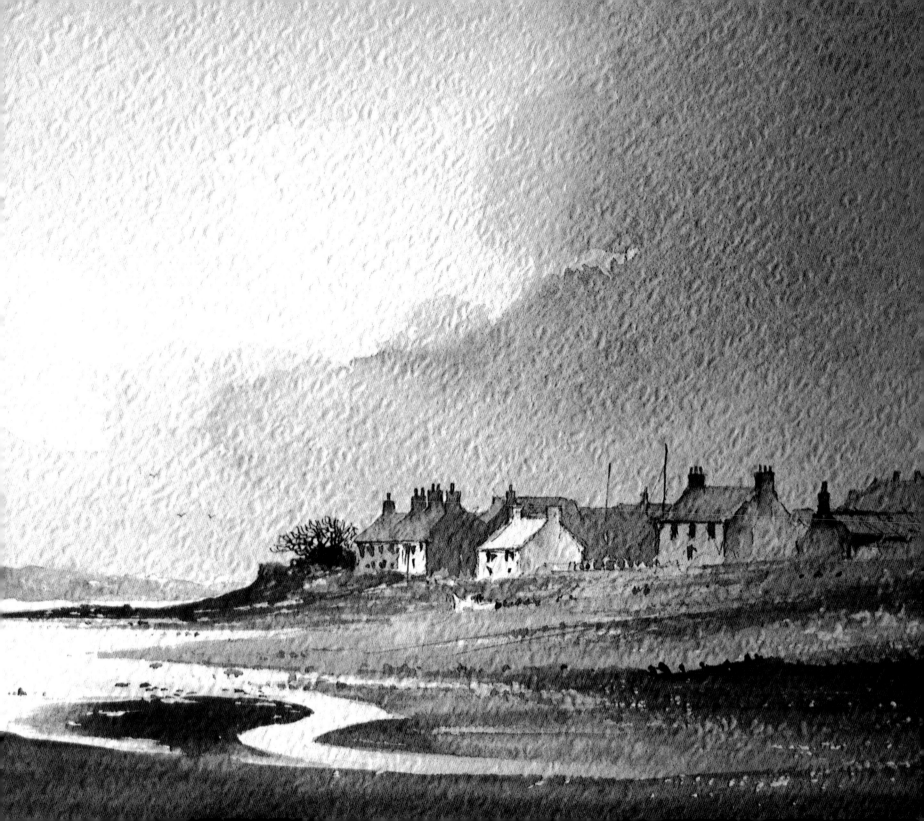

9 Sketching with a Purpose

Being able to roam, climb and live wild in the mountains I feel privileged, for so many students relate how they are unable to sketch outdoors for various reasons. Nature is the greatest teacher we have and so the ideal situation is to be able to get out into the countryside as often as possible. Direct observation from nature is fundamental to the work of the landscape painter. No tricks of the trade, gimmickry or masking of inadequacies with overbearing techniques will substitute for this method of learning. This chapter is aimed at helping you make the most of the outdoors and also suggests alternatives for those who are not able to get outside.

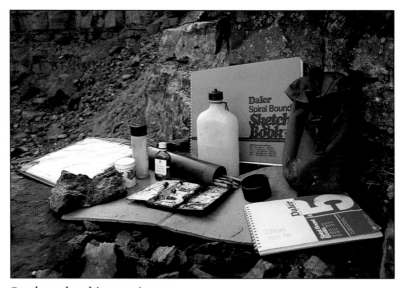

Outdoor sketching equipment

SKETCHING GEAR

For beginners to sketching it is best to buy a pad of cartridge paper about 200×150 mm (8×6 in), plus a selection of pencils graded from 2B to 4B. A larger pad would be a useful addition, but the small size is compact and easy to carry around. These items, together with a sharp knife to keep good points on the pencils, will suffice for the initial few trips. There is no need for any expensive outlay. Onlookers often do not realize you are sketching when working with just a pencil and pad, so this is an ideal way for the timid to begin.

1 Mapcase, for maps and sketchbooks
2 Charcoal pot
3 Water container for short trips
4 Antifreeze (gin), for painting watercolours below 0°C/32°F
5 Water container for long trips
6 Sketchbook (255× 355 mm/10×14 in)
7 Waistbelt pouch, to

hold paints, brushes, pencils and small water container
8 Sketchbook (150× 200 mm/6×8 in)
9 Top of brush and pencil container, used as water pot
10 Brush and pencil container
11 Paintbox with palette lid
12 Closed-cell foam mat

Key

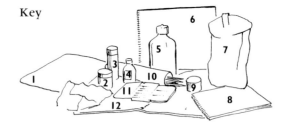

▶ HONFLEUR, FRANCE
Harbour scenes can be extremely busy and here I wanted to focus full attention on the main building by subduing the buildings on either side, even though their details were clearly visible

The Karisma water-soluble pencil enables you to introduce atmosphere into a pencil sketch. Charcoal or Conté crayons are excellent alternatives. Although charcoal tends to be messy, it has a sympathetic quality and is useful for snow scenes when there is little colour and you do not want to hang around too long, as large areas of tone can be applied quickly. If you are using charcoal a damp rag or pack of antiseptic wipes for cleaning hands, and a fixative spray to prevent loss of definition in the finished work are useful. Conté crayons come in pencil and chalk form, in several colours. They are very good for producing quick monochrome studies, and should be fixed like charcoal.

Where colour or atmosphere is important, I find watercolour ideal. Watercolour sketches are best done on watercolour pads or good-quality cartridge pads. If, however, you wish to do full paintings out-of-doors then watercolour blocks are excellent as these do not need stretching. These blocks are gummed all round the edges and form a firm support so that a drawing board is not required. A few watercolour paints, three or four brushes and a water container are all that is needed to extend the sketching kit for painting.

An alternative to pure watercolour are watercolour pencils, a compact and versatile sketching medium. They are superb for rapid colour work. I normally use these pencils in conjunction with pure watercolour washes, but of course they can also be used on their own.

BEING COMFORTABLE OUTSIDE

The weather in Britain is so varied that in the depths of winter the occasional day occurs when conditions are better than in summer: mild weather, low sunshine casting long shadows, and more colour than the overwhelming greenery of mid-summer. So you should be ready to go out sketching at any time. Being prepared is the key: have all your equipment ready for action, with pencils sharp and your bag devoid of unnecessary gear. How often I see students take 20 minutes to get ready to sketch, by which time they are cold and the lighting has changed – even in summer. You should always be ready for instant sketching and be so well organized that you know where to find every pencil or pan of paint.

Proper clothing for sitting around in the cold is vital. Most art students are probably unaware of the vast range of outdoor gear available to them in mountaineering shops. These garments are specifically designed to keep you warm and they work just as effectively for the artist as they do for the belayer who has to stand, tied on to a rock, for ages whilst protecting his climbing partner. Thermal vests and long-johns give supreme comfort in cold conditions; some thermals now available draw away body perspiration, an invaluable feature when you are carrying a rucksack. Fibre-pile jackets are the most comfortable and some are especially designed to combat those icy blasts,

COCKEREL
As this cockerel was constantly strutting around, I waited for him to pause before rapidly drawing him in pencil. When moving creatures adopt a new pose, abandon your drawing and start another on the same sheet of paper. Usually they return to an earlier pose, when you can resume your original sketch. Keeping a number of drawings on the boil at once is the key to sketching animals and figures

zipping up high to protect your neck. Goretex jackets allow your skin to breathe whilst you expend energy, reducing that Turkish-bath feeling you get inside a cagoule in mild wet weather. They tend to be expensive, though, and if you are not so active and need a cheaper but still effective outer shell whilst sitting around sketching, then look for garments made of Aquafoil, another high-performance and extremely comfortable fabric. The range of soft hats with really imaginative designs is increasing rapidly; these are useful in the cold as one third of body heat is lost through the head. Even waterproof socks are available.

As well as providing for your comfort, mountaineering shops usually stock a good range of pouches, bags and accessories that can make working outside less of a hassle. Rucksacks, of course, are invaluable if you intend walking any distance to your subject, as they leave your hands free for balance. Small day sacks are suitable for a day out sketching and with some designs you can clip on your stool. Alternatively, there are some stools which incorporate a bag with ingenious designs, so do explore your local fishing and mountaineering shops before making your choice. Personally, I use a closed-cell foam mat for sitting on; it is as light as a feather and impervious to damp.

▲ COTTAGES, CRIMSWORTH DEAN, YORKSHIRE
This pencil sketch of abandoned cottages shows the typical blackened stonework of South Yorkshire. The squiggle above the buildings is a rough indication of the uneven nature of the roof tiles

▼ BURDON SIDE, KIELDER, NORTHUMBERLAND
Here the dark trees have been used to define the buildings, as well as support the focal point. This is an ideal ready-made composition

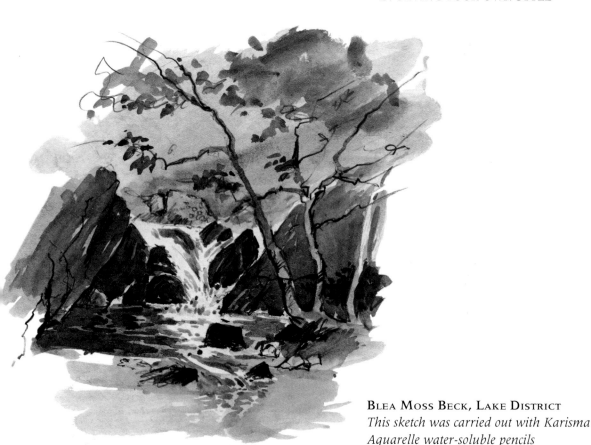

BLEA MOSS BECK, LAKE DISTRICT
This sketch was carried out with Karisma Aquarelle water-soluble pencils

SKETCHING TECHNIQUES

There are many different approaches to sketching and what suits one student may not suit another. You will need to discover what techniques you respond to best. I use various approaches depending on the subject and conditions, but for the moment will outline a few sound methods for the newcomer to sketching. You can gradually modify your approach to suit yourself.

With a sketchpad and pencils you can achieve rapid progress, so concentrate on this method for a while before trying something more ambitious. Do not be too fussy when out looking for a subject to paint. Jenny, my partner, says that when we first went sketching together it opened her eyes as to how little was needed to produce a subject. For years she had always searched for the ideal, ready-made subject, which, of course, rarely appeared. Try to pick out a feature that looks interesting regardless of whether it is surrounded by rubbish or completely isolated. It often helps to 'warm up' by doing a quick study of a

stile or gateway, for example. You may then rebuild the scene around this focal point. Once you have found a scene, study it for a few moments to consider what you wish to include. A simple viewing frame is useful for this – a rectangular window cut out of a piece of card about the size of a postcard is fine. Even a slide mount with the transparency removed will suffice. This device helps to isolate your subject from any surrounding detail.

Pencils are, of course, a linear medium, but this should not be taken as an excuse to exclude tones. Tones are important whatever the medium, as shown in the illustrations in this chapter. Drawing, considered in more detail in the next chapter, is vital to the watercolour landscape artist. On pencil sketches, colour notes can be added in the margin or on the relevant feature. Edward Lear used pencil on location and filled in with colour washes, based on his colour notes, on returning home.

Before starting to sketch, consider what first caught your eye. Maybe it was the light, the texture of a stone wall, a cottage, or perhaps mist weaving in and out of crags. Move around to find the best viewpoint; do not accept the first one offered until you have checked the scene. Begin with the centre of interest that first excited you. Discipline yourself to producing as close a likeness to the original scene as you can. Observation, as I shall keep stressing, is the key to success in sketching from nature. Look hard at both shapes and tonal

relationships. You will probably work on a larger scale back home, so your sketch needs to contain sufficient detail for you to be able to fill a larger sheet of paper. With many subjects I find it propitious to go in close and work in the detail and texture first of all, then retire to draw the surrounding elements.

Of vital importance is the discipline of comparing everything in the subject before you. How dark is the field compared to the lighter wall in front? How much higher is the tree above the cottage? Is the door of the attached barn on the same level as the farmhouse door? Is that cloud really darker than the sunlit hill, or is it your imagination? Are those tree-clad hills really green as your mind may suggest, or are they affected by the intervening atmosphere? Constantly query these aspects and it will strengthen your work. Do this even when you are not sketching, as it will attune your mind to thinking this way.

Apart from looking at the overall scene you should also be doing studies of various landscape features, such as individual trees, boulders, parts of walls, plants, gates, even ditches and puddles! Do not feel the day is wasted if you cannot find a panoramic view to sketch; seek out those exciting details at your feet. Not only will you learn how to render these features, you will also be building up a reservoir of reference material for subsequent paintings.

Many students naturally become confused by apparently contradictory advice. An example of this is where they are told to observe a subject carefully and render it in detail, not allowing any preconceived ideas about it to interfere, whilst at the same time they may be urged to be creative and change the scene to strengthen the composition. Both these approaches are valid, but perhaps need clarifying. Observation, and gaining a thorough understanding of the subject before you, is essential. You will not make a successful landscape artist without that foundation. Only once you have gained a thorough knowledge of how to paint a tree, a cow or whatever, can you be more selective in what you leave out of the scene, and at the sketching stage filter out unnecessary items. It is better to include far more than you need in a sketch and simplify it with thumbnail sketches in the studio than to find it does not contain enough information when you get home, especially if you have travelled a long way.

Many artists prefer to do finished paintings out-of-doors, rather than sketches, as they feel their work loses spontaneity when they try to reproduce the sketch back home. Working on a large scale does present physical problems, however, and there will not always be time to carry out a finished painting. The ability to do rapid sketches is therefore essential for the landscape artist and it also means you take more subjects home, especially important when on holiday abroad. Try each method to ascertain what works best for you.

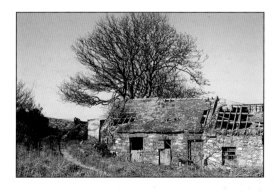

▲ Barn at Caer Lem, Pembrokeshire

▼ Detail of door of Caer Lem barn
As well as painting the overall scene, go in close on certain features such as this to capture the detail and textures

RIO ENTREMONT, NORTHERN ITALY
Rain splashes are visible over parts of the darker washes here. Sketching in watercolour is especially valuable when the mood of a scene is important

OTHER APPROACHES TO SKETCHING

Not everyone, of course, is lucky enough to be able to work outside, maybe because of advancing years or a concern about being outside on their own, perhaps in fairly remote places. Copying postcards, calendars, books and even the television can fill a gap but is certainly not as rewarding or educational as finding your own original material. So what can be done to make painting more enjoyable in these restricted circumstances?

If you are able to get out but are wary about working outside alone, consider joining a group or art society. Not all societies go out sketching, however, so you should check this prior to joining. Alternatively, why not advertise in the local press or art magazines for like-minded people? There are thousands of people like you out there, just wishing they had a sympathetic companion. One way of both finding a sketching companion and taking advantage of sketching outdoors is by joining a course which includes working out-of-doors. Many of my students form long-term friendships with each other.

Much can be done from a car, or ideally a vehicle with a high wheel base which will afford better views over hedgerows. Some artists equip their cars or vans in the most amazing ways, virtually turning them into mobile studios. Certain hatch-backs provide potentially good sketching positions at the rear of the vehicle, affording more room and comfort than the driving seat. Think about these points when next you buy a car.

For many, winter is a barren period. If you are able to get out during summer and autumn then you should ensure that you equip yourself with plenty of sketches and photographs from which to work in the dead of winter. Nevertheless, maybe you can manage the odd foray out to take advantage of pale winter sunshine filtering through trees and casting lovely long shadows. Many winter days can be as comfortable as summer ones and if you are prepared for the conditions life is much easier. This is also the time for evening classes, of course, but again you should prepare for these in advance and take along your own sketches and photographs, for any photographs supplied will probably not be to your liking. If you have only a limited amount of source material then repaint your favourite scenes in varying ways: by painting a different sky, perhaps, moving elements around, and changing the emphasis and mood you may well be able to produce a totally new picture.

THE HOUSEBOUND

For artists who love landscape painting and yet are confined to their homes, it must be a dreadful predicament. I am sure that many more housebound people would take up painting if it were practicable, as painting can take the mind off into new realms – into the

countryside or wherever – even though it may not be possible to venture there in reality.

However, there are still plenty of interesting subjects to paint. The most obvious ones which come to mind are flowers, plants and still life. If possible, ask family and friends to bring back flowers, small rocks, and any interesting artefacts they happen to come across. With a little ingenuity and quite a few rocks and stones you can even set up your own little waterfall in the bath, with a different configuration each time. Allow the water to flow over the rocks and vary the pressure (it need not be running for long). When I set this up at home as an experiment I got some odd looks from the family, so do expect a strange reaction from the rest of your household! Sketch the tumbling water and rocks – the focal point – and then put in a background. This can be obtained from a number of other sources, such as photographs and sketches, if your imagination lets you down.

Measured drawing and perspective, which are covered in the next chapter, can also be studied to a certain degree at home. Tables, cabinets, radiators, beds and all sorts of ordinary objects can be drawn from various viewpoints to produce several different perspectives.

If at all possible, try to make full use of the views from your windows. Look especially for little compositions within the scene – even if it is simply the way sunlight catches the top of the dustbin!

EXERCISES

●

Go out and do some simple pencil sketches of the following subjects: a distant farm or cottage; a bridge; a stile or gate; sheep or cows; middle-distance trees. Make colour notes.

●

Go out without any preconceived idea of what you wish to sketch, and make pencil sketches of anything that excites you in the landscape. Compare your results with the sketches you did for the previous exercise: which approach did you prefer? You may well find, as I do, that a bit of each works well. Repeat the exercise for at least the next 100 years!

●

Use other media when working outside – watercolour pencils, charcoal, watercolour and so on – and find what works best for you.

●

If you are housebound, try to obtain a variety of objects from outdoors to work from: plants, flowers, rocks, stones, fungi. Visitors in the know can bring in all sorts of inspiring objects, such as dead twigs and branches, briars, leaves and cow parsley. Doing studies of these landscape features will strengthen your work considerably and they can then be used with other source references.

With ingenuity you will be amazed at what new subjects can be discovered at home. I am lucky in that my front and rear windows provide me with quite a lot of material for painting, and by hanging out of them this is further extended. Luckily my neighbours are very sympathetic to these habits!

For the landscape artist there is nothing that can compare with working directly from nature and developing observation skills which lead to a thorough understanding of the subject. Do prepare yourself for those long winter evenings, or those times when perhaps you prefer not to venture out much, by building up your source material. Make sure you have more than enough to work from, as this will give you so much more choice when it comes to the painting stages.

10 Drawing and Perspective

For the landscape watercolourist drawing is of vital importance. The classic training of working from the nude figure is of equal relevance to landscape painting as it is to figure studies. If you can draw a nude figure competently then a tree certainly holds fewer terrors. Evening classes can be useful here, especially if you work from a model or still life and do not rely entirely on photographs.

A DISCIPLINED APPROACH

It is important to discipline yourself to produce good studies of a variety of subjects. When drawing rocks or trees, for instance, it does not matter if you fail to place each crevice or branch with absolute precision. However, if you become too sloppy in your work it will show up, so tightening your discipline by working on detailed studies will yield invaluable results in your work. Carrying out studied drawings also helps you to work out how to render the subject. Some subjects, of course, call for a much more disciplined approach than others. Later on you can let your hair down at times and work in a looser style, but to begin with you need to appreciate that it is sound practice to be able to draw properly.

You can make a start in the home. Objects like vases – in fact, pottery is an excellent subject – are useful for learning to draw accurate curves, and though there may not be many vase-like objects in the great outdoors, the discipline of drawing these curves will help enormously when sketching boats, for example. Other useful subjects around the home are plants, flowers, vegetables, and all sorts of surface textures.

Before you start, decide what is your focal point and what are the limits of your drawing. Take your time observing and carefully recording the detail. Work methodically, first outlining the main structures lightly so that any mistakes can be rectified easily or the image reduced if you make it too large. Once this is done you can apply the pencil more confidently and draw in stronger detail. Always use economy of line: try to cover the subject with as little statement as possible. Keep asking yourself, is that line really necessary?

QUALITY OF LINE AND SHADING

Once you have begun economizing on line it is important to think about its quality. The best drawings always reveal beautiful lines of great character and this is something you should strive to achieve. Some artists produce the most awful sketches and from these are born brilliant paintings. I always feel, though,

▶ WILD WEATHER OVER THE TARMACHANS, PERTHSHIRE, SCOTLAND
305×485 mm (12×19 in)

Quality of line
Varying the pressure on the pencil produces a line with more character, as can be seen here on the roof tiles in particular, which are only suggested in places

that discipline in drawing almost always leads to better, cleaner watercolours.

Always use a sharp pencil. Blunt ones will totally wreck your quality of line, making it look like something produced by the end of a poker. When out sketching, take several pencils along so that you are not constantly sharpening them. By varying the pressure on the pencil you will achieve a much more interesting line, something which is particularly apparent when rendering clinker-built boats, irregular clapper-boarding or fissures in rocks and crags.

Shading is regularly seen by many as an excuse for covering as much paper as possible with minimum effort. Laying the pencil on its side and scrubbing indiscriminately can quickly render a competent drawing a fuzzy mess, which might well be attributed to some artistic chimpanzee. Get into the habit of a more positive type of shading by cross-hatching with the pencil. This ensures more accuracy and in fact can produce some incredibly delicate nuances of tone and light which are impossible to obtain with the other method. Even surface texture can be suggested in this way. Look hard at some of the drawings in this book and you will see the advantages of this more considered and positive approach to shading.

CONTOUR DRAWING

Contour drawing is really an extension of the method of shading I have just described. It is mainly used to portray different planes, suggesting slopes, faults and curvatures of features. It is a form of shading which follows the lie of the land or whatever surface is being depicted, though at times the odd line or two is all that is required. Again, this is a disciplined approach to drawing which is fairly easy to practise and yet will yield extremely promising results in your drawings. Study the illustrations here and this should become apparent to you.

MEASURED DRAWING

Many subjects demand a fairly precise rendering of how the various components relate to each other in terms of size and position, particularly on buildings, bridges, boats and other complicated features. Here you need to know how long or high one part is when compared to another, so that a faithful drawing can be done. With a long building, for example, you may well have to determine how many times the height will go into the length. To discover this, hold a pencil vertically at arm's length with the top of the pencil targeted at the top of the building. Slide your thumb down the pencil until the tip of the thumbnail precisely coincides with the bottom of the building. Holding the thumb in this position, turn the pencil horizontal, still keeping it at arm's length. Now calculate how many times the measured height will go into the length of the building by moving the pencil from left to right (or vice versa if using your left hand).

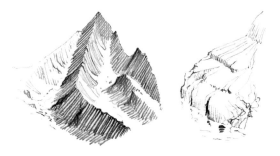

Contour drawing
Here the direction of the line describes the contours of the mountain and rocks

Measured drawing
Here the pencil, held at arm's length, is used to compare measurements in order to obtain a more accurate description of the scene

Buildings cause students some dreadful headaches: many seem to spend the first hour of a sketch erasing and then restating the problem. Leave the eraser at home! A common problem is to find that there is not enough room in which to draw all the windows and doors. If it is complicated, begin by making slight marks where each part of the structure ends. In this way you can estimate its total length, working across the paper. For example, in a row of houses, mark segments off at natural points such as vertical drainpipes. Leave yourself some margin for error. Draw the main outline of the building lightly, then start at one end and work along it until all the main details are in position. It is then easier to position the chimneys, generally the most important features, particularly on buildings in the middle distance. Once this light outline is complete you can get down to the proper drawing, confident that all the details will fit in and also that each part of the building is the right size and in the correct position in relation to the next.

▶ **Drawing complicated subjects**
When the subject is complicated, leave some extra space on the right to allow for error. You can always insert a pig there!
a *Initial outline drawn lightly to ascertain if everything fits in*
b *Modified outline redrawn once the positions of all windows and doors have been calculated and drawn in lightly, working from left to right*
c *Subject rendered in detail once the overall limits have been established*

Angles – for example, of roofs or the booms on boats – can be estimated more reliably by holding the pencil horizontal (or vertical) and then calculating the degree by which the angle departs from that. A primitive angle gauge can be constructed with two lengths of stiff card held together by a paper fastener at one end, like two rulers screwed together. For absolute precision, you could use a protractor. Again, as when measuring length, constantly bear in mind comparisons with adjacent features.

▲ **Linear perspective**
This is a simple example of perspective where the viewer is standing below the level of the cottage floor: hence, the eye level is quite low, aligned with the window sills. Note how the

LINEAR PERSPECTIVE

In landscape painting buildings are the usual cause of perspective problems, but subjects such as harbours, boats and rivers, to mention only a few, can all trap the unwary. Distant objects are rarely a problem: it is often safest to keep lines horizontal in the middle distance, as generally the features will be too small to cause concern. However, even here long buildings may cause some problems, particularly if you are looking up or down at them with quite a difference in height. Careful observation is the key here.

perspective causes lines that are horizontal in reality to slope. These would vary slightly if the viewer stood at floor level, for the eye level would then be closer to the top of the window

As the action gets closer, however, perspective can become hideously difficult. The most basic rule that needs to be understood about perspective is that all horizontal lines above your eye level run downwards as they recede, and those below your eye level rise as they recede. The lines will meet at an imaginary vanishing point further along the line of your eye level. You can represent your eye level with an absolutely horizontal line drawn across the paper, if you wish. Note that the eye level will vary in height as you climb higher or lower, stand up, sit down and so on. Some people have difficulty in establishing their eye level. To help you come to terms with this, find a tiled or brick wall and stand beside it looking along one of the lines of grout or mortar in between tile or brick. You might have to crouch slightly or even go into contortions, but ignore any onlookers for the moment! Look at how the lines of tiles or bricks above you appear, then look at those below you. Change your position and look at it all again, noticing the different angles of the lines.

On occasions you will come across perspective that is actually wrong, particularly on old buildings where perhaps subsidence, rotting timbers and other problems have caused odd tilts here and there. To some this is about as welcome as a class of over-energized youngsters cavorting in front of their focal point! If you sketch the building as it stands the viewer will assume your drawing is at fault. Far better to

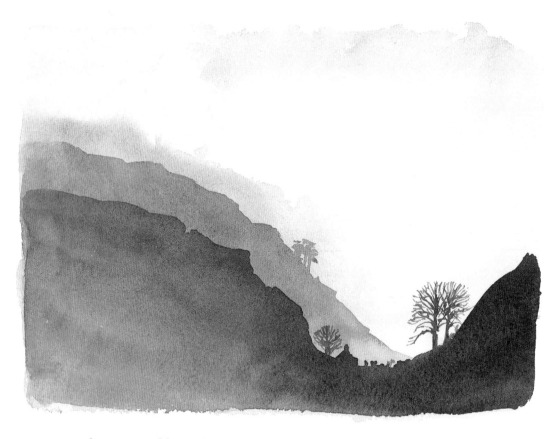

exaggerate the wayward bits. This makes it clear that you have seen the offending features, and it usually has the effect of giving more character to the subject.

AERIAL PERSPECTIVE

Aerial perspective is concerned with the three-dimensional effect in a painting: in other words, making the distance look far away and giving the effect of recession through the work. This is achieved by a number of devices which can be used individually or together. The most usual method of creating depth is

Aerial perspective
The furthest ridge here is lost in places, accentuating the feeling of distance, whilst the closer ridges become darker in tone the closer they are

by rendering the closer features in darker tones and those further away in lighter tones. However, there is always an exception to this rule, for various reasons: for example, a distant mountain might be the darkest part of the scene because of a dark cloud over it. If, therefore, you cannot make a foreground darker, or wish to keep it as it is, the alternative is to make it warmer in terms of colour temperature and to increase the strength of the detail. Warm colours tend to bring things closer, whilst cool colours push things into the background. Again, there are exceptions – sometimes distant hills seem to be almost on fire with warm colours – so to counter this the foreground needs to be more detailed and darker in tone. Distant detail is unlikely, although sometimes a little can be suggested in cool colours and light tones, so allowing the foreground still to dominate. Where one feature stands in front of another, by softening off the details on the more distant feature as it nears the closer one, you will suggest depth.

Perspective need not be the awesome hurdle that it seems. Make it work for you by learning a few rules which should certainly get you by in most landscape situations.

EXERCISES

●

Try drawing some fairly complicated objects, such as mugs, vases, lampshades – anything with curved surfaces. Use deliberate shading and pick out the highlights carefully. Try to improve your quality of line.

●

Sketch a fairly complicated building in pencil from a distance of about 90 m (300 ft), carrying out a reasonably accurate measured drawing.

●

With a more simple building, work in pencil from about 30 m (100 ft), this time concentrating on the perspective. Preferably, find a brick-built house and work from a position where you can clearly see two walls.

●

Paint a picture of Lanjaron Castle in the Alpujarras mountains, Spain (below), emphasizing the feeling of recession. My version is on page 152.

11 Simplifying the Landscape

If we paint a scene exactly as it is – with every bush, tree, slate, button, pebble, plant and so on in place – we will end up with a pretty boring picture. We might as well take a photograph. Such a scene would also be something of a marathon to paint. By reducing the amount of detail in a scene we not only give the work more impact, but also make it more manageable to paint. In addition, it will be more pleasing to the eye. We will have stamped our own mark of creativity on the painting and not just copied the scene without thought for improvement or aesthetic qualities. Often it is the simpler compositions that have the greatest effect on the viewer. So this chapter is really all about leaving things out, one of the most difficult aspects for the artist, whatever the medium.

ASSESSING THE SCENE

Often within a complicated scene there is an outstanding subject. There is no need to reject the scene out of hand because of the mass of inappropriate detritus that may surround the centre of interest. It is a question of deciding how to lose all that extraneous matter – the piles of stones and pebbles, the abandoned pram, the foreground grasses or reeds, the massed trees in a woodland, or the vast areas of textural detail on a mountainside. Close detail and distant features all need simplification in some form. There is no one ideal answer to any of these challenges, as every artist interprets the subject in a different way.

To tackle this problem you should look firstly at the overall picture, and secondly at specific detail. In the case of the former you need to determine the focal point, reduce or eliminate conflicting and unnecessary elements that confuse or compete with the centre of interest, and reposition supporting elements to best advantage. Specific detail needs to be lost in places or left 'out of focus', so that the mass of detail is merely suggested.

THE OVERALL PICTURE

The landscape was not designed specifically with the artist in mind, so sometimes you have to alter it a bit. In deciding what to leave out, also consider the possibility of changing the position of certain features. Slightly moving the odd tree, gate, boulder, stubborn hippo, or even a building, might well make a more dynamic composition. For example, two cottages some distance apart can be distracting in a painting. By placing them almost together, or perhaps understating one so that the other is dominant, you will avoid conflict. Alternatively, one building could be omitted.

CROFT NEAR CLASHNESSIE, SUTHERLAND
305×445 mm (12×17½ in)
The distant cliff detail has been greatly subdued in this painting and the stones in the croft wall minimized. Note how the tree is highlighted by the fact that the hill on its right has been completely lost. Also observe the counterchange on the thatched roof

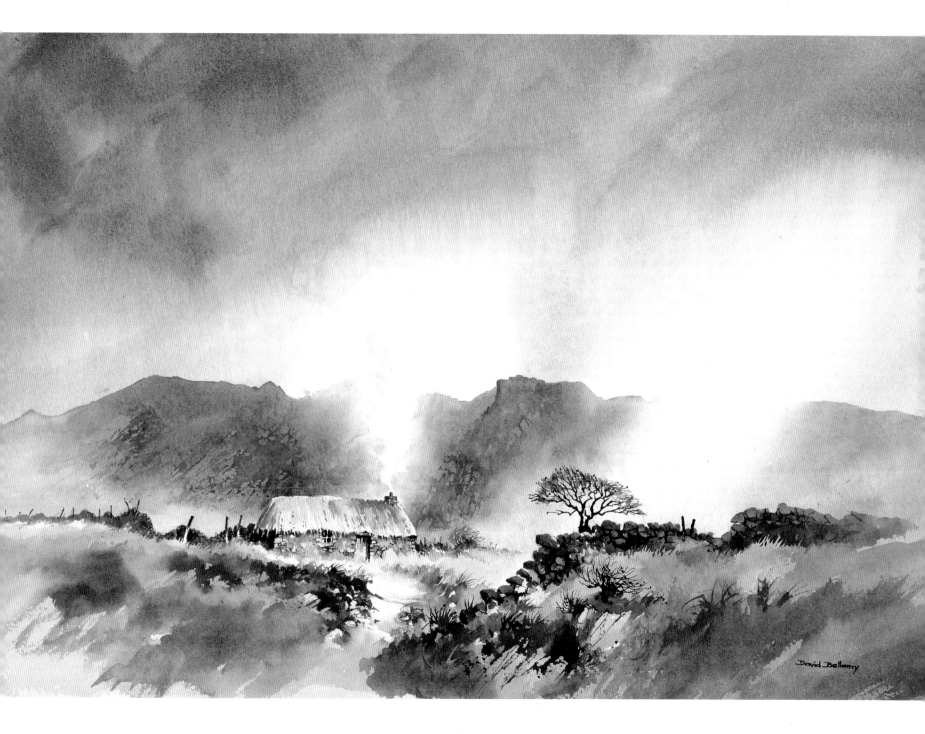

As we have seen in Chapter 7, the best aid to good composition is the use of thumbnail or studio sketches. Whether painting on location or indoors from sketches or photographs, drawing little sketches on scrap paper helps you to plan the finished composition and at the same time reduce any complicated parts of the painting. So simplification of the overall picture should be considered at the same time as working out the composition. You may find that doing studio sketches similar to the *Shrimper at Greenfield* will be helpful in this respect.

Often what you leave out matters more than what is included. Paintings need quiet passages to give more impact to the focal point. One solution to the problem of large areas of repetitious detail is to use a vignette approach: allow the outer regions to fade into a weak wash, or fade out completely, as though they are going out of focus. When painting hillsides, washes of broken colour are another means of suggesting texture, instead of putting in every minor detail. This can be done to advantage when used on rough paper, where the surface texture automatically causes the brush to leave patches of white paper or a previous wash to show through.

One exercise which I feel is extremely helpful in getting to grips with simplification is to carry out two or even three paintings of the same subject. Each painting requires a different approach. Pick a fairly complicated subject – complicated, that is, in the sense that

there is a lot happening in it, rather than involving extremely complex rendering of difficult features. Firstly, do a painting of the scene exactly as it stands. Put everything in, even the discarded old tyres! Then paint the scene again, but greatly simplify it along the guidelines in this chapter and leave out as much as you dare. Really work hard at making it as simple as you can. When you have finished, compare the two paintings and see which one has more impact. If you have enough stamina, try it a third time, but aim about halfway between the two extremes. You may well find that this one works best for you. In doing this exercise, be true to yourself – that is the only way you will learn. After a few weeks, repeat the exercise with another scene. The result may well surprise you.

SPECIFIC DETAIL

One of the most effective techniques for simplifying within detail itself is the 'lost and found' method. Here detail is painted in places but then disappears into an abstract pattern that suggests a mass of vegetation, stones or whatever is being depicted. Indicating every stone and crevice in a dry-stone wall, for example, would require considerable work. Even if grass and undergrowth were brought in to cover part of the wall this in itself could mean more complications. So cut out many of the stones. Ensure the important ones – those on top of the wall or beside a gateway – are inserted, then blend in the

Shrimper at Greenfield, North Wales

▶ **Studio sketch of the shrimper at Greenfield**
Sometimes it is helpful to paint a simplified studio sketch in preparation for a painting, especially when the composition is a little complicated
a *Distant land lost behind atmosphere*
b *Distant land accentuated – varied treatment creates more interest*
c *Distant land lost behind atmosphere*
d *Detail reduced here*
e *This corner kept quiet so as not to detract from centre of interest*
f *Single boat left in – the original scene was far too cluttered*
g *Detail of stones reduced considerably*
h *Old posts used to frame composition*

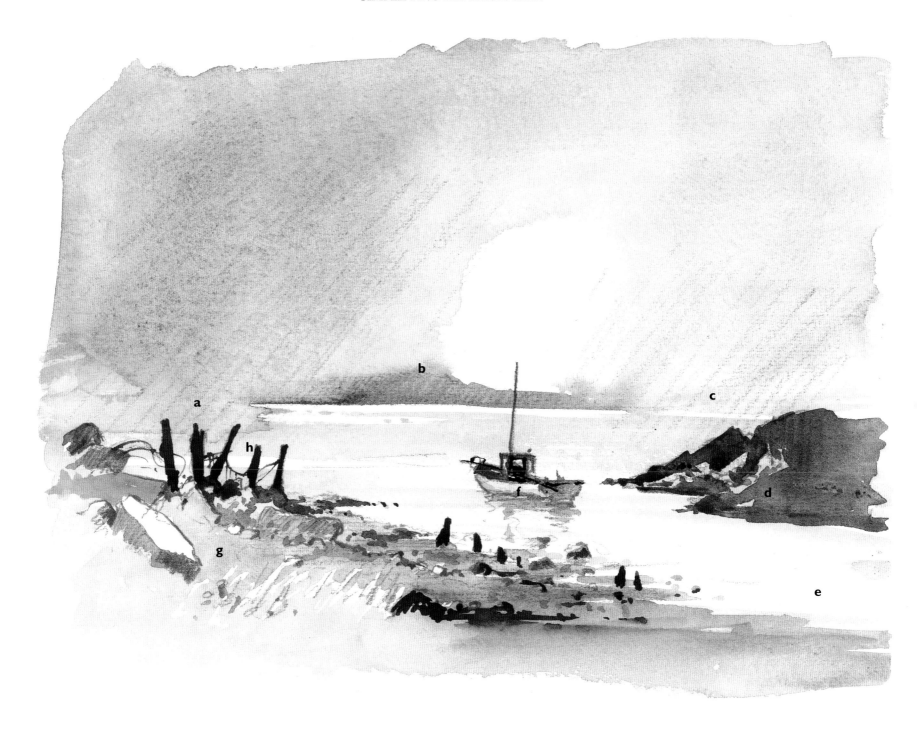

remainder. You can also apply a wash over parts of the detail while it is still wet to soften it in places and completely remove it in others. Try this on scrap paper before doing it on a full watercolour. Likewise, omitting boulders from a stream so that more of the water can be seen makes a painting less cluttered and more pleasing, and creates less work for you.

Suggest rather than define detail with broken colour washes, tonal shapes or variegated colours. For example, a splash of bright red or yellow can breathe life into a painting and at the same time provide interest in lieu of actual detail; but do not overdo it, otherwise the work will resemble a fairground atmosphere. A background mass of houses, trees or crags, in many cases just a backdrop to the main centre of interest, can be broadly brushed in with a flat wash to produce a silhouette effect without any detail. Massed trees are best suggested by a broad approach, defining just one or two individual trees at the edge in a fair amount of detail. Use tonal variation to suggest the edge of a mass of trees within the total mass. If you find you still have problems simplifying, try using a 25 mm (1 in) flat brush for the whole painting. The results can be fascinating.

You should try to avoid overworking small details such as reeds, for example. One way of tackling this type of detail is to load a brush with colour – in this case, the colour of the reeds – and drag it across the area on its side to create a ragged edge at the top. Quickly fade out

the bottom with a wet brush to remove the edge, and then with a fine brush, flick in a few reeds from out of the top part of the colour mass. In effect, you are using this as a reservoir. This technique works best on rough paper. It is also a fine method for portraying small clumps of grass.

Be careful, however, that you do not simplify too much, particularly as far as surface texture is concerned. Overzealous sanitization of legitimate detail can detract from the credibility of your paintings. Strong textural effects

BARN NEAR BRAEMAR, GRAMPIAN
200×280 mm (11×8 in)
Considerable simplification of the distant conifer plantation has enhanced the feeling of recession in this painting. The foreground has been kept simple by restraint in the inclusion of reeds sticking out of the snow. The cast shadows follow the contours of the track

can greatly enhance your work as, for instance, on a weathered stable door in the foreground of a painting. If the texture of the door is totally removed, the charm and authenticity of the feature will be lost completely. Similarly, stonework must look like stonework. Do not, for example, allow a stone bridge to appear too smooth, like a giant grey slug sprawling across a stream, because of lack of texture.

To help you in simplifying your paintings, visit exhibitions of watercolours by first-rate artists and make a point of studying their methods of reducing the scene to the most important elements. Note how they tackle areas that normally contain an amazing amount of detail. Search for the 'missing parts' of the paintings, such as windows, doors, the truck with no wheels, the left leg of the milkmaid, or gates with half their bars missing. Leaving things out is not as easy as it sounds, so work hard at it! It is one of the best ways of giving your work more impact and at the same time saving you a lot of work. Simplification necessitates amazing self-control and a need to resist all sorts of temptations.

EXERCISES

●

Try two or three thumbnail drawings based on the sketch COTTAGES NEAR CEUNANT, SNOWDONIA (below), *aiming at simplifying the scene.*

●

Choose the result of the previous exercise that suits you best and do a painting based on it. My version of the painting is on page 152.

●

Do three paintings of a fairly complicated scene, first including everything, then simplifying the scene as much as you dare – make drastic cuts to the amount of detail – and finally painting the scene about halfway between the two extremes. Which painting gives you most satisfaction?

●

Have a go at the 'lost and found' method of depicting specific detail. Choose a detailed area, such as a bridge with complicated stonework, a dry-stone wall, a mass of reeds or a wooden fence. Firstly, paint it in a painstakingly detailed way, then paint it again, leaving out about two thirds of the detail. Include mainly the important areas of detail – on top or at the edge of the passage. Which of your results do you prefer?

12 Planning a Painting

In this chapter we shall think about the sorts of things you should consider before launching into a painting, to give it a better chance of success. For many, making positive plans for the development of a painting is given about as much thought as planning a sketching trip to Mars, which is why so many paintings are ruined even before the brush first touches paper. Before starting a painting it is essential to have a clear idea of what you wish to achieve, and hence the order of working. This is especially important when doing a complicated painting, but even with the simplest work you will reap benefits from a little planning.

Whilst it is not always necessary to go through all the stages shown in the diagram below when considering how to plan a painting, it is nevertheless a useful exercise when you are inexperienced or about to embark on a particularly complicated painting.

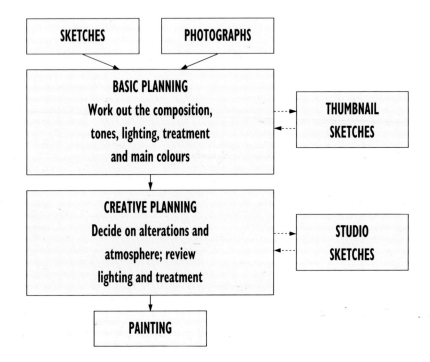

SUTHERLAND COTTAGE
320×485 mm (12½×19 in)
This painting shows counterchange not just on the background rocks and sky, but also on the gate and wall. This device can heighten the viewer's interest. However, it calls for more planning than usual. Preliminary studio sketches can highlight many problems beforehand – that is, before it is too late to resolve them

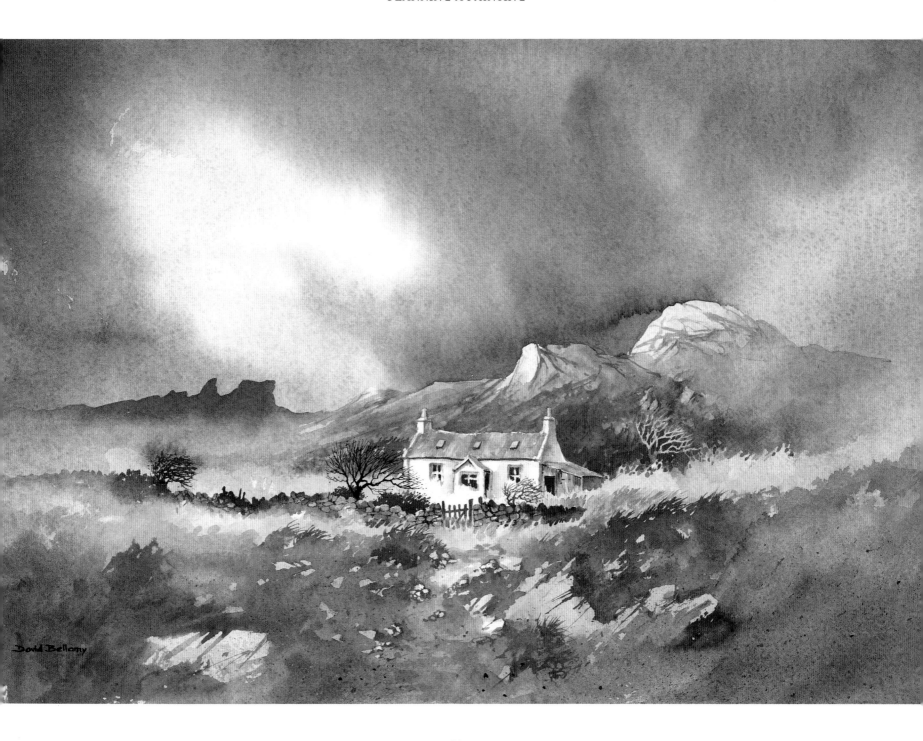

BASIC PLANNING

First, take your original images – sketches or photographs – and decide on the optimum composition, perhaps adding elements from other sketches or photographs. This process is aided by thumbnail sketches. Then consider a number of aspects relating to the basic planning; here a studio sketch, as shown in the monochrome illustration, might help. It is impossible to plan absolutely every specific aspect of a painting before starting, but the Basic Planning Checklist will help you think about your plan of action. Some considerations, notably treatment and tones, are on-going throughout the painting.

▼ **Studio sketch to plan a painting**
As well as showing how each feature relates to adjacent ones, a studio sketch such as this could also indicate the order of working
a *Supporting trees merely suggested*
b *Background tree tone faded out*
c *Background trees not too strong*
d *Fence gives balance*
e *Dark tone to suggest depth*
f *Highlight**
g *Centre of interest is almost darkest tone**
h *Hint of a bank without overworked detail*

**juxtaposed, these tonal extremes emphasize the centre of interest*

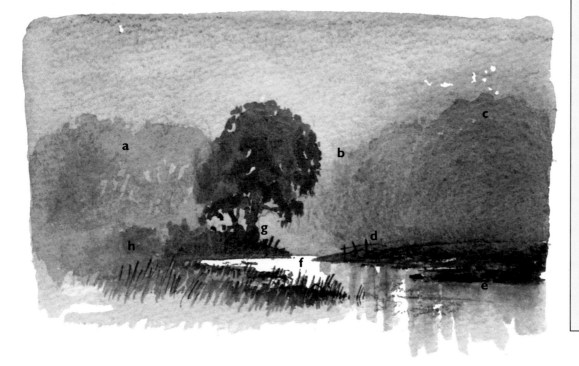

BASIC PLANNING
CHECKLIST

LIGHTING
✓ Which direction does the light come from?

✓ Does the focal point need highlighting with strong light?

BALANCE
✓ Is the composition well balanced?

✓ Do any features need to be added, moved or taken away?

COLOURS
✓ Is a warm, cool or neutral colour temperature best?

✓ Would a warm foreground and cool distance improve the painting?

✓ Is a splash of strong colour needed?

TONES
✓ Where will the strongest tones work best?

✓ How do the tones around the focal point relate to each other?

TREATMENT
✓ Is wet-in-wet or working on dry paper best?

✓ What is the order of working?

WATERFALL AT TIRORAN, ISLE OF MULL
A good subject for creative licence as more plant or rock detail could be included

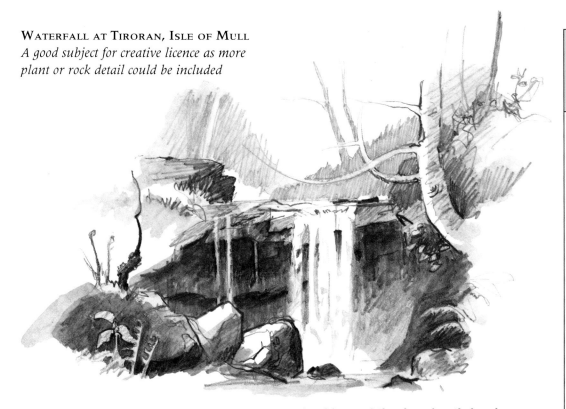

CREATIVE PLANNING

Creative planning is not always necessary and some students may feel that they wish to retain the original image of the scene without alteration. However, if you wish to put something of yourself into the painting, then it is a vital stage. Note that whilst the creative aspect should normally follow basic planning, you will at times find the creative side more dominant. Sometimes when conventions are broken a brilliant work results, so do break a few now and then. It adds spice to your painting.

Aspects to consider at this point are shown in the Creative Planning Checklist. Whilst thumbnail sketches provide a better idea of how the final painting will appear, for creative planning, try doing small studio sketches in watercolour to work out an effect before you do it for real in a painting. You may well need to review your treatment and colours in the light of any changes made during this stage. Set out the order of painting each passage clearly in your mind, at least for a few steps ahead, as in a game of chess. If necessary, write your strategy down on paper. The worst action you can take is to be constantly working out additions and changes during the actual execution of the painting.

CREATIVE PLANNING
CHECKLIST

ALTERATIONS
✓ Is any added feature in character with the rest of the picture?

✓ Would the painting work better as a snow/non-snow scene?

✓ Would figures or animals add interest or detract from the work?

ATMOSPHERE
✓ Could the picture be improved with mist, a rain squall or sunshine?

✓ Should unwanted features be obscured in an atmospheric haze?

✓ Will the sky be kept simple or should it include strong clouds?

LIGHTING
✓ Should the emphasis be changed slightly?

✓ Is the lighting first thought of at the basic planning stage still appropriate?

✓ How could the scene be improved with creative use of counterchange?

DEMONSTRATION

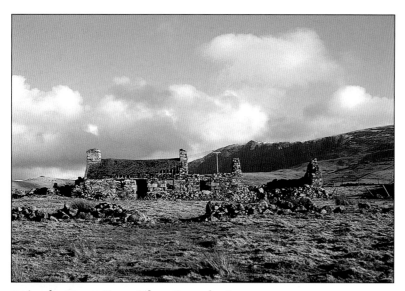
Ruined cottage, Cwm Silyn, Snowdonia

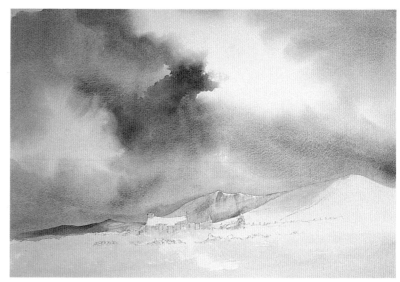
Stage 2

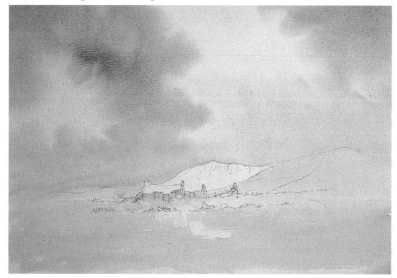
Stage 1

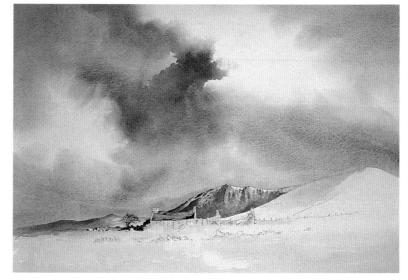
Stage 3

RUINED COTTAGE,
CWM SILYN,
SNOWDONIA
485×660 mm
(19×26 in)

❑ Stage 1
*To emphasize
the imposing
background crag I
raised it slightly and
gave it more impact
by throwing warm
light across the face.
I also decided to
include a towering
cloud formation to
accentuate the
feeling of space. The
paper used was
Saunders Waterford
300 lb Rough.*

*First of all,
masking fluid was
applied to the parts
of the ruin catching
the sunlight – the
right-hand edges of
the walls and
chimneys, plus the
roof timbers.*

*Then the painting
was begun by ·
applying fluid
washes of French
Ultramarine and
Light Red to the sky
and Raw Sienna
lower down,*

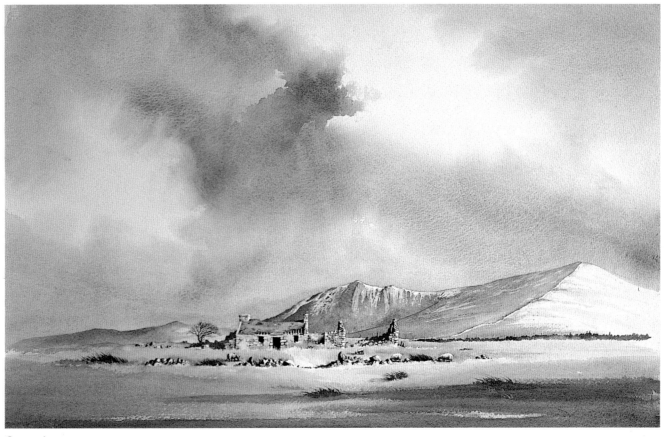

Stage 4

*bringing this colour
over the ruin and
foreground, but
avoiding the crag.*

❑ Stage 2
*Once the paper was
dry, the darker parts
of the sky were
washed in with a
mix of French
Ultramarine,*
*Crimson Alizarin
and Light Red,
softening the lower
parts with a lot of
water on the brush.*

*The crag was
rendered with a
mixture of Cadmium
Red and Raw
Sienna, and then
some French
Ultramarine was*
*put in for the
shadow areas.*

❑ Stage 3
*The roof of the
building was then
painted in and
emphasis on the crag
and ruin built up
with darker tones of
French Ultramarine
and Burnt Sienna.*
*The masking fluid
was then removed.*

❑ Stage 4
*The slope on the
right was then
painted in with a
light wash of French
Ultramarine. When
this was dry a
mixture of Raw
Sienna and Light*
*Red was glazed over
the first wash,
leaving streaks in
places to suggest
patches of snow
lying on the
northern slope.*

*Finally, the
cottage details were
inserted, and the
wall and sheep
added.*

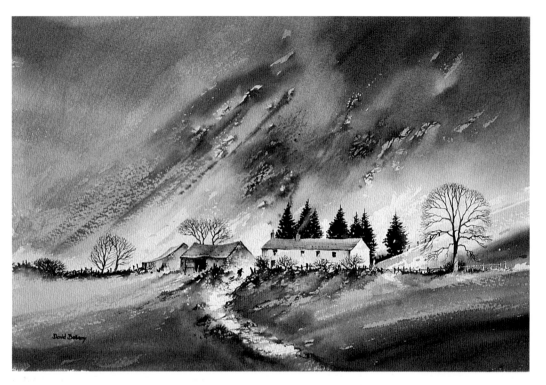

◀ TYWAIN FARM, EPPYNT MOUNTAINS, NEAR BRECON
320×455 mm (12½×18 in)
The basis for this painting was a simple pencil outline drawing, so some planning was needed. I decided to forget about the sky, use a counterchange effect on the right-hand side and add a figure. The painting was done on Saunders Waterford 140 lb Rough

▼ TYWAIN FARM: details
On this small scale, only a suggestion of the farmer and dog was necessary (below left). Placed near the centre of the painting, walking towards the gateway, they add interest. Note how the barn is blended into the ground. In the detail of the tree and fence (below) the effect of counterchange is evident, spicing up this part of the painting with a little variation. Remember that this sort of detail needs to be planned

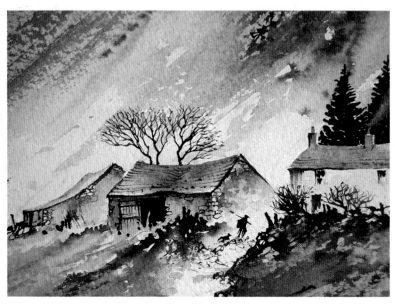

You should always have a vision of how you want your painting to appear when complete – even if you rarely manage to achieve anything remotely resembling that vision! Continually stimulating yourself with visual ideas will improve your chances of success, so keep trying. Hopefully this chapter will have given you some clues as to what you should be thinking about before you begin a painting. Good planning will save many heartaches at a later stage and will strengthen your final work. You may wish to photocopy the planning checklists and stick them on your pinboard as constant reminders.

EXERCISES

●

Run through the planning considerations outlined in this chapter, relating them to the photograph of Becco di Mezzodi in the Italian Dolomites (below). Once you have a clear plan, go ahead with a painting of it. My version is on page 153.

●

Take a scene, perhaps one that you have already painted, and spend a few minutes creatively planning a new

version as a studio sketch. In particular, introduce a strong element of counterchange (as shown in Sutherland Cottage*), cool lighting, and either use mist to obscure a feature or add figures or animals.*

●

Carry out a painting based on the studio sketch produced in the previous exercise, using the **CREATIVE PLANNING CHECKLIST** *as a guide.*

13 Rescuing Watercolours

Contrary to what many people may imagine, watercolours can be rescued from disaster to a great extent. Some of these rescue techniques not only restore a work, but will also give you confidence as a result of knowing that if you do make an error then the chances of recovery are perhaps better than you first thought. That confidence will help your watercolour technique progress considerably. Naturally there is a limit to how far a watercolour can be rescued and many situations are impossible to rectify, but much can be done.

 Before discussing actual rescues we should consider how to reduce the possibilities of needing to resort to these techniques. The previous chapter will, hopefully, have gone some way to helping you to avoid glaring problems. Testing tones and techniques first on scrap paper will also prevent many potential disasters. The elimination of staining colours – such as most ready-made greens – from your palette will help, too, as it is virtually impossible to remove a staining colour completely. The only colour among those recommended in this course that might cause staining problems is Crimson Alizarin, but this is not a regularly used pigment. Also, it is sensible to use a robust watercolour paper, and here Saunders Waterford is unbeatable.

◀ Correcting run-backs
Unfortunately, a run-back has appeared here in the right-hand sky area

◀ When the wash is dry, the offending run-back, or bloom, can be gently removed with a wet sponge

ELIMINATING RUN-BACKS

Run-backs, blooms, cabbages, or whatever you wish to call them, are normally unsightly and especially unwelcome if they appear in the sky area. If you see them forming, leave them alone. On no account try to fiddle them into oblivion, as you are then playing a losing game. Let the wash dry completely. Then, with clean water and a soft sponge, gently rub out the offending run-back, going slightly beyond its boundaries to make it fade away naturally. Let it dry. Generally that will be all that is required, though sometimes a light wash over the area will eliminate all traces of the run-back.

MOORLAND STREAM
280×405 mm (11×16 in)
This watercolour and gouache painting was done on Bockingford Cream tinted paper

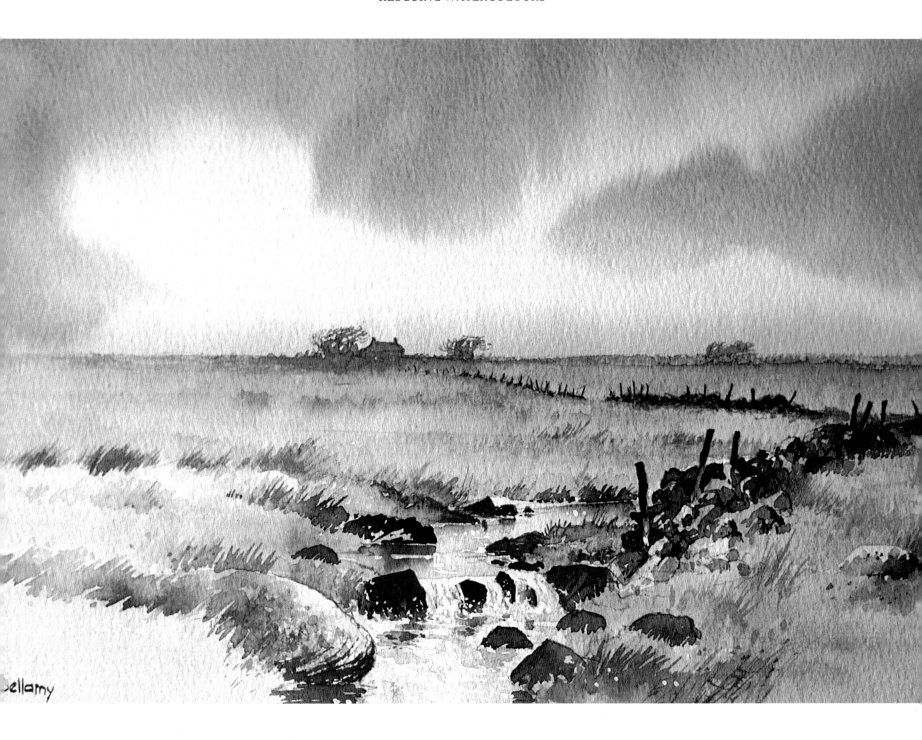

Bellamy

STENCILS

Retaining white spaces in a watercolour is vital, but what if you cover up the intended area accidentally or decide that you need to lighten an area to create a new feature to balance the composition? Here we shall look at a few techniques aimed at recovering as much of the whiteness of the paper as possible.

White masts or posts can be simply rendered by placing two pieces of thin card or paper close together and rubbing the strip in between with a damp sponge, as shown in the example here. Tree trunks can be created likewise, though it is best to have some sort of curve or bend in the card, as required. Boulders, sheep and other light-coloured objects can also be produced in this way with a little ingenuity. By tearing the card or paper, a more ragged edge is formed, and placing the piece as shown, then sponging two or three times, will produce the desired effect. Note that a bottom piece is not required, as this would give objects such as boulders a contrived and unnatural hard-edged base. Buildings can also be 'repaired', lengthened or produced from scratch by this method. Once the area has dried often all that is necessary is a little sharpening up with some paint.

Of all the tools used to rescue a watercolour, the sponge is probably the most versatile, whether used in conjunction with a stencil or on its own. Once the sponging is complete, dab the surface dry with paper tissues.

Stopping out a mast
In order to keep the sky wash fluid the mast has been covered here

By closely abutting two pieces of paper and sponging along the slight gap in between, a positive white line can be created

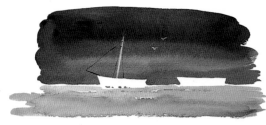

This shows the resulting mast

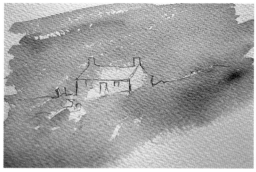

Restoring a white area
The left-hand end of this cottage has been accidentally painted over: the white paper needs to be restored

With two pieces of straight-edged paper held precisely in position against the corner of the cottage, a wet sponge is rubbed across the exposed paper to remove the colour

This shows the final result, with the cottage returned to its whitewashed state and the work completed

Producing a boulder
Sometimes it is necessary to insert some light detail into the foreground after laying on dark washes

This time, use a torn piece of paper and sponge the area gently, towards the bottom where the edge needs to be soft

The result of the sponging, showing the paper mask

The finished result with some detail added

SPRAYING

From time to time everyone has problems with washes. If a wash begins to go badly awry then spraying the whole paper liberally with water from a plant spray is an effective way of washing it off without damaging the paper. Of course, this works best with the initial sky wash, as nothing else is affected, but smaller areas can be rescued with a little judicious masking of important passages. Have plenty of kitchen paper or rags to mop up with and do not try this technique sitting down unless you enjoy getting wet!

This method is very therapeutic and is a good way of getting a lot of aggression out of your system! Spraying can be carried out even if part of a wash is drying, but if the whole thing has dried it is best to plunge it into the bath, let it soak for a few minutes, then gently sponge it down.

COCKLED PAPER

Sometimes, even with stretched paper, if the gummed tape tears or gives way, the watercolour can cockle badly. This is especially annoying if you are well into the painting. If it is badly cockled, no matter how good the painting is, it should be taken off the board, gently immersed completely in water, then restretched. Take great care not to agitate it whilst in the water, and do not touch the actual watercolour until it has dried.

SCRATCHING

Some artists scratch with a knife or razor blade as a planned procedure to create texture or produce a highlight. I prefer to use scratching more as a rescue technique to be brought into operation when all else has failed. At its best it can look quite effective, but it can also be disastrous if it goes wrong. You cannot paint over a scratched area.

The most useful tools for this technique are, to my mind, a scalpel or craft knife and a Stanley knife, as they offer more precision than anything else. I find scratching most effective when, for example, I need to restore a light, distant shoreline, or sparkle on water, or light wires on a fence. A blade held so that the whole edge meets the paper and dragged across the surface can sometimes restore a badly executed dry-brush area, but this works best on a rough surface. Whatever you do, start gently at first and do not overdo the effect.

Using a sponge creatively
Whilst a sponge can be used to rescue a passage that has turned out less than perfect, it is also marvellously effective for creating mist. Here (top) *the hill is painted in*

Once the hill is dry, a wet sponge is gently rubbed across the lower part to remove some of the colour, with more emphasis on the very lowest part of the hill (centre). *This ensures a gradual effect. You will find that some papers will not stand much sponging, so test your surface first*

Again, the paper is allowed to dry before a few foreground details are added to push the hill into the distance (bottom)

LACK OF FOREGROUND HARMONY

Foregrounds tend to trap everyone at some stage and whether deliberately planned or partially included as an after-thought, disjointed individual features in the foreground can lead to a lack of harmony. This can spoil the whole painting. We have all seen those foregrounds that contain a boulder, one or two clumps of grass, a path, a few stones and a bush, all set at roughly equal intervals apart. How can these disparate features be brought together as a harmonious whole?

The real answer, of course, is to thrash this out at the planning stage to ensure that it does not happen. However, if the die has been cast then you can, to a certain degree, rescue the situation. The

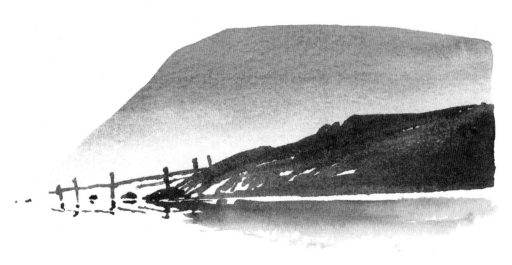

first possibility to consider is whether any part of the offending passage can be masked off by the mount, either at the bottom or at the sides. Next you could try sponging off part or the whole of the foreground, using a mask if it is necessary to protect some areas. A medium-toned glaze – transparent wash – brushed across the foreground can sometimes bring a feeling of unity, and this could be combined with a toothbrush spatter to create texture which would link the disparate forms. To do this, load the toothbrush with paint and then drag a knife blade across it. Mask off any parts that you wish to keep free of spatter and also make sure you move the knife in the right direction! With a combination of these methods you should be able either to reduce or subdue the foreground clutter, or give it more of a feeling of harmony.

LACK OF FORM

There are times when you complete a watercolour only to find that when you look at it from a normal viewing distance the main features do not stand out and it lacks form. This situation should not occur, of course, if you have been stepping back at times to view the work as it progressed. Often the problem can be cured by restating parts of the painting with stronger tones, but an excellent way to recover a work is by using a pen. Simply draw in the shapes with ink. You do not even have to follow the existing boundaries slavishly. Beware

EXERCISES

●	●
Use some of the rescue techniques described here to try to recover any of your old paintings – ones that you are not happy with any more.	*Try using the stencil technique on scraps of paper, to recover the white surface. Some papers will need more care than others when being sponged.*

of strong lines in the distant parts, though, as these will reduce the feeling of depth in the picture. It is not necessary to include a line on every conceivable edge, only where you feel it is important. Too few lines, however, can produce a very odd effect.

GOUACHE

Like scratching with a knife, gouache (opaque watercolour) is really best used as a last resort in a pure watercolour. Applied in small quantities, though, it can be invaluable for features such as distant white masts, gulls and white flowers. Choose quite dark areas on which to paint these, to add sparkle to a painting. This is also a device that can be employed when you have laid on a dark foreground wash and wished you had broken it up with a little interest. Several of the Old Masters, including Turner, used body colour to good effect, but they really knew what they were doing. In watercolour, use gouache sparingly.

REFORMATTING

Finally, a rescue option which is so obvious that it is usually overlooked is to reformat the painting. For this you will need a cut mount at least 305×455 mm (12×18 in). Cut this at two opposite corners to create two L-shaped pieces. Lay these over the painting to be rescued, so that they form a rectangular aperture which can be adjusted to whatever you feel is a reasonable composition. Often, within the main composition you will find smaller ones that work equally well. Sometimes they just need a little adjustment to become an effective painting.

Even when things seem to be getting desperate, therefore, do try to rescue your watercolour by one of these methods, rather than immediately consigning it to the bin! Not every attempt will succeed, but you should find a greater number of your paintings make it through to the framing stage.

FEATURES OF THE LANDSCAPE

At this point in the course you should be gaining in confidence and noticing a distinct improvement in your work. We are now going to take a look at those features of the landscape that give artists the most joy . . . and pain! Skies, water, trees, rocks, mountains, boats, and so much more, all need to be rendered convincingly. They all have their own characteristics and there is no set formula for painting them. Indeed, if you allow yourself the luxury of formula painting, where, for example, every tree is painted in exactly the same manner simply because it works, your painting will become stale and uninteresting. Only one method is guaranteed to produce good rendering of these subjects: directly observing the subject and doing patient studies continually, whether you are working on a sky or a rotting fence post.

This section covers the most commonly painted aspects of landscape scenery and explains how to bring the different elements together with a sense of unity.

FARM IN THE SPEY VALLEY
210×495 mm (8¼×19½ in)
Here the scene has been stretched – the features were not quite so far apart in reality. With few verticals, the scene exudes a feeling of tranquillity. Note the hard and soft edges alternating on the horizon, a device echoed in the foreground pool

14 Painting Interesting Skies

As landscape painters we cannot ignore skies for very long. The sky sets the mood and colour temperature, and should relate to the landscape – or rather to the light on the landscape. It would be good to see more imaginative skies in paintings at exhibitions, instead of so many simple 'play it safe' wet-in-wet ones. Effective skies can be produced fairly simply with a little thought, so do endeavour to be imaginative. In this book you will find many examples of different skies, from the simple to the more complex.

It is important to consider the sky carefully at the planning stage, as this affects so much in the painting. Once the overall design of the painting has been thought out, take a few moments to decide on the sky. If the landscape is fairly complicated or occupies most of the paper, it is preferable to keep the sky simple. Should the composition be unbalanced, then the sky can be used to redress this problem, with, say, heavy clouds to counteract a large void. A fairly large sky area gives scope for an interesting sky, 'the rolling volumes and piled mountains of light', as described by Samuel Palmer in 1828. Just as in other areas of the painting, skies need quiet passages where little is happening, so do not feel you have to cover every bit of paper. Skies are normally done in one or two stages; anything more complicated is beyond the scope of this book.

ONE-STAGE SKIES

As the description implies, this involves painting the whole sky in one go and then leaving it untouched. The advantage of this method is that it is less likely to create mud. At its simplest, a single-colour wash will often suffice, but most of us prefer something a little more stimulating. By washing, say, a pale yellow across the lower part of the sky you can then drop a colour of darker tone across the top part, allowing this to fuse into the yellow and so flow down across the paper. The fewer your brush strokes, the fresher your sky will appear. Do not fiddle with a sky wash as it is very difficult to hide mistakes in this part of a painting.

By shifting the emphasis to one side or another, leaving gaps here and there, you can produce an infinite variety of effects and this method is an excellent way to begin painting skies. You may find the wash flows better if you brush absolutely clean water across the sky area before laying on the colour. As always, use as large a brush as possible.

FARM NEAR LEDBURY, HEREFORDSHIRE
230×305 mm (9×12 in)
The sky here was achieved by laying an initial wash of Cadmium Yellow Pale and overlaying this, once dried, with a wash of French Ultramarine mixed with Crimson Alizarin. The lower half was streaked to allow the yellow to show through

Hard-edged clouds
Painted on dry paper, these clouds were softened at the bottom with a wet brush

Soft clouds
These are created by applying a wash onto wet paper

Dark clouds
These are inserted wet-in-wet into the damp sky area

Although the majority of clouds seem to have soft edges, where they are caught in strong sunlight (usually at the top), the edges can appear to be hard. Whatever you do, however, avoid having clouds with hard edges all round, as this will give them the appearance of a gaggle of misshapen golf balls. On the other hand, clouds which are composed entirely of soft edges can easily become lost in a painting. If you are including a lot of clouds, make the higher ones larger than those closer to the horizon, to achieve a sense of depth. Too many clouds, of course, will make the sky appear too busy.

A further step in the one-stage sky is to add darker clouds using the

wet-in-wet technique. These can range from quite large clouds to minor puffs and they are added by using very little water on the brush, as outlined in Chapter 8. At this point, lighter clouds can be stopped out by dabbing cloud-like shapes into the wet wash with a tissue. Take care to soften off the bottoms of these clouds, perhaps by a weak wash under them, using the side of the brush to blur the hard edges, otherwise they may well look as though they have been cut out with scissors.

TWO-STAGE SKIES

In order to give the sky more interest and depth a two-stage approach can be

effective, particularly for large sky areas. In general, this involves laying an initial wash, letting it dry and then painting a glaze over part of it. In doing this you must ensure that your washes are transparent, so that there is little likelihood of mud forming – the sky is the last place you want to see this! Until you have had some experience of one-stage skies, this is best left alone.

Begin a two-stage sky by laying a simple wash across the paper, varying the tone in places. Try to leave some of the paper bare, as this really brings a sky to life, but keep this mainly towards the centre. White patches in the sky, for clouds, can be left hard-edged by working around them on dry paper, or

Using a tissue
Clouds achieved by dabbing into a wet wash with a tissue

SUNSETS

Sunsets are popular as they give an opportunity to use a much more audacious palette. However, trying to copy some of the more violent ones, such as postcard sunset scenes perhaps, can lead to monumentally garish concoctions. To be most effective you need to tone down the more lurid passages and simplify the complicated cloud structures. Silver linings – light cloud edges – can be achieved with care, by leaving pure white paper. Do not worry if you lose the edge here and there as too long a lining will detract from the sky. Lastly, and of great importance, is the position of the sun and hence the effect of light and shadows on the clouds. The sun need not be visible, but it is as well to plot its position so that all the shadows are consistent. Above all, with a sunset, keep it simple. What looks marvellous in a photograph or real life can appear as a completely contrived mess in a watercolour.

soft-edged by painting around them on wet paper. If you work on dry paper, you are likely to get hard edges all round the clouds, so once this point has been reached, damp the brush and soften off the bottoms of the clouds with water to make them look more natural. I rarely draw cloud formations beforehand, as it is best to keep the sky washes really fluid and not be restricted by specific shapes and positions. However, it is important to have the basic sky design well thought out in your head beforehand, especially as far as the position of the main clouds is concerned. Try out a mini-sky on a scrap of paper first.

Once the first wash is completely dry, the second one can be applied over the first. Of course, you will want to allow plenty of the original wash to remain in view; the second wash is designed to introduce stronger cloud formations and achieve depth in the sky. At this stage it is vital to mix plenty of paint because you do not want to run out halfway through the wash. Make sure it is very fluid and transparent to ensure that some of the original wash shines through. With as large a brush as possible, lay on the wash boldly with the minimum number of strokes. Do not fiddle with it: overworking a glaze will produce dreadful mud with consummate ease. Here and there edges will need to be softened off with a damp brush, so alternate the hard and soft edges to create additional interest. Keep the design of this second stage fairly simple. You might even consider including some birds in the middle distance, to give the sky life – especially in coastal scenes.

DEMONSTRATION

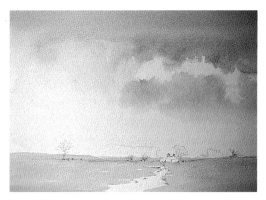

Stage 1

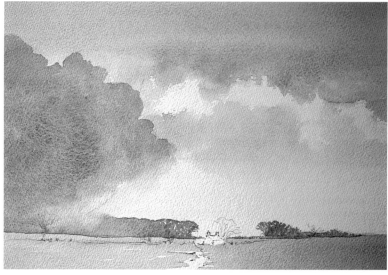

Stage 2

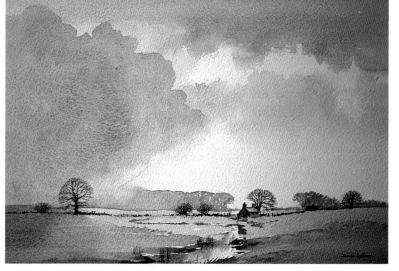

Stage 3

HEREFORDSHIRE
FIELDS
215×280 mm
(8½×11 in)

❑ Stage 1
*This painting
includes a two-stage
sky and was done on
Saunders Waterford
140 lb Not.*

*The top part of
the sky was washed
in with French
Ultramarine, using
a 31 mm (1¼ in) flat
brush. In places a
ragged edge to the
clouds was made by
rolling the brush on
its side.*

*Next, Cadmium
Yellow Pale was run
into the lower part
of the sky to warm it
up a little. Some
cloud shadows were
then added by
applying French
Ultramarine and
Light Red onto the
damp paper.*

*The first stage was
completed by
bringing down a
wash of Cadmium
Yellow Pale and
French Ultramarine
over the field,
strengthened in
places with a touch
of Raw Sienna.*

❑ Stage 2
*With a No. 12 brush
and a mixture of
French Ultramarine
and Light Red the
background trees
were laid in.*

*Immediately the
large dark cloud on
the left was added in
the same colour,
brought down over
the trees so that they
are lost on one side.
Part of the cloud
edge was softened off
underneath, to
complete the
two-stage sky.*

❑ Stage 3
*To relate sky and
landscape the dark
area on the
left-hand field was
washed in with
French Ultramarine
and Burnt Sienna.*

*Cottage, tree and
hedgerow details
were then inserted.
Finally, the
foreground and
stream were put in.*

UP IN THE AIR

Paul Nash wished that he could fly, so that he could explore the mysterious domain of the air. Take your sketchbooks along when you travel by air. I find it fascinating and have, at times, flown with the sole purpose of sketching. Practising painting and sketching skies for their own sake reaps enormous rewards, enabling you to give your landscapes powerful authenticity. Being high in the mountains also often helps me to come to terms with painting the most elusive of all the elements. Perhaps that provides an answer as to why I am often described as being 'up in the clouds'!

As with the landscape, skies are best tackled by doing simple ones first, then gradually attempting ones of increasing complexity. Try some which include the sun itself. Most of all, keep your washes transparent.

EXERCISES

●

Try some cloud formations as illustrated in the examples in this chapter, on small sheets of paper. Use each technique described. Doing several of these will greatly improve your skies.

●

Paint a picture based on the photograph of the Snowdon range from Llyn Mymbyr (below), with the main emphasis on the sky. The 'model answer' is on page 154.

●

On a changeable day, go out and make some cloud studies. Loosen up by using pencil, charcoal or Conté to start with and then try some watercolours. Do not worry too much about the landscape, but you can hint at it if you wish.

●

Practise doing a series of two-stage skies on A5 sheets of paper.

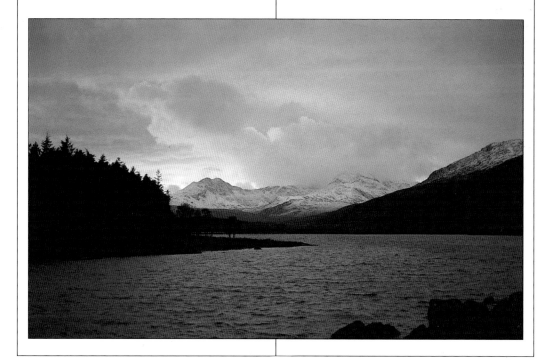

15 Water and Reflections

Water is perhaps one of the most difficult features of the landscape to render convincingly in a painting: it reflects, sparkles, cascades, flows, ripples, and ranges from being almost completely transparent to as thick as pea soup. Once again, you need to simplify the subject considerably, and at the same time ensure that it is always flowing downhill and not appearing to defy gravity! Here we are concerned with streams, rivers, lakes, puddles and waterfalls: the sea is covered in Chapter 20. Many paintings in other parts of the book depict water in various conditions and should be studied in conjunction with this chapter.

STILL WATER

Without reflections, still water presents fewer problems, and in small areas, such as puddles and pools, it can be rendered with a few broad strokes of the brush. The important point to remember, as with all water subjects, is to ensure that there is strong contrast between ground and water. This need not occur all along the water's edge – in fact, it is good to have one or two places where the edge becomes lost (in the same way as with clouds, for example), because often there are indefinite areas where it is difficult to see what is solid ground and what is pure water.

Reflections reinforce the watery feel, and so should be looked upon as an opportunity rather than a problem. They can be applied with the wet-in-wet technique or on dry paper and it is worth experimenting to see which method suits you best. Generally I use wet-in-wet, unless the object being reflected has a hard edge and is close to the water. It is a good idea to position yourself deliberately so that objects such as posts, trees and bushes cause reflections at optimum points. You may even wish to carry your own post around with you to position by a puddle or on a river-bank when sketching!

Mirror-like reflections tend not to be the best from an artist's point of view, so if you come across them, add a few ripples or streaks of light water to your painting. Notice how reflected objects are changed almost imperceptibly: a light object becomes slightly darker in its reflection, and a dark object becomes slightly lighter, the water actually reducing the contrast.

An effective technique where there are dark reflections in a pool or puddle is to use counterchange to define the margin between bank and water. In this way, dark reflections in water can define a light bank, whilst on the other side of the pool light water comes up against a darker bank.

DEVIL'S PATHWAY, PEMBROKESHIRE
610×990 mm (24×39 in)
This huge watercolour took some time to complete and involved quite a few preliminary sketches to ensure a successful composition. The rock structures required considerable working out because of their sheer complexity. The sky has been kept simple on account of the tremendous amount of rock detail. However, by keeping the distant stack and cliff free of much detail, the illusion of depth is achieved. Sea birds help to accentuate the enormous size of the cliffs

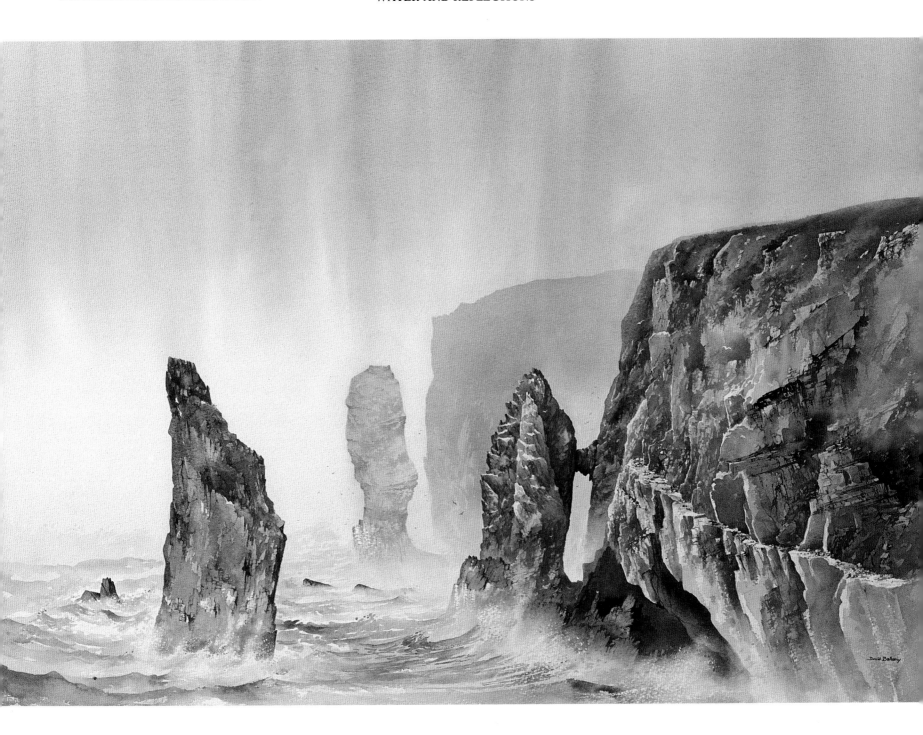

DEMONSTRATION

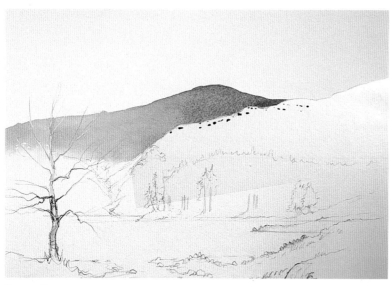

Stage 1

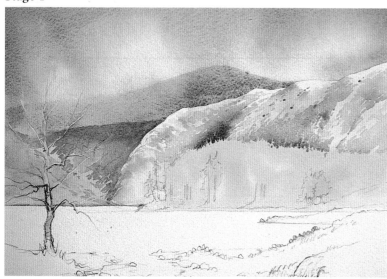

Stage 2

HAWESWATER,
LAKE DISTRICT
240×330 mm
(9½×13 in)

❑ Stage 1
Firstly, masking fluid was painted on the birch tree and some of the stones on the right-hand side, and then masking film was placed over the closer rib of the mountain.

Low-tack masking film is ideal for covering large areas of paper that you wish to reserve and, unlike masking fluid, is effective over painted areas.

Because washes would seep under the edge of the film if a rough surface was used, I worked on Saunders Waterford 140 lb Not on this occasion. The film would create a hard edge above the trees to give strong contrast of mood.

With French Ultramarine and Raw Sienna the background mountain was laid on and allowed to dry.

❑ Stage 2
A weak wash of Raw Sienna was laid across the lower sky and dark mountain, and immediately a mixture of French Ultramarine and Light Red was washed over the top part of the sky and allowed to drift down into the wet Raw Sienna.

Raw Sienna and Light Red were then dropped into the hillside behind the birch.

Once the paper was dry, the masking film was removed. Raw Sienna was washed across the ridge and Cadmium Yellow Pale added where the light mass of trees would come. Blotches of Light Red were dropped into the wet mountain area.

When all was dry, a mixture of French Ultramarine and Burnt Sienna was placed to the left of the ridge, behind the birch.

Gullies and the rough mountainside above the trees were painted in with French Ultramarine and Light Red, and at the same time the tops of the massed conifers were outlined.

❑ **Stage 3**
Some crag detail was suggested and then the shadow sides of the conifers put in with French Ultramarine and weak Burnt Sienna. For the reflections, Raw Sienna was laid on the lake with some Light Red dropped into it, followed by French Ultramarine and Burnt Sienna below the trees.

Lower down Cadmium Yellow

Pale was introduced to reflect the light mass of conifers. Some pale trunk reflections were then picked out with downward strokes of a small flat brush into the wet wash.

Before the lake wash dried a long horizontal streak was pulled out by a 12 mm (½ in) flat brush. Some parts of the foreground were added.

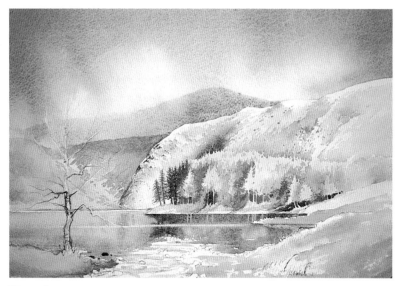

Stage 3

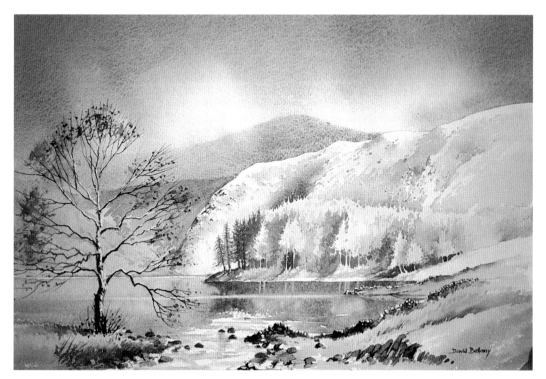

Stage 4

❑ **Stage 4**
The masking fluid was removed and the far bank below the conifers darkened with French Ultramarine and Burnt Sienna.

This mixture, but a little stronger, was used to draw in the details of the birch tree; the leaves were put in with Light Red. Finally, the stronger foreground details were inserted.

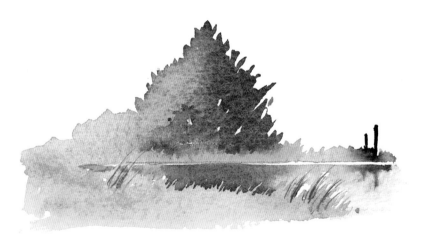

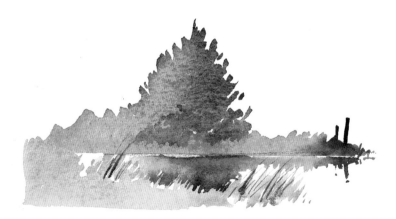

Reflections

On the left the reflections have been achieved by the wet-in-wet technique, whilst on the right they have been painted on dry paper. Each method is equally valid; it is simply a matter of preference

Large areas of still water, such as lakes, for much of the time have their surfaces rippled by the wind, which causes a loss of reflection and usually a complete change of tone. This effect may appear over the whole lake, in parts, or in strips, here and there. As when painting skies, this can be changed to suit your purpose. Ripples can be introduced where you do not wish to include a reflection, for example, or a narrow band of rippled water can be put in to relieve a large expanse of still water with unbroken reflections. You do not have to put the ripple exactly where it is; make it work for you to best advantage. A light streak of rippled water can be inserted on dark reflections by dragging a damp flat brush sideways across the still-wet paint. You will almost inevitably find that you will need to repeat this stroke two or three times in exactly the same place, because the colour will seep back into the original light line. On light reflections a darker strip of ripples can be painted over the top when the wash is dry.

RUNNING WATER

Usually, running water has to be greatly simplified to make it look effective. Leave flecks of white paper to suggest foaming water and use curving dabs of the brush to indicate ripples. If the water is back-lit, this effect is best achieved with the dry-brush technique, working rapidly; but only now and then will you find streams back-lit where the composition works. The dry-brush technique involves having little water on the brush so that the stroke leaves speckles of untouched white paper. It works best on a rough surface. An example of this technique can be seen in *Coniston Water, Lake District* on page 127. Practise the dry-brush stroke beforehand on a scrap of the same paper being used for the painting, and when you have got it right, draw the brush across the paper in a quick movement. Any hesitation and the effect loses some sparkle.

Where currents are strong in running water the ripple effect is pronounced.

Retain this in your work, but as when painting a dry-stone wall, reduce the amount of detail and make it fade away at the extremities. Accentuate speckles of white foaming water. This can breathe life into a tumbling stream, but be careful not to overdo it – too many white blobs over the foreground can create a polka-dot effect and be extremely distracting.

Take special care to note how the water tumbles over and around boulders. Small cascades, not large enough to be waterfalls, provide excellent practice for the latter and add considerable interest to a stream that otherwise has no remarkable features. Emphasize them, if desired, by exaggerating the drop and perhaps making adjacent stones or boulders larger. In this way you could even create a focal point.

In slowly running water reflections tend to be enhanced, so watch the effect carefully; but in swiftly moving water reflections are either non-existent or only discernible in a broken, less distinct form. Look out for reflected light, however, as this can be quite strongly coloured, even on rippled water, where the colour in the sky is prominent.

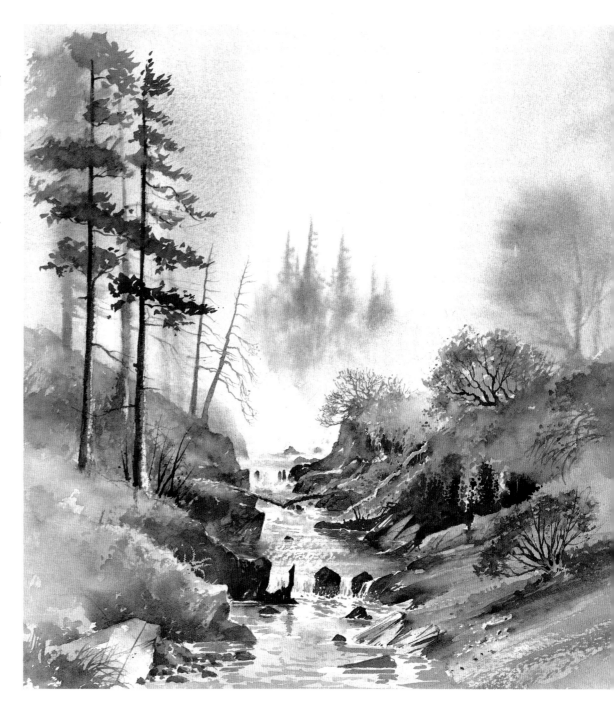

FFRWDGRECH WATERFALLS,
BRECON BEACONS
340×280 mm (13½×11 in)
The water has been kept as simple as possible here and the white, foaming cascades emphasized by dark rocks. A vertical format suits the natural composition

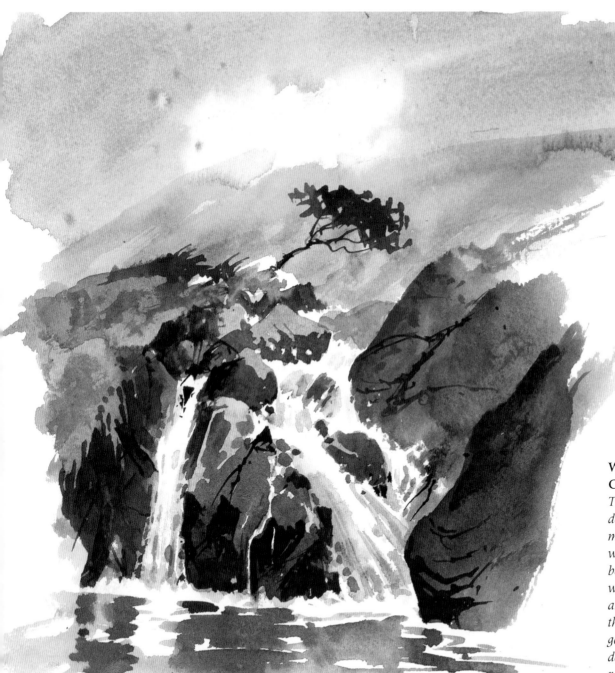

WATERFALL, BUNOWEN RIVER, CONNEMARA

This watercolour sketch was done as a demonstration. Not only were the course members spread out over the crags to view the work, but two mountain goats were keeping a beady eye on us. As this was one of a series of waterfalls we had to sit above the lip of another fall, so the sketch was carried out in the knowledge that at any moment I might get a ducking or the gear might float away downstream. Some spots of soft Connemara rain are visible on the sketch

WATERFALLS

The key to painting waterfalls lies in strong contrasts: white foaming water against dark rock; soft against hard. Too many downward-plunging strokes will result in an overworked painting and spoil the effect of transparent falling water. Evaluate the tones on the water by comparison. See how the falling water is generally slightly darker than the foaming water at the bottom, and the reflection of falling water in the pool below is a further degree or so darker than the tumbling water. Watch the fall for a few moments to see how it splashes, foams and hides parts of rock which for split seconds become visible as the water stops surging momentarily. Most of all, keep your painting simple. Be aware that often we see too much, with the consequent result that too much detail is included.

Like anything else that you find difficult to paint, water is something that needs a lot of practice. Ignoring the problem will not put it right. By using strong contrasts and perhaps leaving out more than you include, your painting of water should improve gradually.

EXERCISES

●

Go out and find some puddles where you can also work on reflections, and do a few studies of the water from different angles. If you cannot get out, then set up some reflections indoors, using large bowls, a sink or bath and any suitable objects.

●

Try painting a river scene leaving out as much as you dare. See how little detail you can get away with.

●

Do a painting based on the photograph of Killary harbour, Connemara (below), aiming mainly at making a competent portrayal of the reflections. Keep the mountain detail to a minimum. My answer is on page 154.

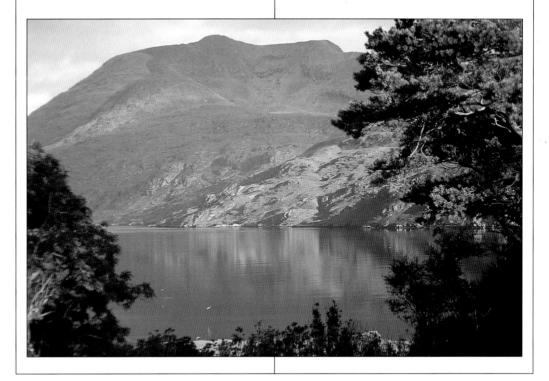

16 Trees in the Landscape

To be able to paint trees in a competent manner is essential for the landscape artist. Do not worry if you cannot tell the difference between a redwood and a giant cactus. There is no real need to be able to identify different species of tree in order to paint them, although it is important to portray the chief characteristics of the various types, and in this respect observation is the key. Trees come in all shapes and sizes, alone, in groups or massed. Time spent producing detailed studies of trees when out sketching is extremely rewarding. Try to build up a reference collection of different types and groupings. Whilst trees are more commonly used to support the main centre of interest in a painting or act as a backdrop, many specimens make worthwhile focal points themselves. So when you are out in the countryside, try to consider trees from both these points of view.

The easiest trees to render are those in the distance or middle distance, as detail is minimal and basically they appear as silhouettes. Seen closer, however, they appear more complicated. Foreground trees need to be portrayed three-dimensionally – that is, with some branches projecting towards the viewer and some receding. Foreground trees can break up or overwhelm a composition if not sensitively positioned: a tall tree close to the centre foreground, for example, can have the effect of isolating part of the picture.

Whatever the type of tree and whether seen in summer or winter, try to make it look as though it is growing naturally out of the ground. An area of shadow under the tree, softened off at the edges, usually works. If the tree itself is the focal point, then undergrowth, grass, a stile or fencing, or even animals can lend support to the image. A solitary tree can look dreadfully lonely.

WOODLAND TRACK, BRECON BEACONS
230×305 mm (9×12 in)
Here the distant misty trees have been rendered flat and thrown into the background by the closer acid-rain conifers. On the right some trees have been suggested by painting darker, tree-shaped passages to define lighter tree shapes. The fence has been rendered similarly. The aim of the picture was to put across the feeling of a day dripping with damp atmosphere

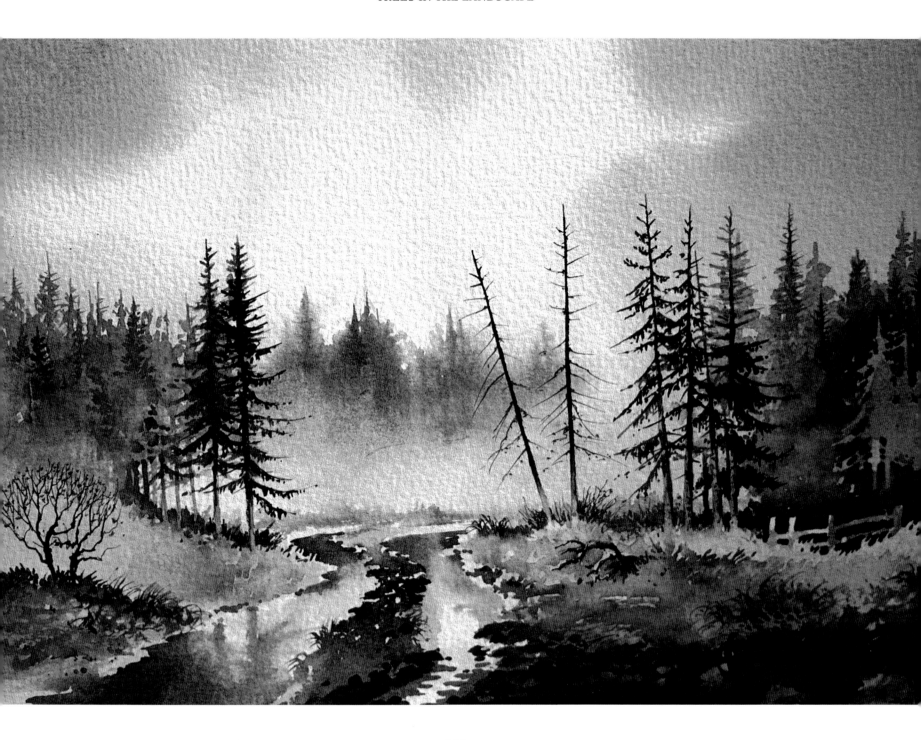

Using a rigger to create winter trees
On the left of this illustration is a sort of deranged specimen of artificiality with adjustable legs like some Christmas trees – I see many of these on courses! The right-hand tree shows a more natural outline, with the base looking as though it is growing from the ground, instead of standing proud of it

WINTER TREES

I find winter trees more exciting than summer ones. Although they take longer to paint, give them as much care as you can. Students often find the branches they paint look more like dead plant stalks than lovely flowing boughs. This can be countered by using the full flow of the wrist when painting branches, working outwards from the trunk. The problem is also caused by a static approach: if you are right-handed you will find the left-hand side of a winter tree extremely awkward to paint. Try turning the board upside down to paint the left-hand branches – you will achieve a more natural-looking tree all round.

A rigger is an excellent tool for painting fine branches, as the long hairs are flexible and hold more paint than a round brush of similar size. Always work outwards from the centre of the tree, to taper the branches more naturally. Watch how the branches run: are they curved gracefully, upwards or downwards, or are they angular and shooting off in all directions? Note the colours and texture of the trunk; many appear light at the bottom, graduating to darker tones as they reach up with the sky behind. Some artists like to render all the branches in a definite way; others prefer to suggest a mass of twigs and branches with a few strokes. The latter is best achieved on rough paper by dragging the side of the brush inwards from the extremities of the branches. A few branches can be added afterwards with the point of the brush. Perhaps the most effective way is somewhere in between these two styles. Try each one to see which you feel suits you. The illustrations portray both approaches.

SUMMER TREES

The sheer mass of greenery in summer is something of a nightmare for the landscape artist. Trying to record every shade of green you see before you is asking for trouble, so you must be highly selective when it comes to deciding which greens to include. Three variations of green within a painting are quite enough. To achieve unity, these can be mixed up using the same blue – say, Ultramarine – with perhaps Raw Sienna in the first instance, then Cadmium Yellow (Hue), and then by adding, say, a hint of Light Red to one of the previous mixtures. I often substitute yellows and blues to vary the effect.

There is also the added challenge of trying to paint foliage as a mass rather than depicting each individual leaf in a furious spate of demented dabbing. Some students dab with brush, sponge or tissue, but this usually ends up messy and looking finicky. Generally a wash produces the best result, reducing the chances of fiddling, and this can be extremely effective if combined with a few loose blobs at the edge to suggest wayward leaves. Do not get *too* wayward with the leaves, though! What you really want to avoid is making your trees look like blobs of cotton wool stuck on lollipop sticks.

Lighting is important, of course. Leaves in general are not normally very reflective, so much of the light is absorbed, producing an amorphous mass to the casual eye. Shadow splattered in patches all over the tree will look ugly, like a lot of grubby and tatty plasters on an elephant's back! A certain amount of organizing is needed to create the weight of shadow on one side and under the foliage, and this may well be even more necessary on dull days when shadows are flatter and less obvious. Do avoid putting in every nuance of shadow. Take care to retain some gaps in the foliage if these exist or might improve the study.

▼ **Creating trees with the side of the brush**
By scrubbing with the side of a round brush you can achieve interesting effects to suggest tree shapes. On the left of the illustration below is a summer tree painted with the tip of a brush, with shadow areas and branches inserted indiscriminately. A better version stands to its right, the trunk and branches having been better considered. This one was achieved by scrubbing the side of a No. 6 brush across the paper and immediately dropping some dark colour on the right side to suggest shadow mass. To the right of this is a middle-distance winter tree, achieved by means of more limited scrubbing and flicking in some branches with a rigger. The whole tree has been kept flat as not much depth is needed for a tree in the middle distance

DEMONSTRATION

Stage 1

Stage 2

TREES, WELSH BORDER
235×310 mm
(9¼×12¼ in)

❏ **Stage 1**
For this I chose Saunders Waterford 140 lb Rough paper. The sky was kept simple, with washes of Cobalt Blue, Crimson Alizarin and Cadmium Yellow Pale.

When this was dry the trees and bushes were put in with a mixture of Cadmium Yellow Pale and French Ultramarine.

While this was still wet some pure Cadmium Yellow Pale was dropped in where the foliage caught the light, and a mix of French Ultramarine and Light Red applied on the shadow side.

❏ **Stage 2**
The background hill was put in next, with a combination of Cadmium Yellow Pale and French Ultramarine for the grassy areas, becoming darker around the small tree on the right with the introduction of Raw Sienna into the mix.

A wash of French Ultramarine and Raw Sienna was used for the backdrop of trees. Then the hedgerows were inserted with a mix of French Ultramarine and Raw Sienna, with some Cadmium Yellow Pale in places.

❏ **Stage 3**
Darker shadows on the trees were then laid on with a mixture of French Ultramarine and Light Red.

Fence details were strongly defined in French Ultramarine and Burnt Sienna, and the darker tree was strengthened with a mixture of French Ultramarine and Light Red.

To complete the painting, the sheep and foreground shadows were delineated in French Ultramarine and Raw Sienna.

▶ Stage 3

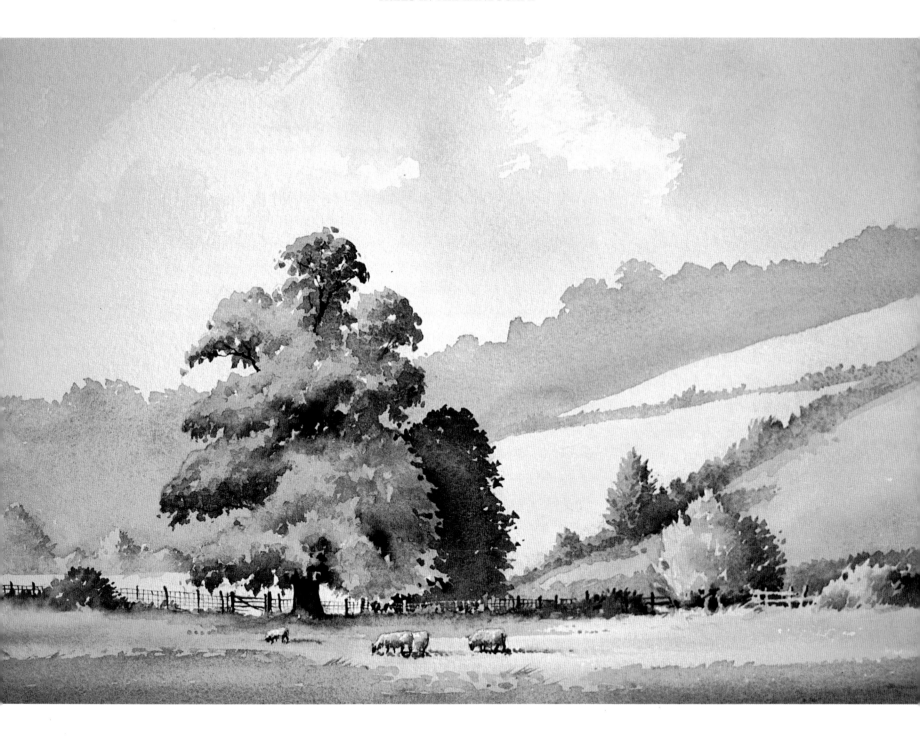

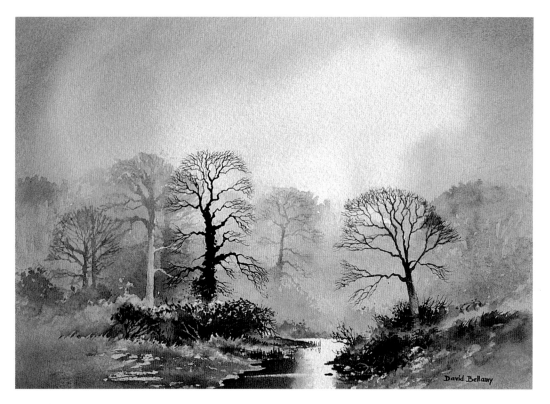

STREAM IN THE NEW FOREST, HAMPSHIRE
215×280 mm (8½×11 in)
Massed woodland needs to be considerably simplified. Here the distant trees were faintly rendered with areas of flat wash laid on where the foreground trees would appear. When the paper was dry the closer plane of stronger foreground trees was painted

DISTANT MASSED TREES

A distant wood or forested hill creates complications for the unwary. Even if you cannot actually see the detail of the trees, your brain will supply this, based on previous observation and knowledge. It will also tell you that their colour is green; but whilst this may be the local colour – that is, the actual colour of the trees – that colour will be affected by the intervening atmosphere. Compare the greens beside you with those in the distance: the latter will appear bluer or greyer. There should not be much colour variation in distant trees.

As far as detail is concerned, all you need do is suggest the tops of the massed trees and fade off the colour below. With a wooded hill, a further line of tree tops can be suggested below the top line, inserted where the upper trees fade away. Again, lose the lower parts of the trees by fading out the wash. Sometimes putting in one or two patches of weak detail will help to convey the feeling of trunks and foliage, but take care to soften these off into the main tonal mass. Where there is a definite end to the tree mass, this is the place to put some slightly stronger details; but do not overdo it.

WOODLAND

Whilst getting in amongst a forest of trees is normally a pleasurable experience, it can be pretty daunting for the artist. The obvious error when painting woodland is to put in too many trees 'because they are there', so great restraint is needed. Begin by selecting a focal point – a prominent tree, a pathway, glade or whatever – then lightly plan your trees around it. Put in two or three of the more prominent ones to support the focal point, plus two or three more, at the very most, faintly in the background. If necessary, move the trees to conform to your composition, but try to retain the character of the place. Strong contrasts between the foreground and background trees will help to achieve depth.

With trees, whether alone or en masse, there is no better way of learning to render them than carrying out methodical studies of many good examples. I mention 'good examples' because nature does have its wayward individuals. You can learn an enormous amount from sketching a really ugly tree, but what are your chances of selling the subsequent painting? Seek out the really handsome ones of every type.

EXERCISES

●

Go out and find six different types of tree. Make a detailed study of each from a distance of 30–40 m (100–130 ft) and 100–200 m (330–655 ft). With each of the best examples, add some support to make it the focal point. If you do this in winter, repeat the exercise in summer, and vice versa.

●

Paint a mass of distant trees on a misty day when you cannot see much detail.

●

Repeat the exercise on a clear day, reducing as much detail as you can.

●

Attempt to paint a woodland track, glade or stream, bearing in mind the advice in this chapter.

●

Do a painting of the River Avon scene, near Breamore, Hampshire (below), concentrating mainly on the large tree. My painting of this is on page 155.

17 Pastoral Scenes

In this chapter various elements are brought together – fields, trees, hedgerows, farms, cottages, lanes, people and animals – and blended into a cohesive whole. At times it is the so-called minor features that let down the student, rather than the farmhouse or the old oak. How often do we see tufts of grass stretching right across the foreground in battle formation? Or hedgerows that appear too artificial? Let us have a look at some of these supporting features and see how to use them to best advantage.

FIELDS

Distant fields can simply be portrayed by a weak wash of colour defined by broken lines to suggest hedgerows or walls. Where there is a complicated patchwork of fields, beware of including too many. Not every patch needs to be shown differently, and rarely in strong contrast to the adjacent patch, if they are in the distance. If there is a farm or large tree in the middle distance, care is needed in the treatment of the fields there. In that instance, you may find it helps to make the fields lighter than they actually are, in order to highlight the centre of interest, or simply to stop features getting lost in mid-tones. The reason why many snow scenes are successful is that the contrast between trees and snowy fields can be striking; so apply the same principle to all your work.

Foreground fields can give rise to perplexity. If there is simply a mass of open, unrelieved space, how do you cope? Should you leave this area virtually free of detail? If the middle distance contains a lot of detail then certainly the foreground needs to be kept uncluttered, and often a glaze washed across the immediate foreground is all that is required. If you wish to suggest blades of grass or clumps of reeds, then be sparing; it is especially tempting to overdo these in snow scenes. If, however, you do need some more interest in the foreground, then cast shadows thrown across the picture might work. Similarly, some animals could be included, although be careful not to put in too many. It is best to keep them generally towards the centre of a field. Old farm implements are always effective, too. They can provide a focal point, but if this is not the intention, make sure they do not compete too much with the centre of interest. Ploughed fields make interesting foregrounds, especially when side-lighting catches the crests of the furrows. I often change the direction of the furrows so that they lead in towards the centre of interest.

HAYMEADOW, PENTWYN FARM
320×430 mm (12½×17 in)
In this painting the wild flowers in the foreground become the centre of interest. The trees are subdued so as not to compete. Green-winged orchids, ox-eyed daisies, knapweed, clover and buttercups carpet the fields in this oasis for wild flowers now under the care of the Gwent Wildlife Trust in South Wales. I feel strongly that we, as artists, should support these organizations that look after traditional landscapes

HEDGEROWS AND FENCES

Foreground hedgerows and undergrowth can lead the beginner into dreadfully murky areas. The overwhelming mass of vegetation needs to be greatly simplified, with much of it reduced to a broken wash. This provides an excellent opportunity to mix colours on the paper. To suggest variety and life, introduce small patches of bright red or yellow into such areas, normally whilst the initial wash is still wet. This has the added effect of bringing the foreground closer, thus creating depth. Give your hedges some variety in shape and size, as well as colour, to break down uniformity. Introduce some hawthorns or bushes, perhaps. One technique I use here is to drop a pool of liquid colour onto the hedge area and use it as a reservoir, working with a No. 1 rigger – or even a fingernail. Breaking up horizontal lines in this way makes the scene much more dynamic. This also applies to fences, which ideally, I feel, should be limited to short gaps in hedgerows. If there is a fence, hedgerow or wall right across the foreground of your scene, then either leave it out or break it up with gaps, gateways or other similar devices.

Make studies of hedges whilst out sketching. Note how the grass or verge of the field meets the tangled undergrowth and how fences become caught in the grip of weeds, plants and briars. Do not forget flowers, which can relieve dismal passages with bright splashes of colour.

LANES AND TRACKS

Lanes and tracks, like streams, are a powerful means of providing a lead-in to the focal point. By introducing puddles, ruts, grassy verges, hedgerows, animals or people, they become more interesting. If you position a tree, barn or other large feature near a bend in the middle distance, it will create more of an air of mystery, a desire to see what is round the bend. In such a case the lane becomes the main centre of interest, with surrounding fields playing a supporting role. In order to suggest a feeling of depth, try washing a glaze of blue or grey across the foreground part of the lane. Some lanes are so light in tone that where they slightly rise in the middle distance I leave the paper white.

BUILDINGS IN THE LANDSCAPE

Cottages, farms and barns are very much part of the pastoral scene. They are often scattered across the countryside with no consideration for artistic composition, so you will invariably have to reposition them in your paintings. You may need to omit one or two buildings if they compete with the focal point, or perhaps subdue them by showing just part of the building, painting it in silhouette or washing over a glaze to obscure it. Trees in many places are used as windbreaks around buildings, and they certainly enhance the composition, 'anchoring' the building as a centre of interest.

When painting buildings the most important features are the lines of the roof and chimneys. You do not need to put in all the windows, or all the panes of glass – it is, in fact, more subtle to omit some, especially if there are a lot. Strong contrast between roof and background helps to pick out the building. Where there are walls, hedgerows or fences in front of a building, make a gap – a gate perhaps – to lead in. If the building is made of stone and not rendered or whitewashed, the wall textures are often clearly visible from some distance, but do not overwork these, even if the building is fairly close. Putting in a strong base to the walls makes a building look like a tabletop model, so allow the washes on the building to run into the ground wash in places without any definition. Here and there a stone at the bottom of the wall could be suggested if necessary.

Gates
The left-hand gate here is too pedestrian, too much like a perfect model. By losing some of the detail, as in the right-hand gate, a more natural-looking effect can be achieved

ANIMALS

Animals can bring a scene to life. I am concerned mainly with farm animals here – a farmyard looks empty without some livestock. Sheep, cattle and horses can enhance field and lane scenes, often to the point of becoming the centre of interest. Sketch animals whenever you can. Happily, when grazing, most of them stand still enough to be sketched. I often sketch several animals in succession, returning to each one as it resumes its original position. Watch, when taking photographs of sheep for reference, that they are not all looking at you. Usually it is best to let them get used to your presence first, so that you can capture a more natural pose.

It can be daunting to paint a field full of sheep or cows. Reduce their numbers and concentrate them slightly to one side of centre so that most of them face into the picture. Then add a few strays outside the main group of animals. In winter I look for feeding troughs, as these automatically concentrate animals at a focal point. I rather like painting cows. As the Reverend William Gilpin remarked in the eighteenth century when comparing the picturesque qualities of cows and horses, 'in a picturesque light the cow has undoubtedly the advantage and is in every way better suited to receive the graces of the pencil'.

Cockerels can add a splash of colour to a farmyard. Geese make wonderful models, being natural posers, but keep

an eye on them – they can be vicious. One gang chased Jenny and Catherine round a French farmyard once, whilst I was sketching some stone huts! A good choice for a focal point is a farmer and a sheepdog.

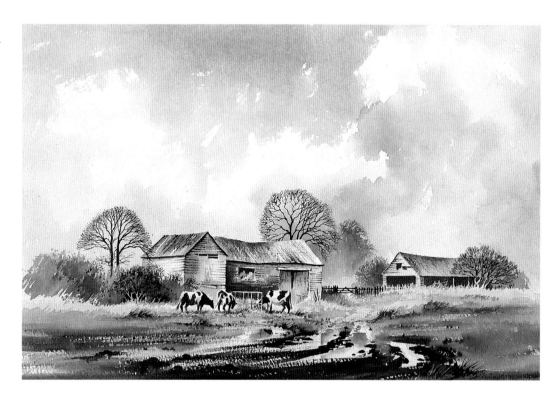

HEREFORDSHIRE BARNS
335×445 mm (13¼×17½ in)
Unlike sheep, cattle normally stand out strongly in contrast to their surroundings. Make studies of them when out sketching, so they can be included in a painting like this

Cow and pony
Quick pencil studies of animals form useful reference material for when you need to add life to a painting

DEMONSTRATION

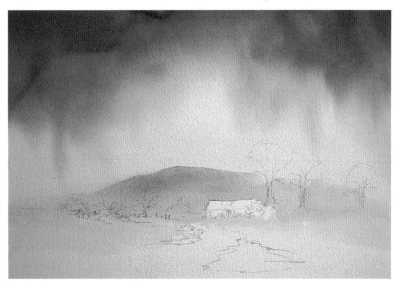

Stage 1

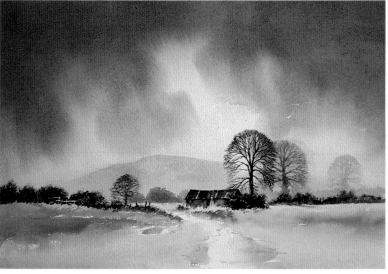

Stage 3

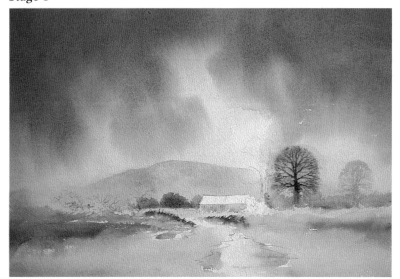

Stage 2

WILTSHIRE BARN
320×470 mm
(12½×18½ in)

❑ Stage 1
This was painted on Saunders Waterford 140 lb Not paper. Weak Raw Sienna was brushed across the lower sky and a strong mix of Burnt Sienna and French Ultramarine brought down from the top, flowing into the wet Raw Sienna. The hill was painted in French Ultramarine and weak Burnt Sienna, with Raw Sienna added lower down and then some Cadmium Yellow Pale below.

❑ Stage 2
The misty trees on the right and the background bushes were indicated with French Ultramarine and Light Red, the barn wall in Raw Sienna and the fields in various strengths of Cadmium Yellow Pale, French Ultramarine and Burnt Sienna, with Raw Sienna in the foreground.

Work was carried out on the puddles with a weak mix of French Ultramarine and Light Red.

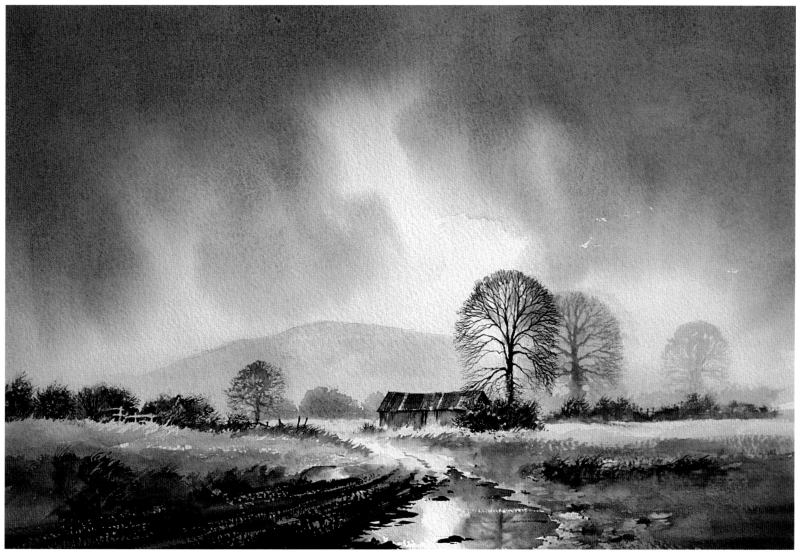

Stage 4

☐ **Stage 3**
The stronger middle-distance features – the hedges and large tree – were then included in French Ultramarine and Burnt Sienna, and a mixture of Light Red and Cadmium Red was used on the roof of the barn to suggest some rust.

☐ **Stage 4**
Finally, the foreground was rendered with dark mixtures of French Ultramarine and Burnt Sienna, creating strong contrasts with the puddles. *A dry-brush effect suggests the muddy track.*

Figures

Figures look more realistic if they are involved in some activity, as here

PEOPLE

Everyone is aware that certain scenes, such as towns, harbours and villages, are much improved by introducing figures. However, this prospect does terrify a lot of students who, rather than run the risk of a potential crisis towards the end of a competent painting, prefer to leave their villages or towns deserted. Even when they gather up the courage to insert a figure they are usually too nervous to do a proper job, and so the inevitable happens.

The first course of action is to consider the introduction of figures at the planning stage. If you feel they would enhance the painting then indicate them lightly in pencil. Where you position them is important: too close to the viewer and they can take over the painting. Normally somewhere in the middle distance is best, with no detail behind them, as they need to stand out. For example, try not to place figures directly in front of a house which has intricate doors, windows and drainpipes. If a figure has to be positioned there, these features must be softened off to a plain wash first, otherwise there will be a conflict.

When the time comes to paint in the figure, therefore, the planning beforehand will ensure that the odds are on your side. With just two or three quick strokes of a small round brush or a rigger, put in the upper part of the body. If this goes wrong, immediately wash it off with a No. 10 or No. 12 brush awash with clean water; keep these items close to hand before starting on the figure. Soak up the water with a tissue then wait for the paper to dry. You can then have another go – as many as you need, in fact! Once the top part of the figure is acceptable, put in the trouser or skirt colour, even whilst the body part is wet, and follow it up with the head, though

that can be left until the rest is dry. I rarely put in anything below the knees as this makes the figure bottom-heavy, so to speak. Should the worst happen and you do not like the result when it has dried, then sponge it off gently and start again. That procedure will give you much more confidence in tackling figures, so now you have no excuse for excluding them! Nevertheless, it is imperative to practise them on scrap paper before you work on your proper painting.

My paintings tend not to be too populated with people. If figures are included they are usually farmers or sea fishermen in a harbour. It is important to have them actually doing something – driving a tractor, herding sheep or feeding animals – as this makes them part of the scene. Often a splash of bright colour – a red jacket perhaps – is helpful, but remember, generally farmers are not colourfully attired, especially when muck-spreading! Watch the way people hold themselves: an arched back, for example, can indicate activity and movement.

Bringing together all the various elements of a pastoral scene needs care and study in order to achieve a sense of unity and authenticity. Again, I should stress the usefulness of thumbnail and studio sketches here, to clarify your composition before you start.

EXERCISES

Go out sketching with the sole aim of drawing people and animals, whether in town or country.

Practise some figure and animal painting for middle-distance areas; pick those you dislike and wash them off immediately, as described. Follow this up by inserting figures and animals into some of your earlier paintings – where they are appropriate.

Sketch buildings in the middle distance, in their environment. Carry out paintings from these sketches.

Try to find some interesting field gates from which you can sketch the field, tractor ruts, puddles, farm implements.

Do a painting of the Duddon Valley, Lake District (below). *My version is on page 155.*

18 Light on the Landscape

Without light we have no subject. Light affects the way we see things so much that it can turn the most mundane scene into one that we become desperate to put down on paper. We can walk past a scene a dozen times in different lighting conditions, but when the light is right it can have a stunning impact on our visual sense. The combination of low, strong, evening or morning sunshine at the same time as stormy, wild weather is guaranteed to get me out of the house.

Unless you live in a sunny climate, however, you will have to sketch and paint on days when the lighting is less than ideal. Days of dull cloud and flat light can affect not only your subject but also your spirits, rendering you less likely to do a good job. You need to counter this with the positive aim of turning the lack of strong light to advantage. Low lighting conditions can impose an air of mystery and mood over a place, and by helping you to omit things you cannot see, may well result in a stronger composition. Less detail should lead to a less cluttered composition. Water and snow scenes obviously do better than most others in a low-light situation, because of their reflective qualities. On the other hand, sketching farms on moorland, for example, is quite difficult as buildings merge into moorland on dull days, like stone chameleons. Therefore,

when the lighting is suspect, take care in choosing your subjects.

MAKING THE MOST OF LITTLE LIGHT

Even on dull days, what light there is has to come from one direction and it is beneficial to establish this early on, especially if you are working on buildings, boats and man-made structures. Sometimes, when there is no sunlight, strong shadows appear on the sides of buildings because tall dark trees stand close by, and this can account for inconsistencies in lighting. Unless you exaggerate what little light there is the painting will look flat and uninteresting. If the sun does make an appearance, then immediately work rapidly on the light and shade effects. Once the sun disappears it might not come out again for a long time, so make the most of it when it is there.

CONISTON WATER, LAKE DISTRICT
320×485 mm (12½×19 in)
Think about including the sun in your painting: it must be the lightest part of the picture, though! For the light on the water here a dry-brush technique was used with a mix of French Ultramarine and Burnt Sienna

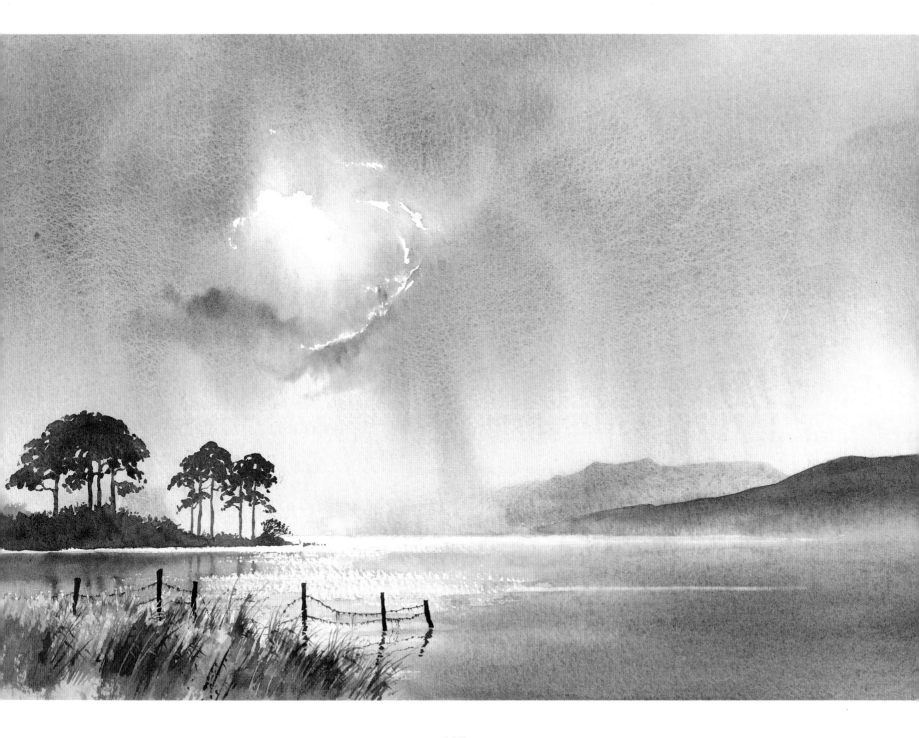

CHANGEABLE CONDITIONS

Cloud and sunshine are perhaps one of the best combinations, as the sky is generally more interesting and the landscape has alternating patches of sunlight and shadow. Once you have picked out your centre of interest you need to observe the changing light patterns across it, and also how the adjacent areas are affected. Whole mountains can change character in seconds because of these fleeting conditions. In these circumstances a camera can be useful. Students are always asking whether they should work from photographs. As many professionals use cameras I see no reason why students should not do likewise. This is especially true for those who cannot get out into the landscape very often. Photographs can be used in changeable conditions to capture the shadow and light situation, and are excellent when used in conjunction with the sketch.

As with any subject that is moving, it is important to watch the scene for a few moments and then when you are clear about what you wish to achieve, get it down quickly. This is easier said than done, of course, and requires constant practice. You need to be able to render large tonal areas rapidly, so organization is vital. Give some thought to the materials you will use. Watercolour, with a No. 8 or No. 10 brush, can cover large areas much more quickly than pencil. You may find it best to outline in pencil first, then lay quick washes on the paper

once the shadow-sunlight combination has been observed. Charcoal is another quick medium, with the advantage that you can happily draw with it and also, by laying it on its side, cover large areas with tone.

No doubt you will sometimes be tempted to change your initial shadow plan when a feature is suddenly lit up differently, but try to be consistent. Changing your plan will simply create problems. Instead, if there is time and opportunity, carry out another sketch depicting a different lighting combination over the focal point. You will then have a choice for the finished painting.

STRONG SUNLIGHT

If we had strong sunlight every day of the year the landscape would become rather boring, with little atmosphere and mystery. There are other drawbacks, too. The reflection of strong light on paper can cause considerable discomfort. If your work cannot be shielded from the sun, you could try working on tinted paper or wear sunglasses – the best ones are those with neutral grey lenses, as blue, green or brown tints can badly affect your colour vision. Sunlight coming from directly behind you causes a flat-lit subject and, in the case of a mountainside, can obscure interesting crag details which often stand out better when mist isolates them from the main cliff. As a consequence, take some time to determine the best angle to work from, as far as the lighting is concerned.

Do remain aware that the sun is moving constantly: shadows will be changing all the time. There will be occasions when you may want to wait for the sun to be at the right angle, and other times when you work feverishly to complete a passage before the shadow is lost. Twenty minutes is a long time when dealing with shadows on a complicated structure. Reflected light poses a further challenge. Rocks, walls, surfaced roads and other hard areas can reflect light and strong colours onto adjacent surfaces, so take advantage of this. Note particularly any downward-facing rocks splashed by waterfalls or waves: these surfaces often can be very light as they reflect foaming water.

TRELEDDID FAWR
330 × 510 mm (13 × 20 in)
This traditional Pembrokeshire cottage positively lights up in brilliant sunshine, with its whitewash and light cemented roof. Little surface texture has been indicated on the front wall, despite the irregular stonework which protrudes in places. On the end wall strong reflected light is visible, thrown up from the whitewashed shed, and more reflected light is evident inside the porch

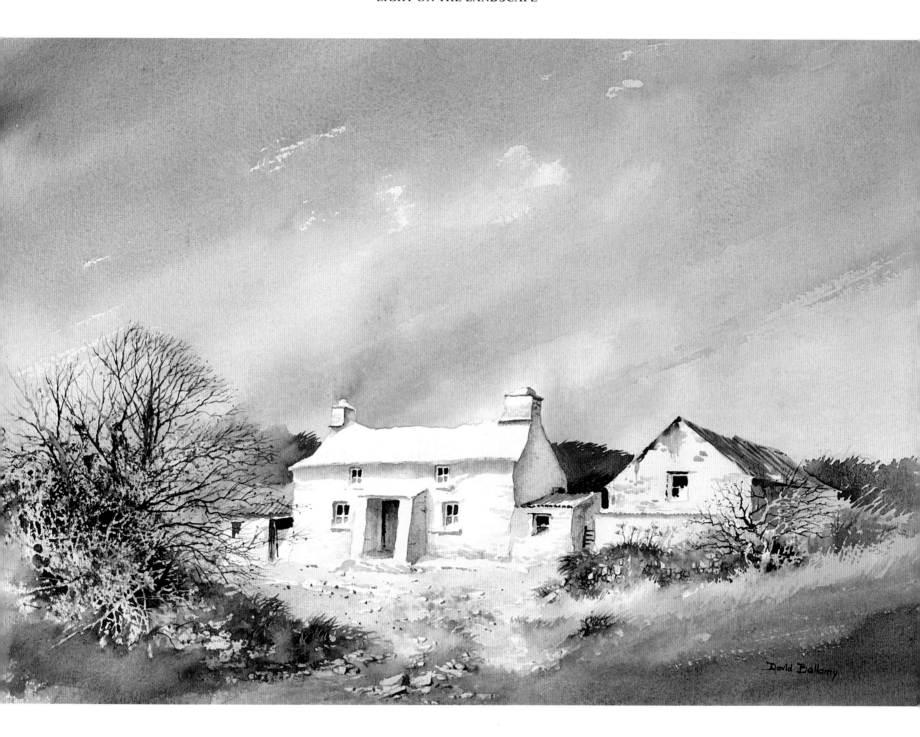

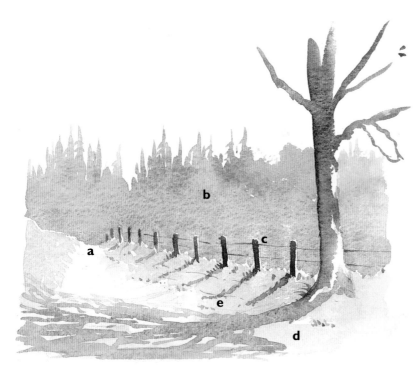

Anatomy of a sunlit scene
This shows some of the ways light and shadow can be portrayed in a painting
a *Track left as white paper for emphasis*
b *Background painted in cool blue to contrast with warmth of sunlit area*
c *Posts highlighted on right sides to indicate back-lighting*
d *Light wash of Raw Sienna over foreground track*
e *Cast shadows follow contours of ground*

▼ **Cast shadows**
The top illustration shows the best way of portraying cast shadows – by laying a glaze in one wash right across the local colours. The shadow in the lower illustration has been painted by treating each part of it separately and as a result it is less effective

DEPICTING SUNSHINE AND SHADOW

Cast shadows caused by cloud are normally soft-edged, although ridges and undulations in the topography will cause hard edges to appear. Shadows with hard edges are generally found only in the foreground, but these are cast by solid objects such as buildings. Throwing a cast shadow across the foreground of your painting can be very effective, especially if the shadow follows the contours of ruts, banks and the like, emphasizing the slope of the ground. Cast shadows are best laid on as a glaze, using perhaps Ultramarine or a weak purple, allowing the original wash to show through. Greys and intensely dark overlaid colours

are too dull and do not allow the local colour to shine through. Cast shadows, of course, can be lengthened if necessary, as they are not always in the right place from the artist's point of view.

To achieve a feeling of strong sunlight, put as little detail and texture onto the sunlit area as you can get away with. At the same time areas of strong detail in adjacent shadow passages will accentuate the contrast. Make these adjacent shadows much cooler and darker to emphasize the sunlit areas, which conversely should be painted in warm and light colours. Shadows further distant should err more on the cool side than the dark, in order to achieve aerial perspective. Leaving white areas of paper

is another way to suggest sunlight. Warm evening light can reveal some dramatic changes of colours, even warm reds and purples, especially on reflective surfaces such as rock. I have seen a whole hillside look like a fiery furnace when caught in a sunset, even when much of the hill was covered in grass.

Sunlight can totally transform your paintings, but do take care that your light and shadows are consistent throughout the painting. Naturally, within a scene shadows can cause the light to be concentrated at one or two points. Watch that the sun appears to be shining from only one direction! This may seem an obvious point, but it is occasionally overlooked.

Sunlight on a building
Here the wash on the end of the cottage has been graduated so that the right-hand side stands out strongly against the dark tree – an effective technique. Note that there is no stone work detail on the sunlit wall and that the windows and door are in strong contrast

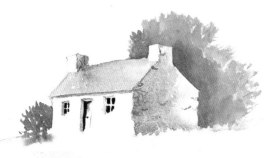

EXERCISES

•

Go out on a sunny day and attempt some watercolour sketches with the aim of capturing the effect of strong sunlight. Try some light-coloured – preferably whitewashed – buildings to start with. Look for cast shadows and reflected light.

•

Try sketching on a dull day, making use of what little light exists. Before you start, ensure you are aware of where the light source is, at least approximately.

•

Paint the Auchindrain scene, Strathclyde (below), making the lighting and cast shadows a strong feature. My painting is on page 156.

19 Mountain Scenery

No other scenery excites me as much as the mountains. Whether in the form of a lonely bothy standing amidst a cirque of snowy peaks, or a sparkling stream tumbling down a grit-stone staircase, wild beauty is my prime source of inspiration. At first glance mountains can appear to be overwhelmingly difficult to paint. In sunshine you can often see too much detail, yet if it is wet and windy you may not even wish to get out your paints. The closer in you move the more intimidating that detail becomes. If you retreat, however, the detail recedes only to reveal more mountains, and then where do you start? Yet mountains, despite the apparent difficulties, constantly appeal to the artist.

PAINTING MOUNTAINSIDES

If you are new to painting mountains, try starting with a whole mountain first, without including too much detail. Chose a single mountain rather than a vast range which would present you with a dilemma about where to start, but try to avoid a featureless rounded peak. Position yourself so that there is a lead-in to the mountain – a track, river, wall or whatever. Observe not just the outline but the way that parts of the mountain come towards you. Select only the main gullies, crags and obvious features, and

ignore the rest. Sometimes you will find that nothing is outstanding, so you then have a choice of making one or two features more prominent. Do not delude yourself into feeling the need to fill up every square centimetre, with gullies climbing the north face like a row of upwardly mobile slugs.

Note the colours and surface textures of the slopes. These can be achieved by using broken washes – allowing the original colour to show through the overlaid wash – and dropping other colours into wet washes. Diagonal dry-brush strokes down the slopes will suggest scree. Over all this the shadow areas might need to be placed. Ensure these are consistent in following the gullies and hollows of the mountainside. Finally, any strong, dark rock masses and crags should be painted over the top. Leave these till last so they stand out, sharp edged, against the background.

◀ **Painting a mountainside**
This shows the various stages of painting a mountainside
a *Initial wash of Raw Sienna applied, with patches of Light Red dropped in in places for variation*
b *French Ultramarine and Light Red applied diagonally over the dried Raw Sienna wash, using the dry-brush technique*
c *Dark rocks inserted in keeping with the character of the mountainside*
d *Some specific detail rendered with a fine brush once the wash is dry*

BIDEAN NAM BIAN, GLENCOE
510×710 mm (20×28 in)
The massive buttresses dwarf the three climbers in the middle distance, but without the figures the sense of scale would be completely lost

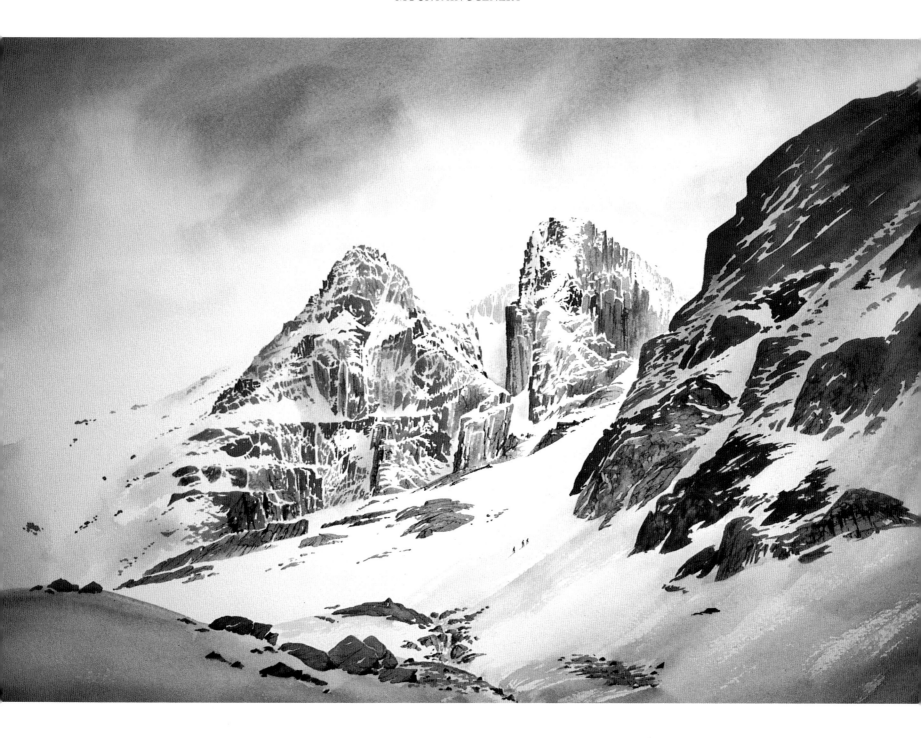

▲ Painting rocks
Here different types of rocks are illustrated at various stages of completion. They are lit by strong, low lighting from the left
a *This shows the initial stage: the colours have been splashed on and blended into one another*
b *Here shadows have been laid on to indicate form. This simplified approach is adequate to suggest rocks effectively*
c *Surface texture, fracture lines and yellow lichen have been included here to give some idea of the possibilities for a more complicated approach. This section was painted in the following order: colours, lichen, textures, shadows and fractures*
d *Here a dark background highlights rock forms dramatically, with just a few simple strokes depicting the fracture lines*

◄ Monte Popero Valgrande, Italian Dolomites
310×455 mm (12¼×18 in)

ROCKS AND BOULDERS

Rounded boulders, whether in streams or on a mountainside, are useful for fitting into all sorts of places in a mountain environment. Angular rocks are more interesting as their different planes catch the light. Usually the top of the rock or boulder is lightest. Paint on the local colour first, dropping further colours into the wet wash if there is more than one. When this has dried, lay on the shadow areas, followed by the darkest recesses. Next come the surface textures, if apparent, and finally any fracture lines. In the case of the latter, note how these run: vertically, diagonally, horizontally? Also, vary their width according to their character and ensure they start and end naturally: do not tail them all off in the middle of nowhere.

Practise painting rocks as often as you can. When out sketching, try to capture their surface textures as well as form and colour, and notice how rocks are affected by moss and water. One method of suggesting texture quickly is to load a rigger with medium-toned colour and, using the brush on its side, work it across the rock surface in a scrubbing manner. This is most effective on rough paper as the brush misses the indentations of the surface. The extra-long hairs of the rigger also contribute to a less contrived effect.

CRAGS

Crags are mountains in miniature, but are virtually all rock, and so reflect the light considerably. Much of the advice on painting mountainsides and rocks applies here, though the surface texture and details are often more pronounced. If the crag itself is the focal point, you will find that a vertical format adds drama and probably best suits the vertiginous form of the subject. Sometimes it is not easy to isolate a crag from the bulk of the parent mountain, unless mist intervenes between the two. Choose your viewpoint carefully and make full use of any cast shadows. Including climbers in your painting can add a splash of colour and lend scale. Also look out for the odd rowan tree or thorn bush which can be put in to break up the hard lines.

DEMONSTRATION

BEINN FHADA,
NORTHERN
HIGHLANDS
320×470 mm
(12½×18½ in)

❏ Stage 1
The mountain is
viewed from Glen
Affric, one of
Scotland's most
beautiful glens.
With changeable
weather and
lighting conditions I
could have sketched
this scene all day
in differing moods.
The paper is
Saunders Waterford
140 lb Rough.

Having drawn in
the pencil outline, I
began with a wash
of French
Ultramarine right
across the sky and
down over the
right-hand side of
the mountain.

Some light Raw
Sienna was washed
over the lower sky
and immediately

a strong wash of
French Ultramarine
and Burnt Sienna
was dropped into
the sky and allowed
to flow down
gradually, etching
a strong definition
between mountain
and sky.

Some mountain
detail was then
introduced.

❏ Stage 2
Work on the flanks
of the mountain was
continued, using
mainly French
Ultramarine and
Burnt Sienna on the
lower parts.

The valley was
washed in with Raw
Sienna and the
boulders in the right
foreground put in
with French
Ultramarine and
Burnt Sienna.

Stage 1

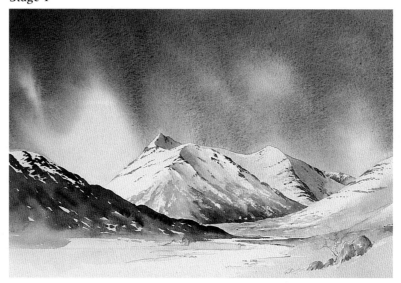

Stage 2

❏ Stage 3
The painting was
then completed with
strong tones of Burnt
Sienna and some
French Ultramarine
on the left-hand
slope, and patches
of white left here
and there to
suggest snow.

Some Light Red
was added to the
foreground and the
ruin was inserted,
using French
Ultramarine and
Burnt Sienna.

Finally, the River
Affric was suggested
with a few strokes of
a flat brush, and the
tree in the right
foreground rendered
with a No. 1 rigger.

▶ Stage 3

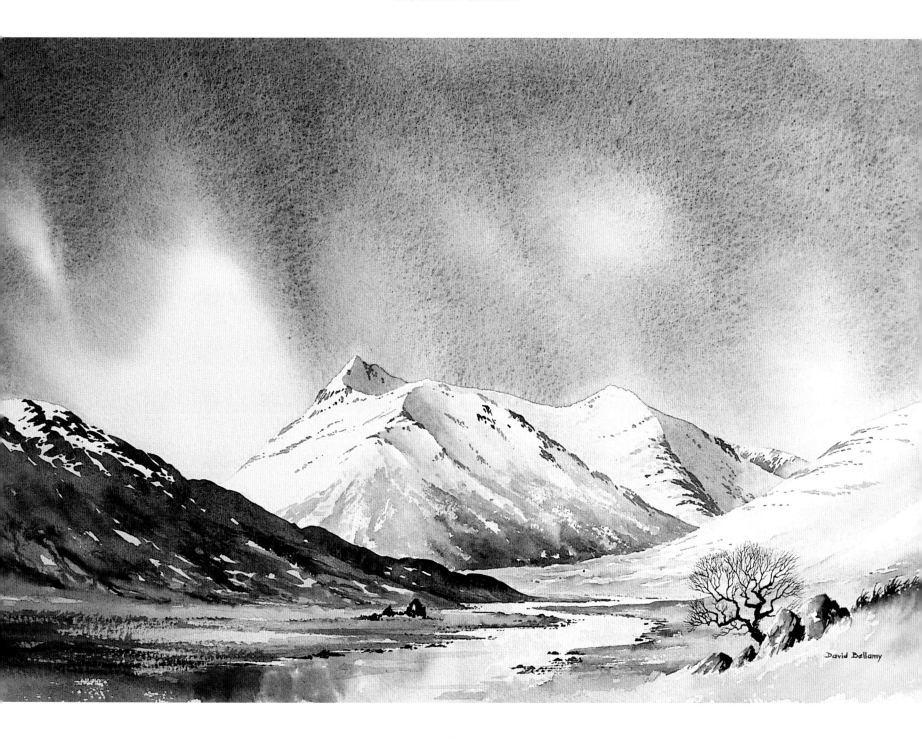

David Bellamy

SNOW-CLAD MOUNTAINS

Just a light dusting of snow makes the mountains so much more impressive. They seem to climb even higher. When the sun lights up the snow-rimed face, the whole mountain becomes alive, with shadows cast into the gullies. These shadows should be painted in as soon as the mountain is defined, then allowed to dry before any detail is added. Distant rocks can be made too dark when seen against stark white snow, so compare their tones with those of much closer rocks. Ask yourself if you can see any local colour in these. Reduce the number of individual rocks and crags quite considerably, but try to retain the overall character and shape of the more important crags, gullies and rock formations. Much of the time there is little colour on mountains in winter raiment, so take every opportunity to add some. Accentuate any warmth in the sky, for example, and, correspondingly, any light reflections in foreground water.

SCALE

Pastoral scenes are scattered with features that provide a sense of scale – trees, houses, animals, vehicles, hedgerows and so on. In the high mountains, however, it is not always obvious how large a rock, crag or mountain actually is – if, indeed, it is at all possible to take in the overall size of a mountain! To give some idea of scale you need to include an object of a known size. At lower levels, farms or cottages can be inserted to accentuate the bulk of a background mountain, but high up such features are non-existent. However, animals and climbers will lend a feeling of size, and so will small trees such as hawthorn or mountain ash. It is important when including features which provide a sense of scale to place them a little way into the picture. In the foreground they would dominate the scene and have totally the opposite effect to that intended. Naturally, whatever you include for scale purposes, do ensure that it is characteristic of the area!

WORKING IN OPEN COUNTRY

Moving around and finding the optimum viewpoint on the subject is easier in the mountains as there are fewer fences and walls. Still, the terrain can be pretty demanding. A 1:50,000 scale map is a must, not just to help you find your way around, but also to assist your search for subjects. With experience you should be able to read a map like a book, and so have a fair idea of the prospect of subject matter in an area even before you set eyes on it. The map will also help you identify mountains, of course, and will indicate streams and tracks that might be a good lead-in, as well as taking you close to farms, cottages, lakes and so on, potentially good subjects in themselves.

There is not much shelter in mountains, so you should be prepared for the worst. I sometimes sleep between rocks: this enables me to stay at high

CRIB GOCH, SNOWDONIA
This monochrome sketch in Payne's Grey shows reticulations at the top of the wash caused by instant freezing-up

level overnight and get the best of the light at both sunset and sunrise. For the less adventurous, much work can be done from a car, but even then it makes sense to get out and walk a few paces to obtain the best angle possible. It is always sensible to have a companion with you in these places, as breaking a leg even a short distance from the road could prove disastrous. If you want to sketch at high level, make sure you have the right equipment, as well as the ability to find your way around the mountains in bad weather. If you are really interested in painting mountain scenery, my book *Painting in the Wild: A Practical Guide* explores the subject in depth.

Mountain scenery is so varied, from valley floor to summit, and little has changed over the centuries. Much of it remains as it was 200 years ago when the first artists ventured into the wild places, awe-struck by the fearsome crags and terrified of avalanches, bandits, wolves and the unknown. Many ancient packhorse bridges and old stone-built dwellings can still be found. These lovely old structures make excellent subjects, especially before a mountain backdrop. Walking and sketching is an idyllic combination and in these wild places you are highly unlikely to get anyone looking over your shoulder – except a few sheep! At the time, the effort might seem like purgatory, but long after the symphony of the mountain winds has faded to an echo, your sketches will bring back those magical images of visual grandeur.

EXERCISES

●

Try to find some rocks to sketch in watercolour, either in mountain, moorland or coastal scenery. Failing that, try to find a quarry.

●

When sketching in mountain or hilly terrain, try to accentuate the size of a mountain or hill by including some features to give it scale. First carry out two or three thumbnail sketches, in

each one placing the feature included for scale purposes further into the picture. Use the most effective composition for the main work.

●

Do a watercolour painting based on the photograph of Crib Goch, Snowdonia (below), being as adventurous with the sky as you wish. My version is on pages 156–7.

20 Coastal Subjects

Many students feel ambivalent about coastal scenery. It is dramatic, beautiful and generally a pleasure to see on a fine day. However, waves, boats and cliffs are not the easiest of subjects to paint; harbour scenes often cause perspective problems; and the sea is constantly moving in and out with the tide. It presents an enormous challenge. Still, there is a lot you can do to make life easier for your paint brush, so take heart.

Before you visit the coast it helps to know when high and low tide occurs, and, if you are unfamiliar with the area, what to expect in the way of scenery and harbours. For example, what beaches are accessible? Often the more interesting parts of a coastline are well served by a variety of walking guides. These not only make life easier in finding your way around, but also provide a wealth of information, and in many cases illustrations, which give you a clue as to what lies ahead as far as subjects are concerned.

BEACHES

Beaches are probably easiest to paint, and if you stand well back from the water you will not be bothered by those nasty waves! Beaches are best visited at half-tide on the ebb, not only from a safety point of view, but also because at this stage you are more likely to find reflections of rocks and people in the wet sand. Figures in the middle distance, for instance, have superb, elongated reflections.

Try to find a scene with some cliffs or rocks in the background, an area of sea suitably foaming white at the water's edge, and a little interest closer in, perhaps in the form of rocks. The idea is to keep things fairly simple at this stage. At times you will see many waves: reduce these to two and keep the distant sea more or less as a flat wash. Far-off waves can even be rendered by leaving a ragged line of white paper, perhaps broken here and there. No matter how calm the sea appears, try to give it a sense of movement. Also, observe how the sand varies in tone and colour as it recedes from the sea, drying out on the way. Make use of seaweed, beach debris and perhaps even sea-shells to give it interest, but limit these: do not put them all over the place. Rocks and rock pools add interest in the foreground, too, and suggest a feeling of depth. They can, of course, form excellent subjects in their own right.

MOMBASA HARBOUR, KENYA
230×330 mm (9×13 in)
The old harbour used to be full of Arab dhows, but these days they are much fewer. The figures provide a sense of scale and the lack of detail on the right-hand buildings helps to push these back so that they do not compete with the focal point. Strong, dry-brush work suggests foreground detail without describing it too much

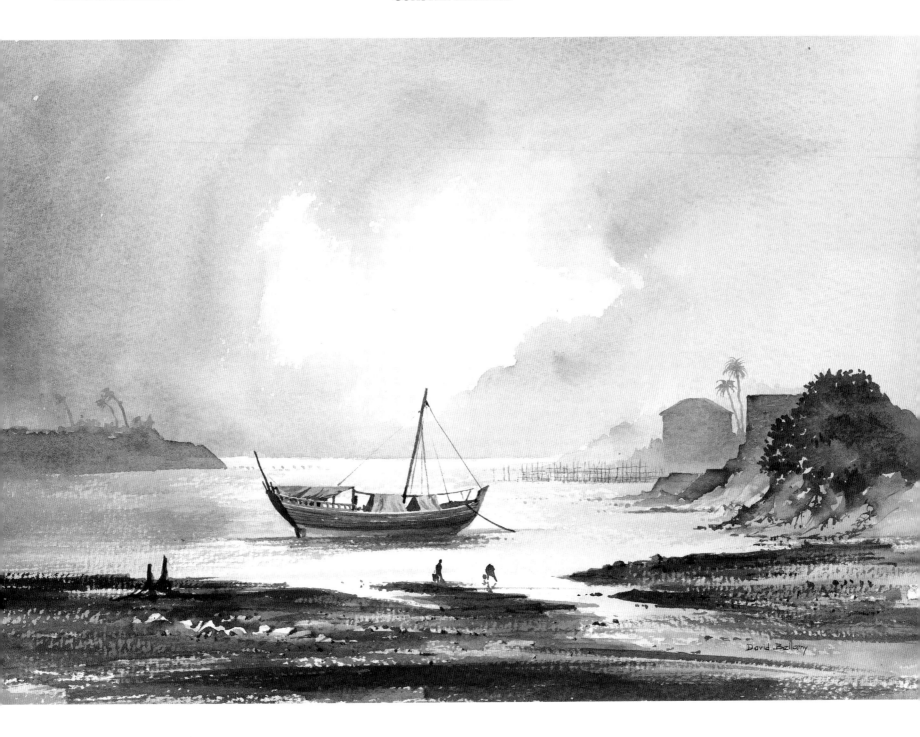

David Bellamy

DEMONSTRATION

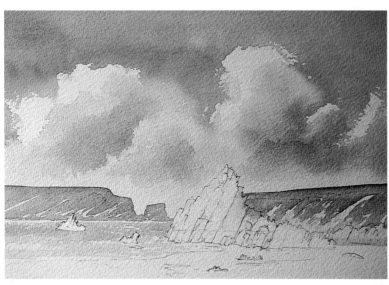

Stage 1

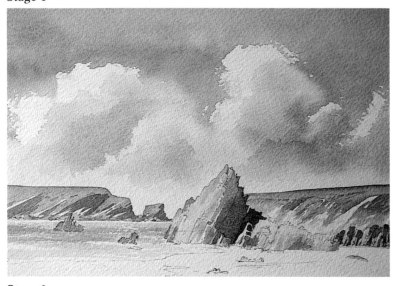

Stage 2

MARLOES BEACH,
PEMBROKESHIRE
215×305 mm
(8½×12 in)

❑ Stage 1
*Once again I used
Saunders Waterford
140 lb Rough.*

*A Cobalt Blue
wash was brushed
down over the sky,
leaving white areas
to suggest clouds.
With the sunlight
coming from the left,
the top and
left-hand sides of the
clouds were left
hard-edged, whilst
the other sides were
softened off with a
wet brush.*

*Raw Sienna was
applied to the lower
half of the sky and
the distant cliffs.
Whilst the sky wash
was still wet, the
shadows beneath the
clouds were
portrayed with a
mix of Light Red
and Cobalt Blue.*

*When the initial
wash on the cliffs
was dry, Cobalt Blue
and Raw Sienna
was brushed with
diagonal strokes to
suggest the lines of
the strata, although
some of the original
Raw Sienna was left
to show in places.*

*For the sea some
Cobalt Blue was
brushed across
quickly, the rough
surface of the paper
accentuating the
dry-brush effect.*

❑ Stage 2
*With the paper now
completely dry, the
darker parts of the
cliffs were delineated
with Light Red and
Cobalt Blue. The
same mixture was
then laid across the
water in bands to
create interest.*

*Raw Sienna was
applied to the rocks
and then detailed
work on them was*

*begun, with the
shadow areas
rendered with a
mix of French
Ultramarine and a
little Light Red.*

*The undercolour
of Raw Sienna gives
a warm glow
through the glaze of
French Ultramarine.*

❑ Stage 3
The shadows of French Ultramarine and Light Red on the rocks were completed and Raw Sienna washed across the beach, leaving streaks of white paper to suggest glistening water.

On the left-hand side Cobalt Blue was run into the wet Raw Sienna at the transition between sand and water.

The dark reflection was achieved by brushing a mixture of Light Red, Raw Sienna and a little French Ultramarine horizontally across the beach, leaving streaks of untouched paper.

Next, darker French Ultramarine and Light Red areas were inserted wet-in-wet and light parts pulled out with a damp brush.

This was then allowed to dry before dark blobs of French Ultramarine and Burnt Sienna were dabbed in for the pebbles and a dry-brush passage placed across the immediate foreground.

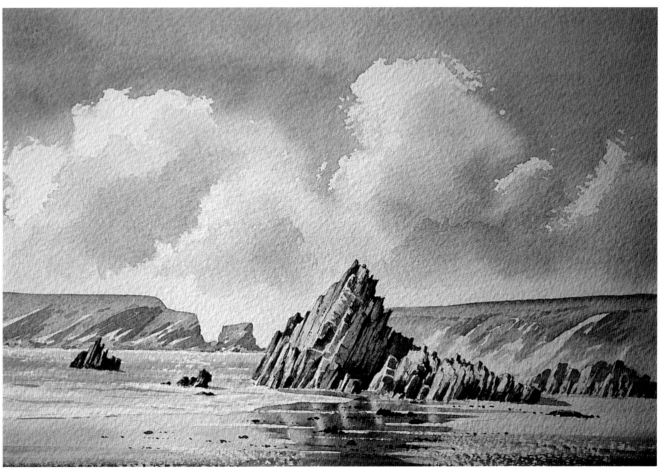

Stage 3

WAVES

When you feel ready to tackle waves at close hand, prepare to get wet! If it is safe to do so there is nothing better than going for a paddle, sketching waves at the same time: being at flotsam level certainly makes them much more impressive. Waves are best viewed from slightly to one side rather than head-on. If they are to be the centre of interest you need to make them fairly large. Distant cliffs without too much detail form the ideal background, otherwise you will need to include an interesting sky in your final painting, which, of course, you can work on at leisure afterwards.

For a few moments, study the action of the waves. See how they break, spill and crash onto the surf, to expend themselves on the beach. Note also how they crash onto rocks, followed by cascades of white water pouring back into the sea. Once you are ready, work quickly. A pencil is hard to beat in difficult conditions; you can always make colour notes and follow up with some photographs later. Draw in the curve of the breaking wave, concentrating on the apex as the water starts to spill. Forget the rest of the scene: just get down that small part. When the next wave arrives you must be ready to observe that part of the wave directly below the portion already sketched. Put in the shading under the spill and render the concave wall of water; see how it is flecked with swirling light streaks and blobs. Study the colours and how the wall of water becomes a flat, moving kaleidoscope, surging forward in front of the wave. With the next wave, note how it appears to one side of what you have sketched. Continue in this way, gradually building up your sketch and including the sea immediately beyond the wave, until you have sufficient information to make a painting. Note also the direction of sunlight, the colours and the surrounding scene. If you make an error, leave it and start afresh either on a new

Study of a wave
Do ensure you reserve the white foaming splashes when laying the surrounding washes. Also realize the need at times to accentuate the adjacent mid-tones so that those splashes stand out

sheet or, if you are working on a large sheet, on another part of that. It is best to use as large a sheet as is practicable. Even if you are painting on site, doing preliminary sketches of waves in this way is an excellent planning exercise.

Whilst on the shore, watch for large splashes of white water as waves hit rocks. Again, you should watch for a while before you put down anything on paper. When doing a painting you will of course need to reserve white paper for these areas. Rocks partially lost in spray are evocative of wild coastal scenes. To portray these effectively, put in the detail, then remove part of it by sponging across with clean water. Soak up any excess water with a tissue.

CLIFFS

Cliffs are ideally sketched from beach level rather than cliff-top, as looking down on a subject presents greater perspective problems. From water level they are also much more dramatic. On some of my courses we have a two-hour session sketching from a boat close in to the cliffs, which enables us to manoeuvre into the optimum position. One of our wilder adventures afloat was the return journey from the Skellig Islands off the Southern Irish coast. With the boat battered by waves and spray drenching me completely every 30 seconds (whilst everybody else sat in the shelter of the cabin), it was certainly not the easiest platform from which to sketch!

The wildlife is also more apparent from a boat. Take opportunities to go for a boat ride, if you can, and make sure your sketchbook is to hand. Canoes also enable you to enter sea arches and caves, and to sketch in the most fantastic places. On a calm day it is one of the pleasantest ways of getting into a sketching position. Do watch the incoming tide, however, when out in a boat sketching cliffs.

HARBOURS

Harbours provide fascinating subjects for the artist, but be warned: there are many pitfalls. Harbour walls, wherever they are sketched from, can cause prodigious perspective problems. Try to stand away from them, as the closer you are, the more acute the perspective angles. Break up their monotony with ropes, masts, lobster pots, people, gulls, bollards and the like – but not too many or it will look like a circus. At low tide, use ropes, chains, seaweed and the channels gouged by the keels, to act as a lead-in to your painting.

It follows that doing studies of lobster pots, fishing nets and all the trappings of harbours makes good sense, as these sketches form a reservoir of material which can be used over and over again. Harbours definitely need life, otherwise, like villages and towns, they can look ghostly. Whilst it is all right to include the odd tourist, harbour-master, fire-eater or whatever, it is best to concentrate on fishermen, boat repairers

and working people. Have them doing things rather than simply posing like maritime fossils.

Some harbours and quays seem designed to cause maximum nuisance to the artist, as they prevent any decent views of the moored vessels. Maldon in Essex is one such place, made even more frustrating by the fact that its lovely old sailing barges are right under your nose. It is one of my favourite Essex haunts, but to view the vessels you either have to walk sea-wards some way to see them end-on or use a boat. Swimming is not always recommended in these circumstances. Sometimes binoculars and a telephoto camera lens can be useful when faced with this problem, and they also help you to sort out which mast belongs to which vessel when they are double-moored.

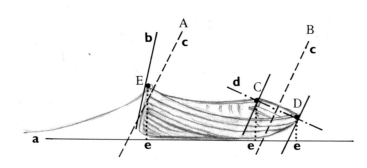

Studies of boats

When working on studies of boats, seek out fine examples, choose the best angle to sketch from and keep the background simple

a *Begin with a base line*

b *Note that the line of the bow is rarely vertical*

c *Estimate the true vertical line, as indicated by the dotted lines **A** and **B**: often a mast or rudder will help here*

d *The line athwart the stern, at 90 degrees to the vertical, will establish points **C** and **D***

e *Calculate the heights of points **C**, **D** and **E** by measuring along the vertical dotted lines from the base line, using your pencil at arm's length*

BOATS

Begin by selecting simple boats. Their easiest aspect is from broadside-on, but the best angles are generally to one side, at a point where much of the bow or stern detail is visible. From here the artist is usually presented with a more handsome profile. Until you have had plenty of practice, stick to upright boats – that is, those with twin keels or held up by side struts or sitting in the water. Only when you are more confident should you attempt boats lying on their side.

Getting the curves fairly accurate is important. To achieve this, use reference points and constantly compare sizes and angles at critical points. Measure accurately with your pencil. Establish a base line: this is usually where the vessel sits on the ground or, when it is afloat, the waterline. A vertical reference is also helpful. Use a mast, rudder line or vertical lines on the cabin, if these features are visible; otherwise, estimate where an imaginary vertical would be. Include this vertical reference as a lightly drawn line and use it to estimate the

positions of other lines on the boat by constant comparison. Finally, do keep your eye on the tide, whether it is rising or ebbing, as it can quickly change the attitude of your boat, not to mention your position! With constant practice the problems of boat sketching will recede.

It seems that everything connected with marine painting, whether water, rocks, boats or harbours, has extra complications. However, the subjects are so lovely that the challenge is worth the trouble. Exploring in such an environment is also an extremely pleasant way of passing time. I do hope I have convinced you to have a go at this aspect of painting. As with most things, it takes time to gain competence to a satisfying degree, but half the fun is what you do along the way.

EXERCISES

●

Go out and sketch some boats – often canals and large rivers have boatyards and moorings. Use pencil at first, then graduate to watercolour. Include some of the background but do not overwork that aspect.

●

Try some simple 5- or 10-minute sketches of beaches or estuaries, including some feature of interest to act as a focal point.

●

Once you have gained in experience, have a go at some cliffs and waves. They can be difficult, so do not expect too much of yourself at first.

●

Carry out a painting based on the picture of Minehead harbour in Somerset (below). Keep the background trees and houses extremely simple – use just a flat wash if necessary. My version is on page 157.

GALLERY OF PAINTINGS

This section contains a gallery of finished paintings, most of which form 'model answers' to the exercises featured in the previous chapters. These 'model answers' do not by any means represent the best way of painting these subjects; each simply suggests one of countless ways of achieving a pleasing result from source material. If I painted the subject again it would probably end up as quite a different picture. Some of the problems encountered when painting one subject can also be found in others. This overlap ensures that some of my paintings produce different answers to similar problems, so do watch out for these variations. Remember that in order to get the most out of the exercises it is best not to examine the 'model answers' before doing your paintings. However, by all means repeat the exercises once you have compared your results with mine.

The source material I used for my own paintings was sometimes slightly different from the photographs in the exercises. This was because my sketches did not always correspond exactly with the photographs, some of which were taken on completely different occasions. Most of my paintings are reasonably faithful to the subject, but in a few cases I have taken artistic licence a little further than in others. In these instances the text mentions any wide discrepancies.

COTTAGE AT DUNSTER, SOMERSET
180×230 mm (7×9 in)
For this scene I felt a vignette was appropriate, to soften the painting at the edges and to avoid the foreground stream which would otherwise become an enormous distraction. Some detail has been inserted into the background mass of trees, but much simplification ensured this did not overpower the work. The dark trees help to make the cottage stand out and the open gateway invites the viewer towards the focal point. Splashes of red in the foreground hedge help to bring it forward. The painting was carried out on a Not surface and the three colours used were Cadmium Yellow Pale, French Ultramarine and Light Red

David Bellamy

▶ GALWAY THATCH
200×495 mm (8×19½ in)
You do not always need to stick to the same format as the original scene, which is why I have taken a few liberties here. Just because photographs come in a standard format is no reason why paintings should! The buildings that have been left out did little for the composition – in fact, I felt they detracted from it quite strongly. An elongated format suits this subject, as there are few vertical features on this part of the Galway coast. Payne's Grey, Cadmium Yellow Pale and Raw Sienna were the main colours used

STOB COIRE NAN LOCHAN, GLENCOE
255×340 mm (10×13½ in)
The day before I painted this I had climbed down a face on the other side of this peak – 180 m (600 ft) of sheer terror that made me decide to stay in the valleys painting flowers; but when I saw this scene I completely forgot my resolve! The composition has been kept faithful to the original. With little scope for change, the main concentration was on building up the picture gradually. The bright sunlight catching snow-bound ridges has been emphasized by placing strong French Ultramarine shadows in the gullies and on the slopes in the shade. The rocks were then painted over shadow and sunlight areas alike. What little colour was in the scene has been accentuated, particularly in the sky and warm-coloured crags on the right-hand side. Strong foreground tones achieve a sense of recession and also frame the focal point

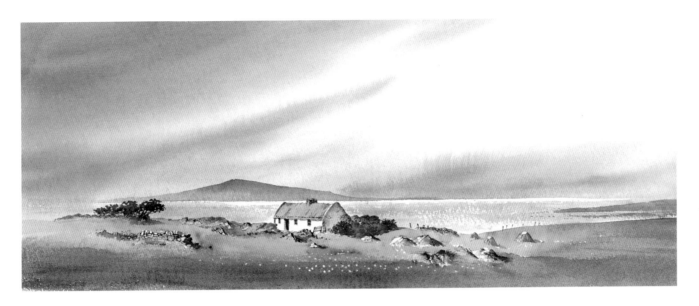

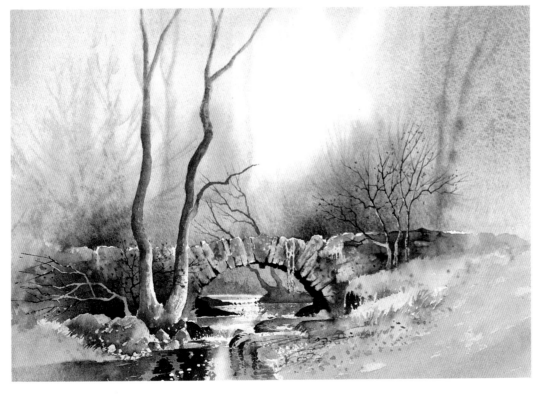

PACKHORSE BRIDGE, CROOK GILL, YORKSHIRE

290×405 mm (11½×16 in)

The background mass of trees and undergrowth has been greatly simplified here, using the wet-in-wet technique. Detail on the bridge stones has been 'lost and found', with a variety of colours splashed into it whilst it was still damp. Flecks of white paper have been left on the top stones to add a little sparkle. To avoid detracting from the bridge itself, detail on the stones lying below the right-hand side of it has been kept minimal, merely suggested in outline

CASTLE AT LANJARON, ALPUJARRAS
MOUNTAINS, SPAIN
235×330 mm (9¼×13 in)
The painting does not really deviate very much from the original scene, although I have closed in the atmosphere a little. Detail on the castle itself has been considerably reduced. Aerial perspective, which is the subject of this exercise, has been achieved by making the mountain ridges progressively stronger in tone as they come closer to the viewer

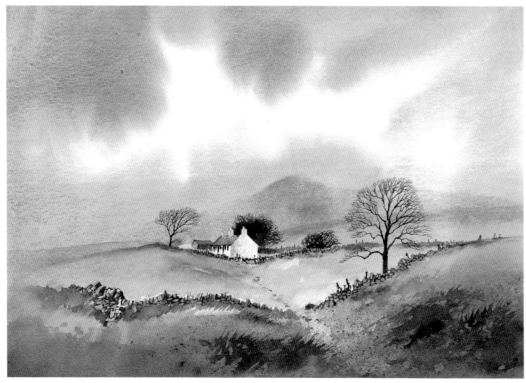

COTTAGES NEAR CEUNANT, SNOWDONIA
240×340 mm (9½×13½ in)
Yes, this really is based on the sketch in Chapter 11! Because the composition has been simplified considerably, the impact is so much stronger. Do not despair if you have left other buildings in, as the composition could still work provided they are not too far apart. I have simply gone to the extreme in order to provoke an enquiring attitude to compositional challenges. In the foreground field I have used toothbrush spatter to suggest texture. The thumbnail sketches I drew to work out this composition are on page 50

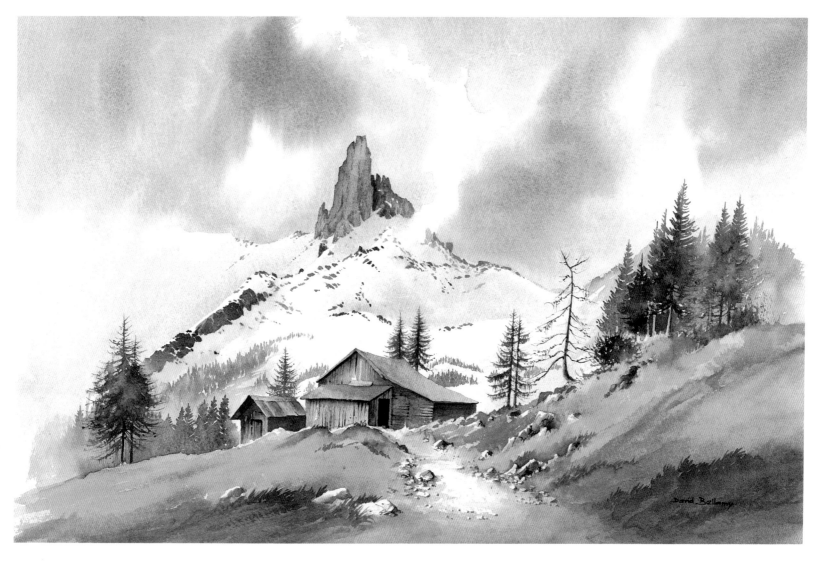

BECCO DI MEZZODI, ITALIAN DOLOMITES
330×495 mm (13×19½ in)
The amount of planning in any painting obviously varies with the complexity of the composition. Here, the key planning consideration was whether to include the main hut on the right, the Rifugio Gianni Palmieri, *or put in just the outbuildings. In the end I decided on the latter course, since only part of the refuge could be seen anyway. Much of the clutter of trees and rocks on the distant slopes has been reduced and the ridges on either side of the peak faded out. The two trees towards the bottom left-hand corner* provide a valuable stopping point for the ridge running down diagonally from the peak. Although the atmosphere remains much the same as in the original scene, considerable thought was given to planning the dark and light passages in the sky and on the ridges

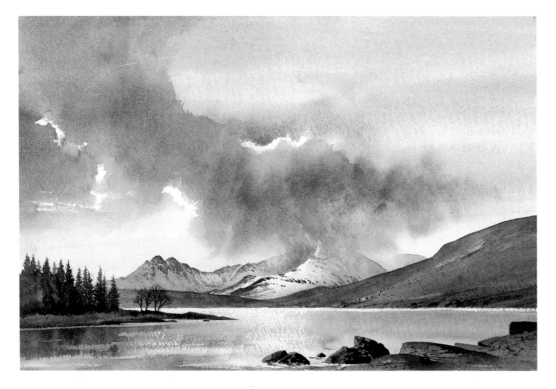

SNOWDON RANGE FROM LLYN MYMBYR
290×465 mm (11½×18¼ in)

This is the classic view of the Snowdon range, viewed from Capel Curig and easily accessible. Apart from the sheer magnificence of the view, what has impressed me over the years is that every time I visit this spot the sky holds tremendous interest, as though trying to compete with the topography. Here, the additional complexity was that the large expanse of water needed to relate to the sky, however simply. The lake, Llyn Mymbyr, has been kept simple, but dry-brush work near the centre both adds interest and suggests a light reflection from the snow slope. The colours reflect those in the sky. The peak which stands to the left of the main massif is Y Lliwedd and it was important to make this stand out. I did this by introducing a glow in the sky behind it. The east ridge on Snowdon is gradually lost in the thick clouds which obscure the summit. At the top of the cloud formation I have alternated the tones, with almost a silver lining in the centre and dark, ragged edges on either side, carried out with the side of a brush

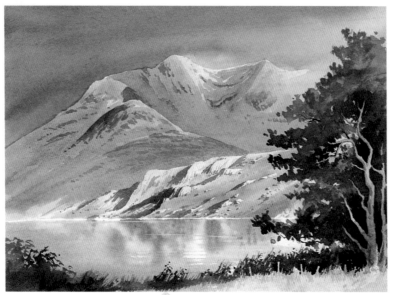

◀ KILLARY HARBOUR, CONNEMARA
240×340 mm (9½×13½ in)

I hope the complicated mountain structure did not put you off this scene! Whilst the reflections were the raison d'être *for this painting, in actual fact they form quite a small part of the composition. Really, only the lower band of mountain ridge is relevant to the reflections, so it was important to finish painting this area before starting on the water. A medium tone of Cobalt Blue and Payne's Grey was applied for the water and*

then weak Raw Sienna was brushed in for the lighter parts of the reflections. This actually took out more paint than it put on to the paper. Whilst the wash was still wet the darker reflections were dropped in, using French Ultramarine and Burnt Sienna, and then the streaks suggested with a flat brush

▶ RIVER AVON NEAR BREAMORE, HAMPSHIRE

230×330 mm (9×13 in)

The biggest change I have made here is to lose all the detail on the far hillside, which was put in simply as a flat wet-in-wet wash. The lighter parts of the central tree were painted first and when these were dry the background hill was inserted, colour also being added to the gaps in the foliage. Again, once the paper had dried, the shadow side of the tree was washed in, hard and dark against the distant hill but softened off into the lighter foliage to the right. Turning to the bank of trees on the right, the outer two were painted first and then the middle one in darker tone

▶ BARN IN THE DUDDON VALLEY, LAKE DISTRICT

230×335 mm (9×13¼ in)

Whilst retaining the sunlight, my intention here was to impose a new sky over the scene. Darkening the sky in places allowed me some interesting counterchange between sky and hill. I suggested the mass of trees on the hill by picking out one or two here and there. The number of sheep has been reduced and some of them are grazing

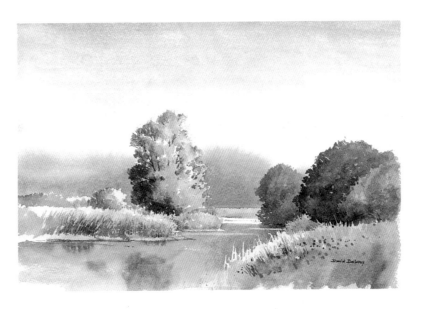

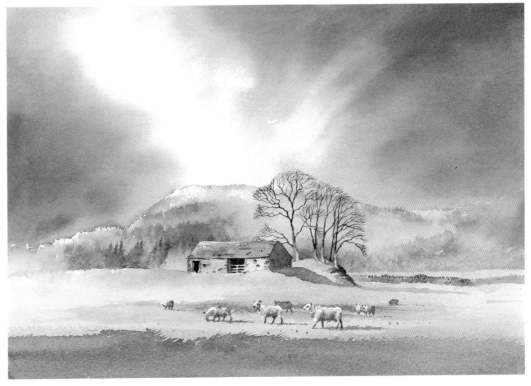

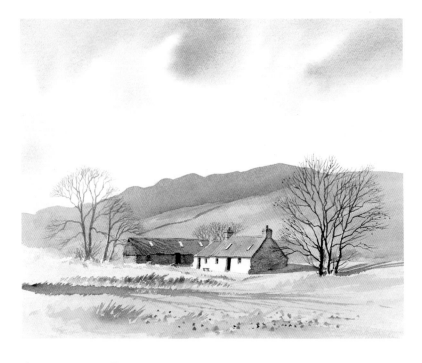

AUCHINDRAIN, STRATHCLYDE
210×265 mm (8¼×10½ in)
Auchindrain, near Inverary, is a traditional Highland township museum of many old buildings, a gem for those interested in country living long ago. The inclusion of cast shadows in this painting is vital to the feeling of bright sunshine, together with strong contrasts between sunlit passages and shadow areas

CRIB GOCH, SNOWDONIA
635×1000 mm (25×40 in)
Whether climbing, sketching or looking at this peak, it never ceases to thrill me. With so much snow, ice and rock, and an immense piece of watercolour paper to cover, this subject was quite a challenge. I could have got away with a simple sky but I wanted it to echo the drama of the subject, so boiling cumulus clouds seemed more appropriate.

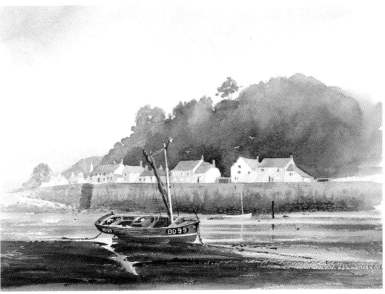

MINEHEAD HARBOUR, SOMERSET
235×330 mm (9¼×13 in)
With harbour scenes it is easy to overwork the confusing background to the detriment of the boats, so here I have kept the distant trees and line of buildings fairly subdued. Similarly, a background boat has been left out as this could have confused the eye and detracted from the main boat. Harbours, however, do benefit from some life, so I have included some gulls and figures in the distance. This particular boat is quite colourful, but if you come across boats without much colour, consider adding a splash of red – it can work wonders!

Warmth in the sky accentuates the coldness of the ice and snow. Note how the twin peaks of Y Lliwedd on the left appear pink, caught in the evening light. Flecks of white paper have been left on the ridges where snow catches the light and the rocks have been painted in such a way as to suggest the direction of the slope. In the foreground the frozen lake, Llyn Cwmffynnon, does not show much detail apart from the rocks

Useful Addresses

The Artist magazine, Caxton House, 63–65 High Street, Tenterden, Kent TN30 6BD
Contains articles on practical art and other subjects of interest to artists, plus exhibition, book and materials reviews and a gallery guide

Artist's and Illustrator's Magazine, The Fitzpatrick Building, 188–194 York Way, London N7 9QR
Has in-depth articles on art materials, features on artists and galleries, and practical articles

Leisure Painter magazine, Caxton House, 63–65 High Street, Tenterden, Kent TN30 6BD
Excellent instructional magazine for beginners and experienced artists alike, crammed with practical articles plus reviews

Daler-Rowney, Ltd, P.O. Box 10, Bracknell, Berkshire RG12 4ST
Suppliers of art materials

Patchings Farm Art Centre, Oxton Road, Calverton, Nottingham NG14 6NU
Art centre with a difference for those who would like to get out into the countryside but are nervous about painting alone. The centre includes facilities for handicapped students to work from specially constructed gazebos. A lake, bridge and haystacks, based on a Monet theme, are prominent features

Pro Arte, Park Mill, Brougham Street, Skipton BD23 2JL
Manufacturers of paintbrushes

BEN WHISKEN, COUNTY SLIGO, FROM THE WEST
140 x 200 mm (5½ x 8 in)

Index

Page numbers in **bold** refer to illustrations